Paul

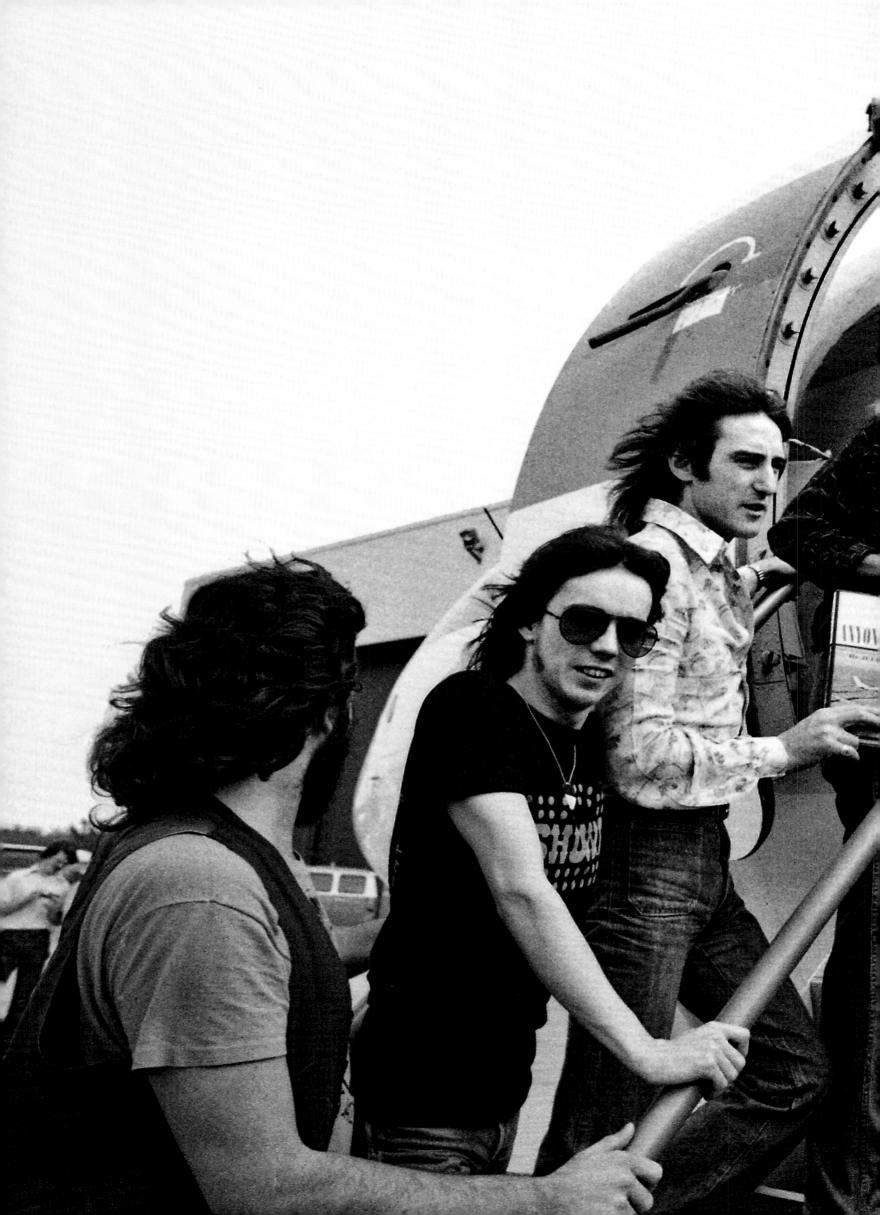

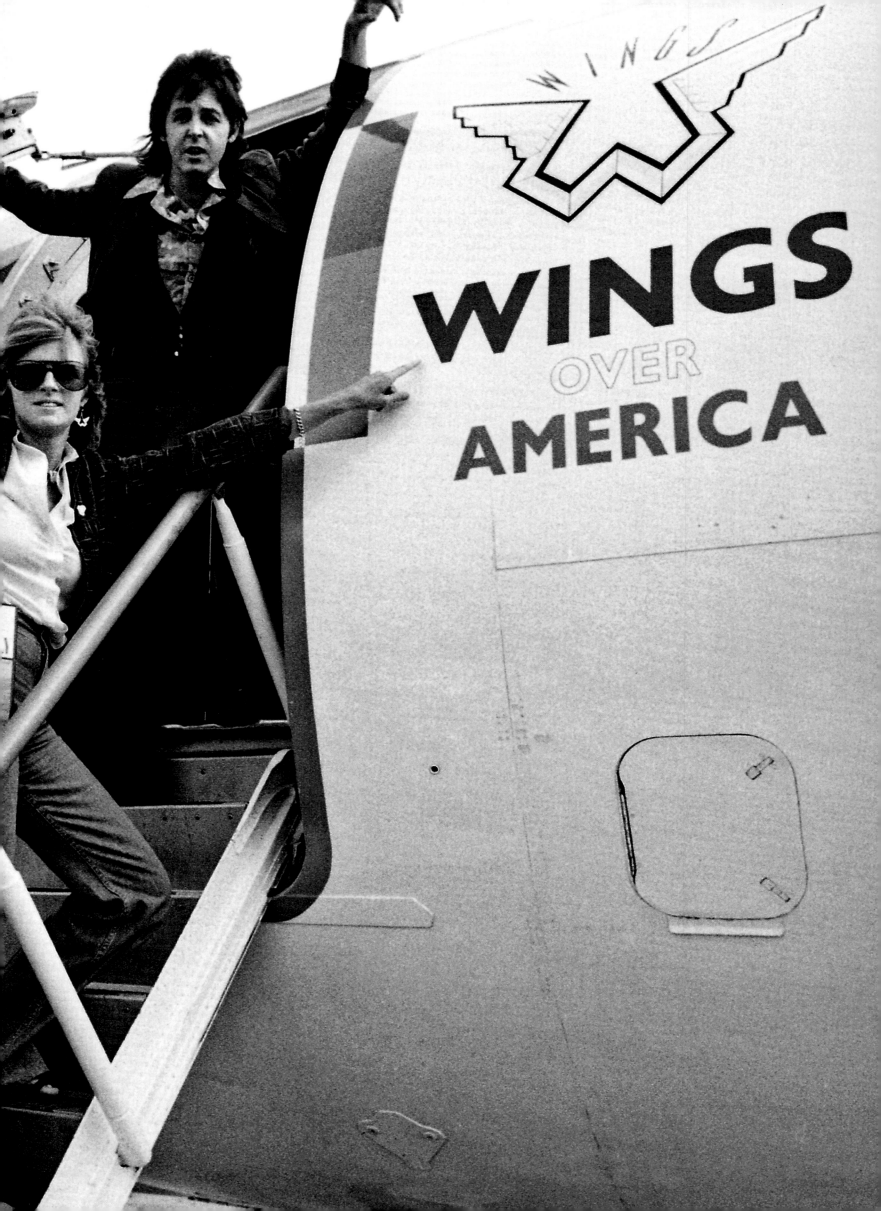

Harry Benson

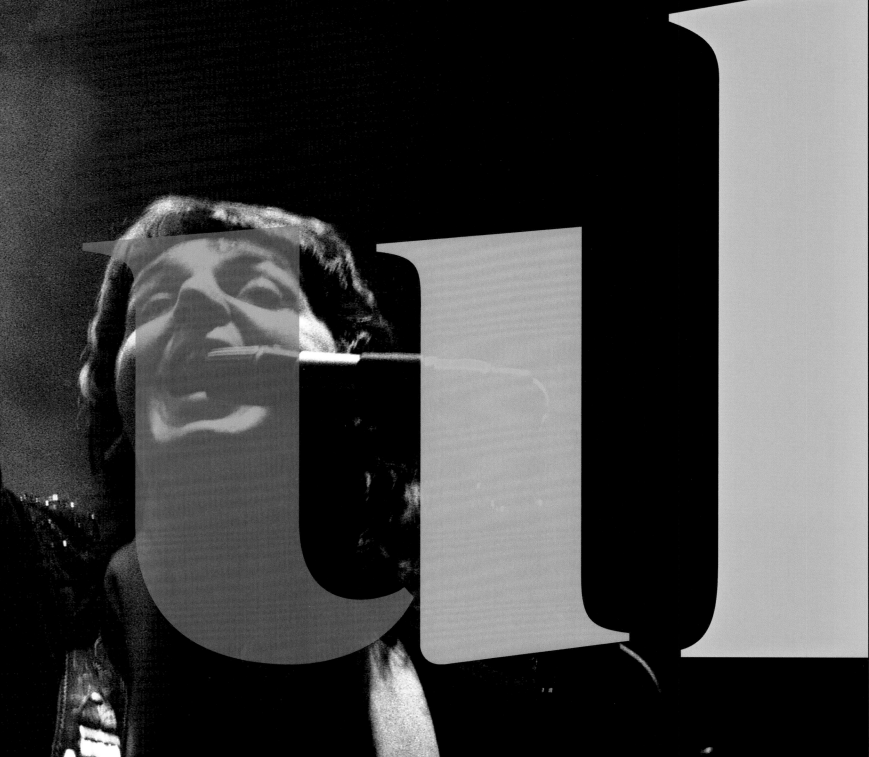

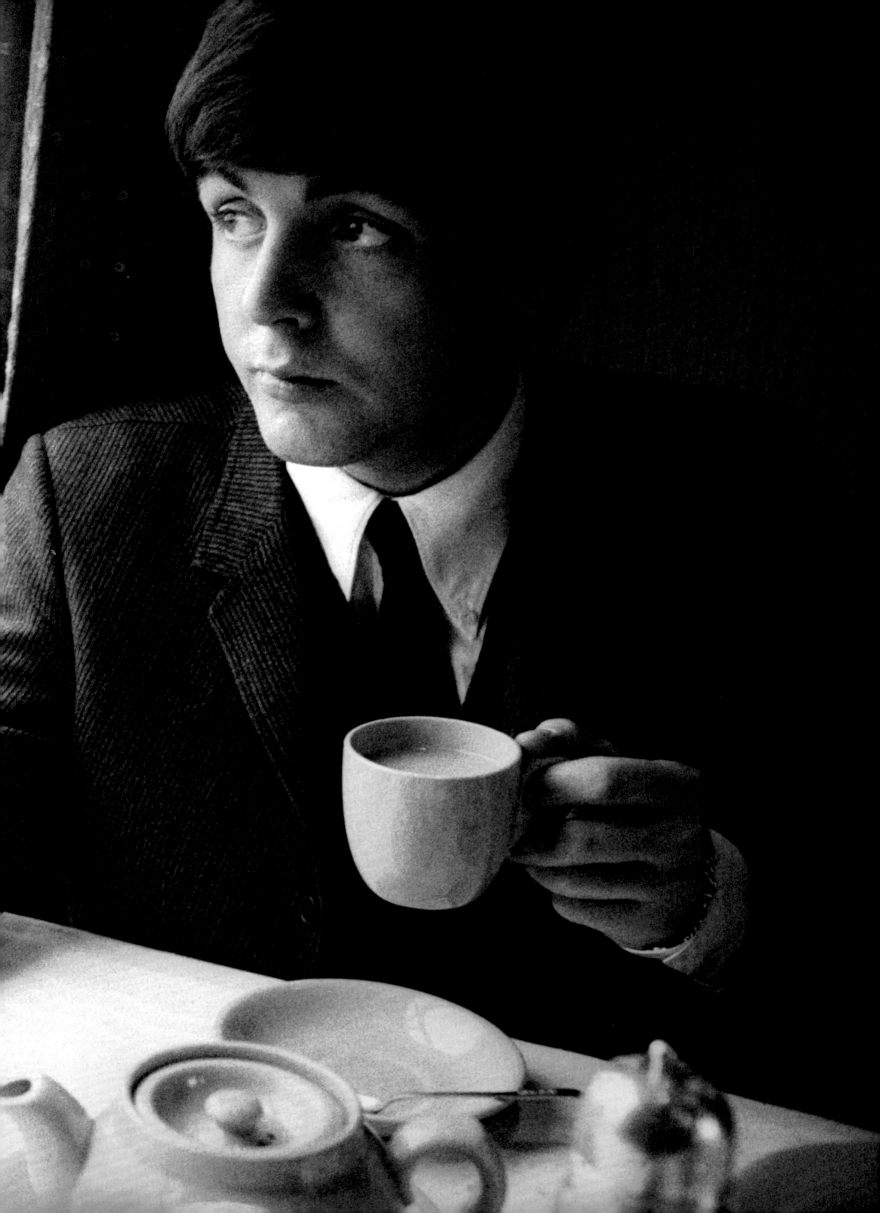

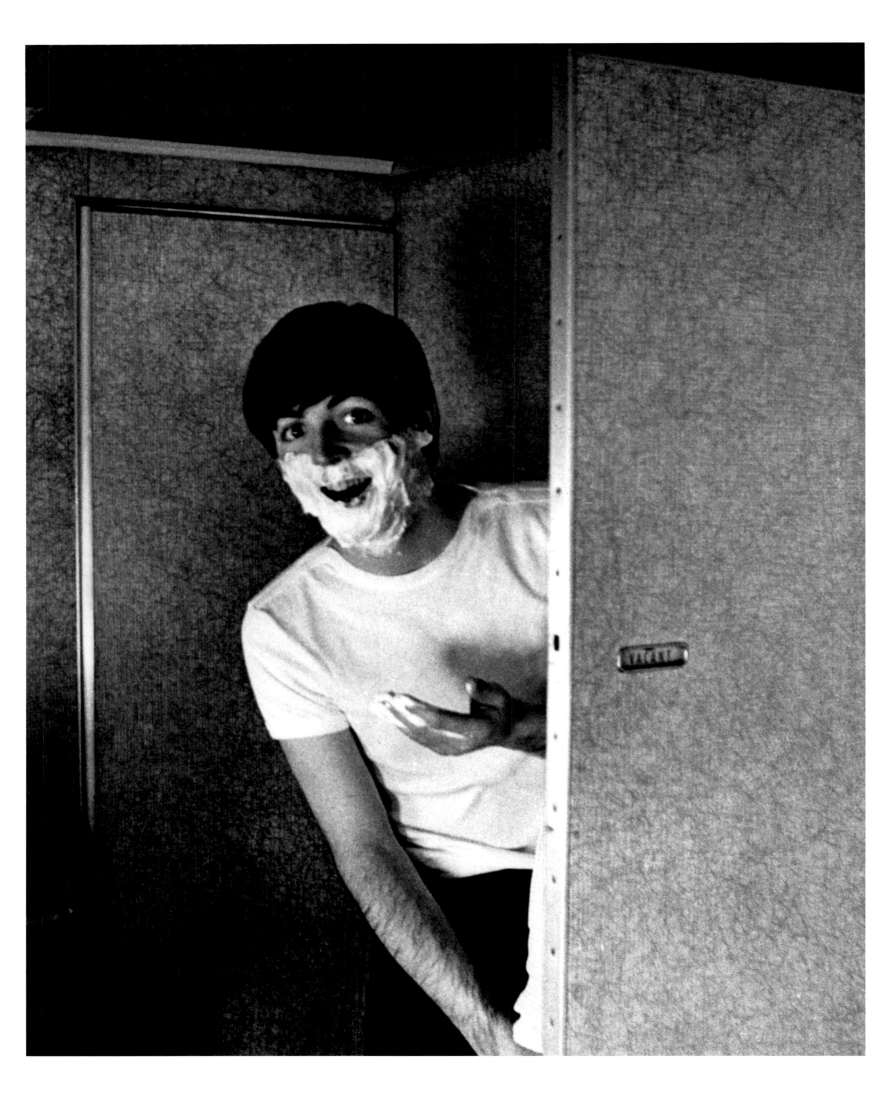

Pictures of Paul

Harry Benson tells the stories behind the images

Interview by Reuel Golden

With the Beatles

The story of how I came to photograph the Beatles is well documented. I was working on London's Fleet Street shooting news stories all around the world and was planning to leave the next day on assignment for *The Daily Express* newspaper in Africa. The phone rang late at night, and I was told by the photo editor that I was going to Paris to photograph the Beatles. I was not happy about it because I saw myself as a serious photojournalist, but thank God I took that call. It changed my life.

I soon discovered that you could take photos of the Beatles, but Paul had to be in them. A picture of the Beatles without Paul was not a picture of the Beatles. He was the magnet; he was the one you looked at, the one who would carry the mood of the situation. Like the pillow fight photo: without the charm of Paul, it's just four young men with pillows; he's the one standing up making the picture. He's an intelligent man who takes his work seriously, and of the four, he was the one who seemed most comfortable with the fame, welcoming fans, signing autographs, and holding his head up. John would do it, but he didn't like it. Paul was the leader on any given day, but then so was John. It's debatable, but I think that without question Paul was the most photogenic.

My favorite portraits of Paul from the Beatles period are the ones on the train from *A Hard Day's Night.* You see the self-contained Paul, private moments away from the insanity of Beatlemania.

My other key session from this period is of Paul and John composing quietly at the piano at the George V Hotel in Paris. There are so few photos of them actually making music. I was just there in the background shooting while they were getting down to the business of being the greatest songwriters of all time.

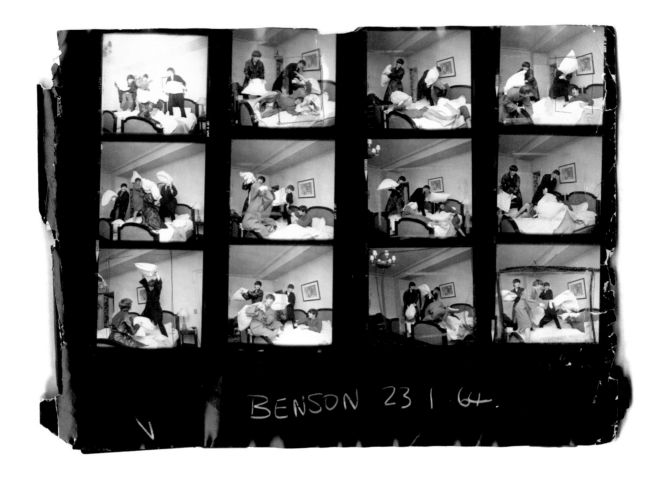

BENSON 23 1 64.

Wild Life

I was living in the United States and working for magazines such as *Life* and *People*. The images from the 1970s were for *People*. Paul and Linda were living in Los Angeles, working on a new album, and had rented a comfortable house, but not a big "showbiz"-type mansion. Paul is a real family man, and that comes across in the photographs. They were having fun with their life. I remember it like it was yesterday: he was playing the piano, singing. It was a lovely California morning, and Stella came and sat next to him—I love that photo.

I had a very good relationship with Linda. She was helpful and would come up with suggestions about how to make the sessions more lively and natural. As a photographer, she knew what it took to make a good picture. Often the person closest to the subject can be a big pain for me and say things like, "I hope this doesn't go on for much longer." Linda was the opposite. Paul would say, "Come tomorrow. 10 a.m. will be fine." Linda would say, "No, Harry, come at 8 and have breakfast."

Paul was content in his personal life, but there was also more pressure on him to come up with hits. I went back to their house three or four times and then photographed him in the LA studio. We were pleased to see each other, but it's not like we sat around talking about the old days. I was there to do a job, and he respected that.

The other session is from the early 1990s. The shoot was for *Vanity Fair*, near Paul's farm in Peasmarsh, East Sussex, in southern England. They wanted a more reclusive kind of photo, and so it was my idea to shoot them in the open field. I was up early, scouting the place with Linda. The plan was to feature her and her favorite Appaloosa and have Paul in the background, slowly walking toward them. The last thing he wanted to do was walk several hundred yards on a hot day, but Linda convinced him. It's a little story unfolding in front of your eyes. It's easy to see Paul and Linda were a team completely at ease with each other.

Band on the Run

The live and backstage material is from their tour *Wings Over America*. It had been 10 years since Paul had played with the Beatles in the US, so this was big news. I did maybe four shows; sometimes I would focus on the performance, sometimes on the crowd, and sometimes it was backstage.

My best work from this period is backstage where he's bursting through the door after a show, lying down exhausted, sweating. Linda told me that he'd never let anyone photograph him like that. You only get that access if they like you and don't mind you or your camera being there.

I was now part of the crew if I wanted to be, and once after a gig I rode on the Wings plane. But for the other performances, I would go home and catch up with them at the next concert. I didn't want to hang around too long — they get sick of you, and don't give you the pictures.

For the cover shot, I didn't tell Paul to pose. He was just in a good place; he wanted to be photographed. It's one of my favorites from that period.

The final section of the book is a launch party for the Wings record *Venus and Mars* from 1975. The party was aboard the luxury liner the *Queen Mary* in Long Beach, California. I was the only photographer allowed on board, and it was the first time that Paul and George had been seen together in public since the breakup of the Beatles. Bob Dylan, Michael Jackson, Cher, Tatum O'Neal, Dean Martin, and many other celebrities were dancing the night away. I like doing parties because you have 20 minutes to work a room and capture people when the energy is good and everyone is still sober enough and happy. It's very rewarding; no one wants to go unnoticed at Paul McCartney's big party, not even Bob Dylan.

I'm proud of the work that I've done with Paul over the years. He's one of the most talented people on earth, but also somewhat enigmatic. He's managed to live a relatively normal existence despite his enormous fame, and I respect that. As a photojournalist, I'm grateful Paul allowed me to document some private and personal moments in his extraordinary life.

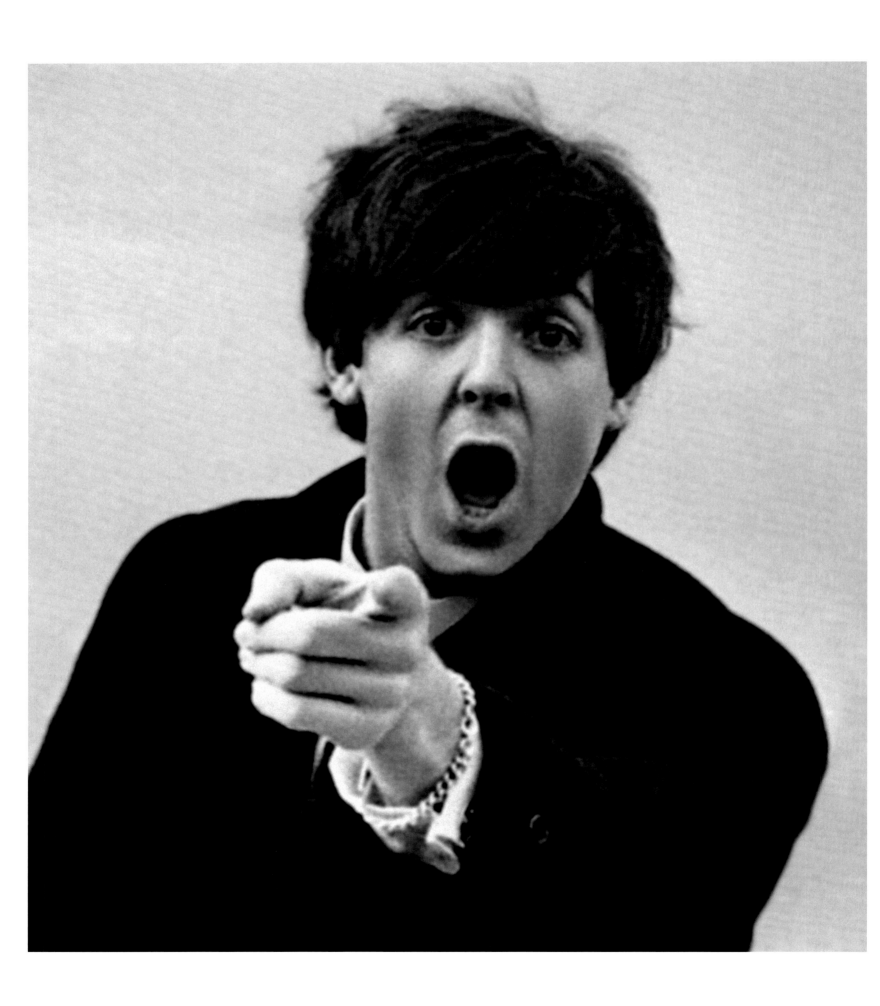

Bilder von Paul

Harry Benson erzählt die Geschichten zu seinen Fotografien

Interview von Reuel Golden

Unterwegs mit den Beatles

Wie ich dazu kam, die Beatles zu fotografieren, ist gut dokumentiert. Ich war damals als Pressefotograf für Londoner Tageszeitungen überall auf der Welt im Einsatz. Am Tag, bevor ich für einen Auftrag des *Daily Express* nach Afrika aufbrechen sollte, klingelte spätabends das Telefon, und der Bildredakteur teilte mir mit, dass ich nach Paris fliegen würde, um die Beatles zu fotografieren. Ich war darüber nicht erfreut, da ich mich als einen seriösen Fotojournalisten betrachtete, aber Gott sei Dank nahm ich den Auftrag an. Er veränderte mein Leben.

Wie ich bald herausfand, war es möglich, die Beatles fotografieren, aber nur, wenn Paul mit im Bild war. Ein Bild von den Beatles ohne Paul war kein Bild von den Beatles. Er war der Magnet, er war derjenige, den man ansah, derjenige, der die Stimmung der Situation transportierte. So wie bei der Aufnahme von der Kissenschlacht: Ohne Paul wären es vier junge Männer mit Kissen, aber er stellt sich hin und gibt dem Bild seine Stimmung. Er ist ein intelligenter Mann, der seine Arbeit ernst nimmt, und er schien von allen vieren am besten mit dem Ruhm zurechtzukommen, begrüßte Fans, schrieb Autogramme und ließ sich nicht unterkriegen. John tat das zwar auch, aber ungern. Paul war immer der Kopf der Band, was allerdings auch für John galt. Man kann darüber streiten, aber für mich war Paul ohne Frage der fotogenste Beatle.

Meine Lieblingsporträts von Paul aus der Beatles-Zeit sind die im Zug aus *A Hard Day's Night*. Sie zeigen einen in sich gekehrten Paul, private Momente abseits der Beatlemania.

Die zweite wichtige Bildstrecke aus dieser Zeit zeigt Paul und John einträchtig am Klavier beim Komponieren im Hotel George V in Paris. Es gibt nur sehr wenige Fotos von ihnen, die sie beim Schreiben neuer Songs zeigen. Ich war einfach im Hintergrund und fotografierte, während sie ihrer Arbeit als großartigste Songschreiber aller Zeiten nachgingen.

Wild Life

Ich lebte in den USA und arbeitete für Zeitschriften wie *Life* und *People*. Die Bilder aus den 70er-Jahren entstanden für *People*. Paul und Linda wohnten in Los Angeles und arbeiteten gerade an einem neuen Album. Sie hatten ein komfortables Haus gemietet, keine Riesenvilla im „Showbiz"-Stil. Paul ist ein echter Familienmensch, und die Bilder transportieren das. Sie freuten sich des Lebens. Ich erinnere mich daran, als wäre es gestern gewesen: Paul spielte gerade Klavier und sang dazu. Es war ein herrlicher kalifornischer Morgen. Dann kam Stella und setzte sich neben ihn – ich liebe dieses Foto.

Zu Linda hatte ich ein sehr gutes Verhältnis. Sie half mir und machte oft Vorschläge, wie sich die Sitzungen lebendiger und natürlicher gestalten ließen. Als Fotografin wusste sie, was es für ein gutes Foto brauchte. Oft nervt mich die engste Bezugsperson meines Modells mit Bemerkungen wie: „Hoffentlich dauert das nicht mehr so lange." Linda war genau das Gegenteil. Wenn Paul sagte: „Komm morgen vorbei. Zehn Uhr genügt.", dann sagte Linda: „Nein, Harry, komm um acht zum Frühstück."

In seinem Privatleben war Paul zufrieden, doch er stand auch unter dem Druck, Hits liefern zu müssen. In Los Angeles war ich noch drei oder vier Mal bei ihnen zu Hause und fotografierte Paul anschließend im Studio. Es war schön, sich wiederzusehen, aber wir saßen nicht etwa zusammen und plauderten über die alten Zeiten. Ich war dort, um einen Job zu erledigen, und er respektierte das.

Die andere Fotostrecke entstand Anfang der 90er-Jahre in Südengland, in der Nähe von Pauls Farm in Peasmarsh. Ich war im Auftrag von *Vanity Fair* dort und sollte Bilder vom zurückgezogenen Leben der McCartneys liefern. Also kam mir die Idee, sie in freier Landschaft zu fotografieren. Ich war früh auf den Beinen, um mit Linda die Gegend zu erkunden. Der Plan war, sie mit ihren Lieblings-Appaloosahengst in den Vordergrund zu stellen und Paul von hinten langsam auf sie zugehen zu lassen. An diesem heißen Tag mehrere Hundert Meter zu gehen, war das Letzte, was er wollte, doch Linda überredete ihn. Es ist eine kleine Geschichte, die sich dem Betrachter da auftut. Dass Paul und Linda völlig miteinander im Einklang waren, ist leicht zu erkennen.

Band on the Run

Das Live- und Backstagematerial stammt von der Tour *Wings Over America*. Das war eine kleine Sensation, denn das letzte Mal, dass Paul mit den Beatles in den USA aufgetreten war, lag zehn Jahre zurück. Ich fotografierte vielleicht vier Konzerte; mal konzentrierte ich mich auf die Musiker, mal auf das Publikum, mal auf das, was backstage passierte.

Meine beste Bildstrecke aus dieser Zeit zeigt, wie Paul nach einem Konzert backstage durch die Tür platzt und sich schweißgebadet und erschöpft hinlegt. Linda sagte mir, dass er sich

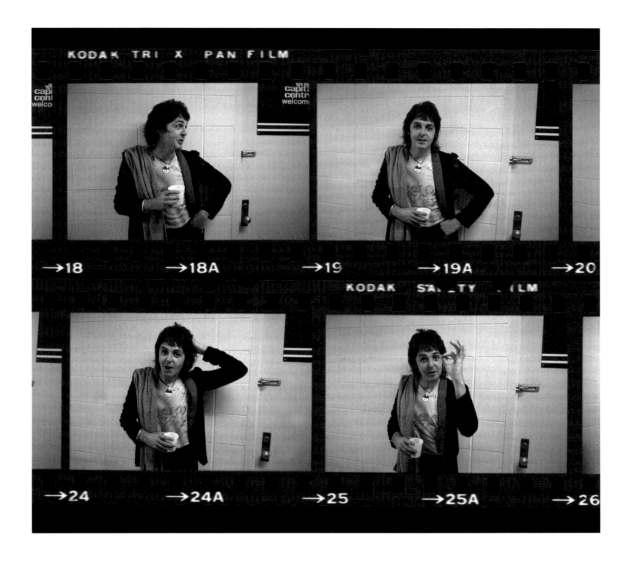

sonst nie so fotografieren lasse. So etwas darfst du nur, wenn dein Gegenüber dich mag und dich oder deine Kamera nicht als störend empfindet.

Ich war jetzt Teil der Crew, wenn ich es sein wollte, und reiste einmal nach einem Gig sogar im Wings-Flieger mit. Aber bei den übrigen Auftritten fuhr ich anschließend nach Hause und stieß erst beim nächsten Konzert wieder dazu. Ich wollte nicht zu lange bei ihnen herumhängen – sonst fängst du an, sie zu nerven, und bekommst deine Bilder nicht mehr.

Für das Coverfoto habe ich Paul keine Pose vorgegeben. Er stand einfach günstig und wollte fotografiert werden. Es ist eines meiner Lieblingsfotos aus jener Zeit.

Der Schlussteil des Buches zeigt die Release-Party zur Veröffentlichung des Wings-Albums *Venus and Mars*, die 1975 in Long Beach auf dem Luxusliner *Queen Mary* stattfand. Ich durfte als einziger Fotograf mit an Bord. An diesem Abend waren Paul und George zum ersten Mal seit Auflösung der Beatles wieder gemeinsam in der Öffentlichkeit zu sehen. Bob Dylan, Michael Jackson, Cher, Tatum O'Neal, Dean Martin und viele andere Stars tanzten die Nacht durch. Ich fotografiere gerne bei Festen, weil man sich in 20 Minuten

durch den Saal arbeiten und die Leute ablichten muss, solange Hochstimmung herrscht und alle noch relativ nüchtern und happy sind. Es war ungemein lohnend, denn niemand, nicht einmal Bob Dylan, wollte bei der großen Party von Paul McCartney unbemerkt bleiben.

Ich bin stolz auf die Aufnahmen, die ich über die Jahre von Paul gemacht habe. Er zählt zu den größten Talenten auf dieser Welt, und er ist doch auf irgendeine Weise rätselhaft. Es ist ihm gelungen, trotz seiner ungeheuren Berühmtheit ein relativ normales Leben zu führen, und davor habe ich Respekt. Als Fotojournalist bin ich dankbar dafür, dass Paul mich einige private und persönliche Momente seines außergewöhnlichen Lebens dokumentieren ließ.

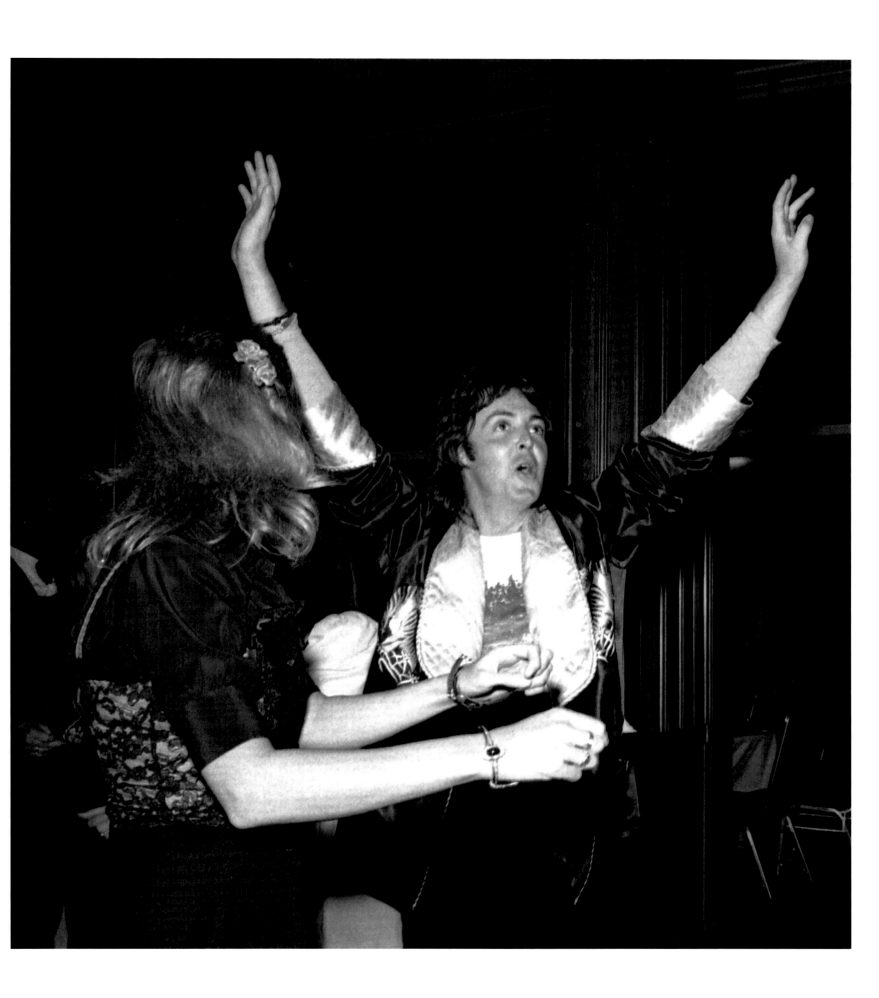

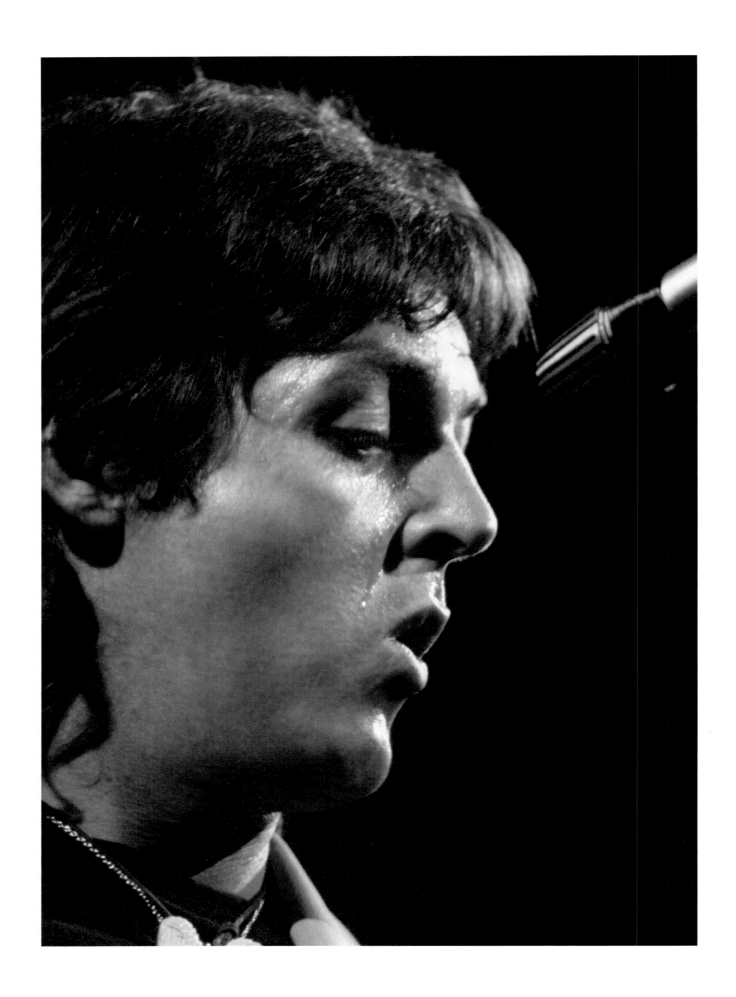

Des images de Paul

Leur auteur, Harry Benson en raconte la genèse.

Entretien avec Reuel Golden

Avec les Beatles

Comment j'en suis venu à photographier les Beatles est une histoire bien connue. Je travaillais à Fleet Street, le quartier de la presse londonienne, et réalisais des reportages dans le monde entier. Je devais partir en Afrique le lendemain pour *The Daily Express* quand, tard le soir, le téléphone sonna. L'éditeur photo m'annonça qu'on m'envoyait à Paris pour photographier les Beatles. Je n'étais pas très content car je me considérais comme un photojournaliste sérieux, mais, grâce à Dieu, j'obtempérais. Ce qui changea ma vie.

Je compris vite que si l'on voulait faire des photos des Beatles, Paul devait toujours y figurer. Une photo des Beatles sans Paul n'était pas une photo des Beatles. Il était l'aimant, celui que l'on regardait, celui qui exprimait le mieux l'atmosphère de la situation. Comme le cliché de la bataille de polochons : sans Paul, ce ne serait que quatre jeunes hommes avec leurs oreillers. Il est celui qui se détache, qui « fait » littéralement l'image. C'était un garçon intelligent qui prenait son travail au sérieux et, des quatre, celui qui semblait le plus à l'aise avec la célébrité, recevant les fans et signant des autographes sans se laisser déborder. John pouvait aussi le faire, mais n'aimait pas ça. Paul était un leader né, mais après tout John aussi. On peut en discuter, mais je pense sans hésitation que Paul était le plus photogénique.

Mes portraits favoris de Paul de la période Beatles sont ceux pris dans le train de *A Hard Day's Night*. On y voit Paul, tel qu'en lui-même, dans son intimité, loin de la folie de la Beatlemania.

L'autre séance clé de cette période est celle où Paul et John composent tranquillement à un piano du George V à Paris. Il y a très peu de photos où ils font réellement de la musique. Je me trouvais là, dans le fond, les photographiant dans leur travail, celui des plus grands compositeurs de chansons de tous les temps.

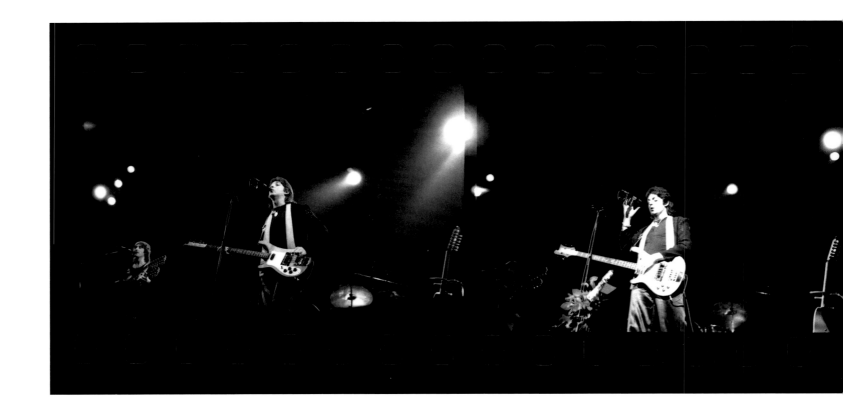

Wild Life

Je vivais aux États-Unis et travaillais pour des magazines comme *Life* et *People*. Les images des années 1970 ont été réalisées pour *People*. Paul et Linda qui vivaient à Los Angeles et travaillaient à un nouvel album avaient loué une confortable maison, pas une de ces énormes résidences des stars du show-biz. Paul aime la vie de famille et cela se sent dans ces photographies. Ils prenaient du plaisir à vivre. Je m'en souviens comme si c'était hier. Il jouait du piano, chantait. C'était par une belle matinée californienne. Stella vint s'asseoir près de lui. J'adore cette photo.

J'avais une très bonne relation avec Linda. Elle aidait beaucoup et arrivait souvent avec des suggestions pour rendre la séance plus vivante, plus naturelle. Photographe, elle savait ce qu'il fallait faire pour obtenir une bonne image. Souvent les proches du sujet sont difficiles et disent des choses comme : « J'espère que ça ne va pas durer trop longtemps. » Linda était à l'opposé. Paul disait : « Viens demain. À 10 heures, ce sera parfait. » Linda corrigeait : « Non, Harry, viens à 8 heures et on prendra le petit-déjeuner ensemble. »

Paul était heureux dans sa vie privée, mais il avait aussi de plus en plus la pression pour produire des hits. Je suis retourné chez eux trois ou quatre fois et l'ai photographié dans le studio de Los Angeles. Nous étions contents de nous revoir, mais je n'étais pas là pour parler du bon vieux temps. J'étais là pour travailler, ce qu'il respectait.

L'autre séance date du début des années 1990. C'était une prise de vue pour *Vanity Fair*, qui avait lieu près de la ferme de Peasmarsch dans l'East Sussex, au sud de l'Angleterre. Ils voulaient un genre de photo plus intime et mon idée était de les prendre dans les champs. Je m'étais levé tôt et avais repéré les lieux avec Linda. Le plan était de la photographier elle avec son cheval préféré et d'avoir Paul en arrière-plan, s'avançant lentement vers eux.

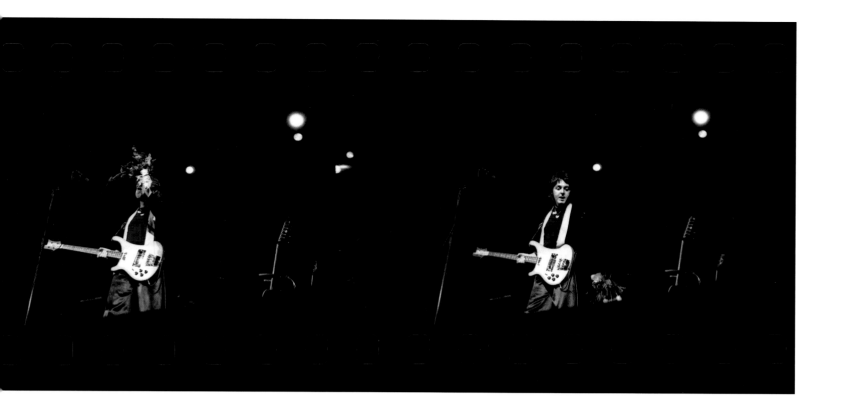

Il n'avait pas très envie de marcher par cette chaude journée, mais Linda le convainquit.
C'est une petite histoire qui se déroule devant nous. Il est facile de voir que Paul et Linda
formaient une équipe, totalement à l'aise ensemble.

Band on the Run

Les photos de plateau et de coulisses datent de la tournée *Wings Over America*. Cela
faisait dix ans que Paul avait joué avec les Beatles aux États-Unis, son retour était donc
un évènement. J'ai suivi peut-être quatre concerts. Je me concentrais sur le spectacle, mais
parfois aussi sur la foule ou les coulisses.

Mon meilleur travail fut en coulisse. Paul jaillit ainsi après un spectacle, s'étend, épuisé,
en sueur. Linda me confia qu'il n'avait jamais laissé quelqu'un le photographier dans cet état.
C'était possible parce qu'ils m'aimaient bien et que mon appareil photo ne les gênait pas.

Je faisais maintenant partie de l'équipe et un jour je les ai suivis dans leur avion. Mais pour
les autres concerts, je rentrais chez moi et les retrouvais à l'étape suivante. Je ne voulais
pas traîner autour d'eux trop longtemps. À la fin ils auraient pu se lasser et ne plus me
permettre de prendre ces images.

Pour la couverture, je n'ai pas demandé à Paul de poser. Il était juste au bon endroit et il
voulait être photographié. C'est une de mes photos préférées de cette période.

La dernière section du livre porte sur la soirée de lancement de l'album des Wings *Venus
and Mars* de 1975. La réception se déroulait à bord du *Queen Mary* à Long Beach en
Californie. J'étais le seul photographe autorisé à bord et c'était la première fois que Paul
et George se retrouvaient en public depuis la séparation des Beatles. Bob Dylan, Michael

Jackson, Cher, Tatum O'Neal, Dean Martin et beaucoup d'autres célébrités dansèrent toute la nuit. J'aime couvrir les réceptions parce qu'on ne dispose que d'une vingtaine de minutes pour capter les gens lorsque l'énergie est bonne et que tout le monde est encore sobre et heureux. Le résultat est très gratifiant. Tout le monde avait envie d'être vu à cette grande soirée donnée par Paul, y compris Bob Dylan.

Je suis fier du travail réalisé avec Paul au cours de ces années. C'est une des personnes les plus talentueuses que je connaisse, mais aussi quelque peu énigmatique. Il a réussi à vivre une existence relativement normale malgré sa célébrité phénoménale et je le respecte pour ça. En qualité de photojournaliste, je lui reste reconnaissant de m'avoir permis de documenter quelques moments très privés de son extraordinaire existence.

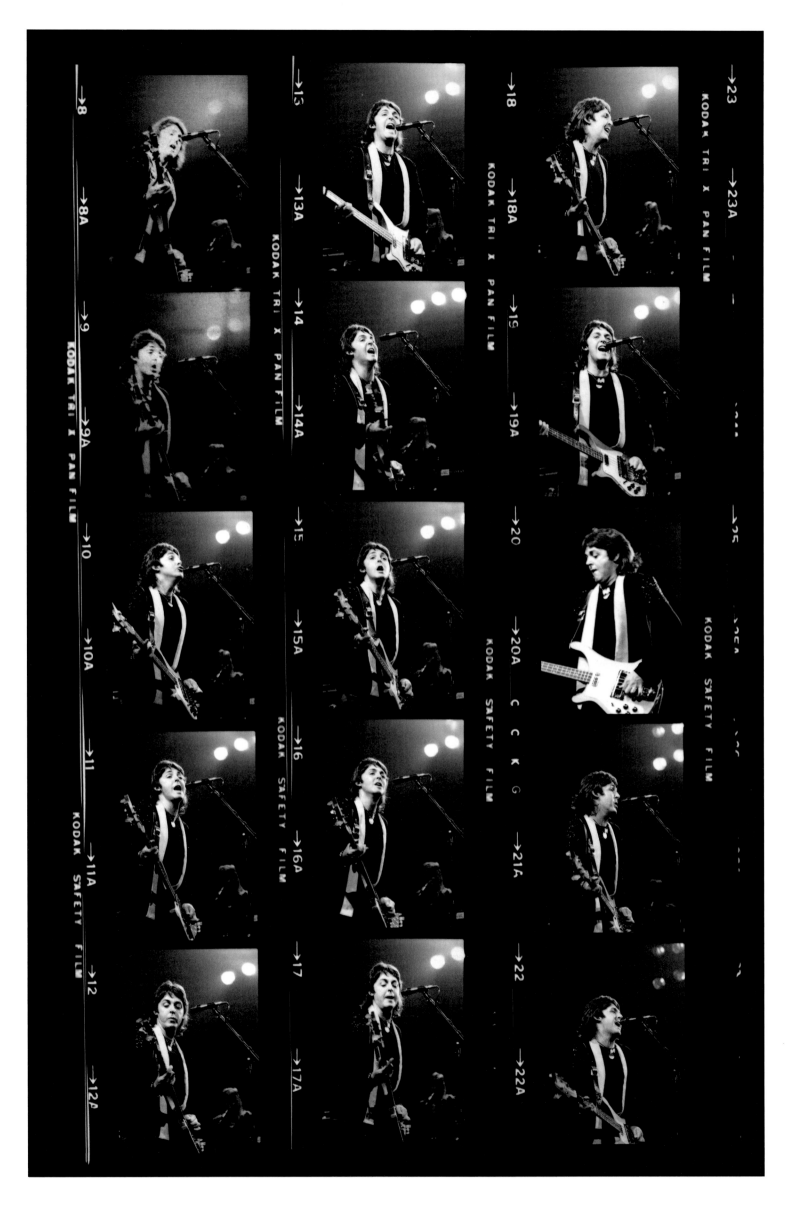

Beatles

"I could take a photograph of three of the Beatles, but Paul always had to be one of the three. You always looked at Paul first — he made the picture move. It was often debated as to who was the leader of the Beatles — some would say it was John — others would say it was Paul. It would end like that, without an answer — either of them could have been the leader — but to me both were the leaders."

—Harry Benson

„Ich konnte ein Foto von drei der Beatles machen, aber Paul musste immer einer davon sein. Ihn sah man immer als Erstes – er brachte Bewegung ins Bild. Es wurde ja oft diskutiert, wer der Kopf der Beatles war – manche sagten, John, andere meinten, Paul. Die Antwort blieb letztlich offen – jeder von beiden hätte der Kopf sein können, aber für mich waren es beide zusammen."

« Je pouvais prendre une photo de trois des Beatles, mais il fallait toujours que Paul en fasse partie. On regardait toujours Paul en premier. Il faisait vibrer l'image. Qui était le leader des Beatles ? Certains disaient que c'était John, d'autres Paul. En fait, il n'y avait pas de réponse. L'un ou l'autre aurait pu être le leader, mais, pour moi, ils l'étaient tous les deux. »

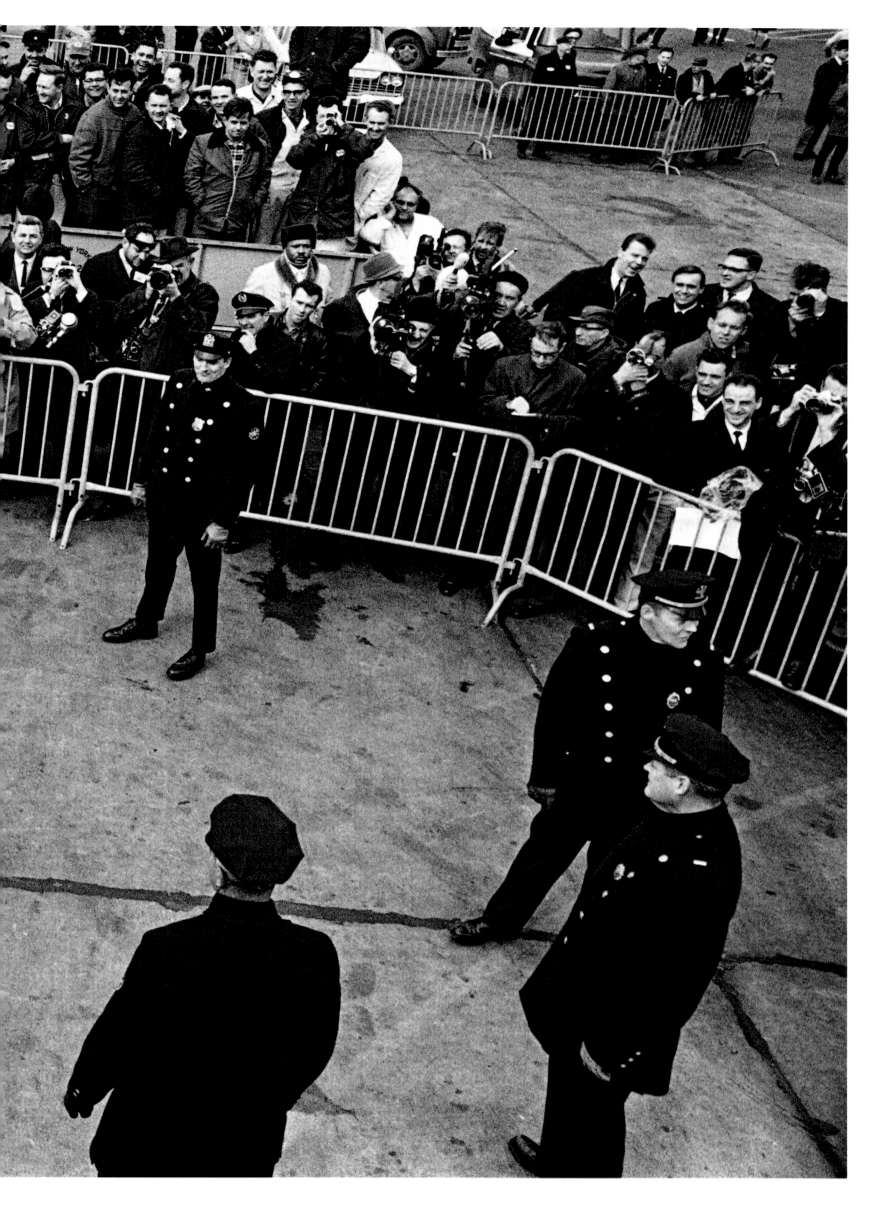

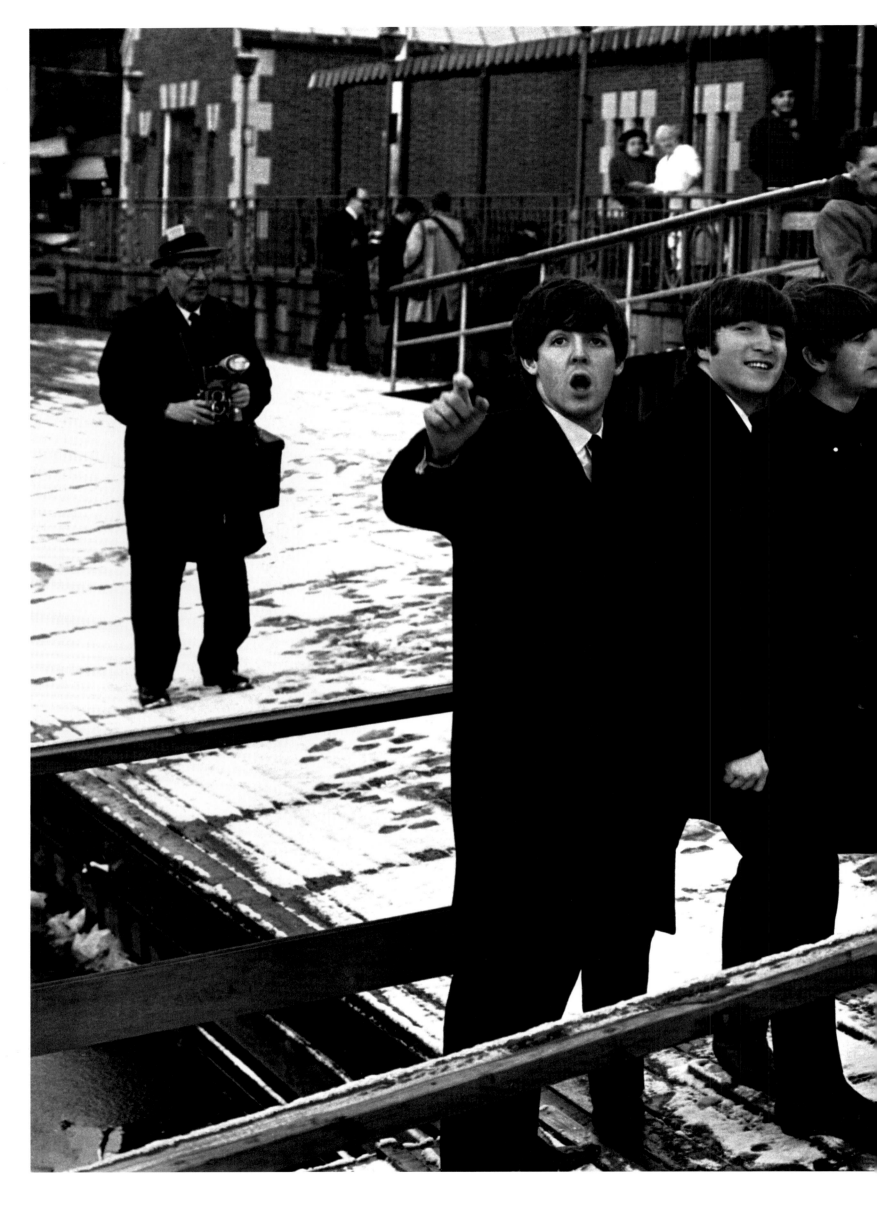

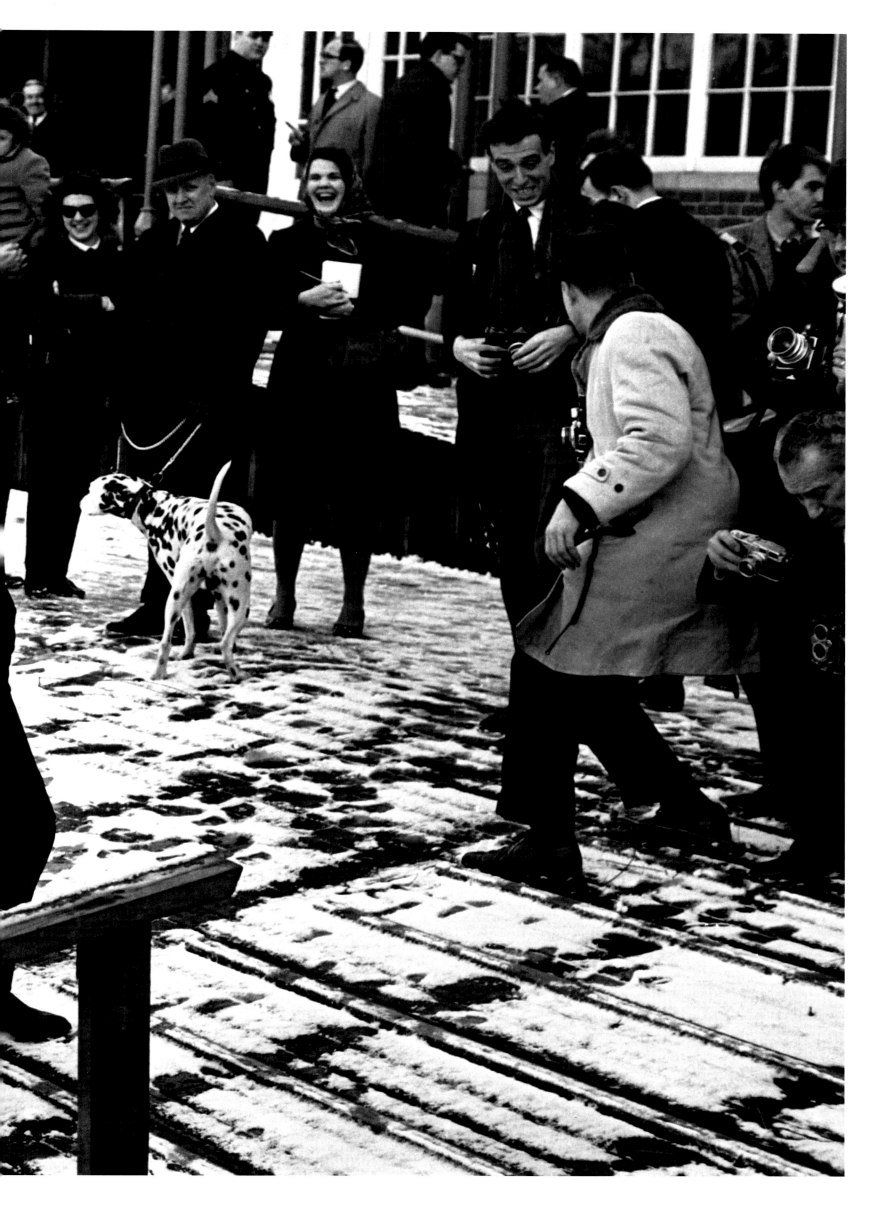

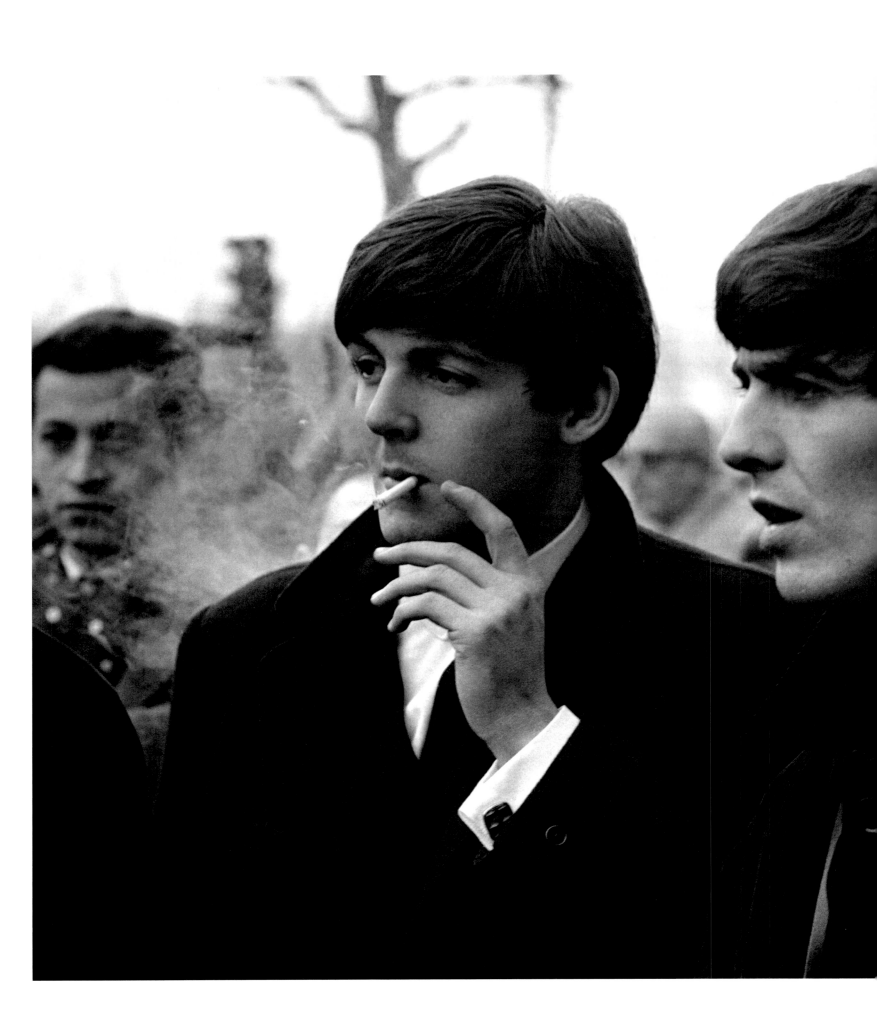

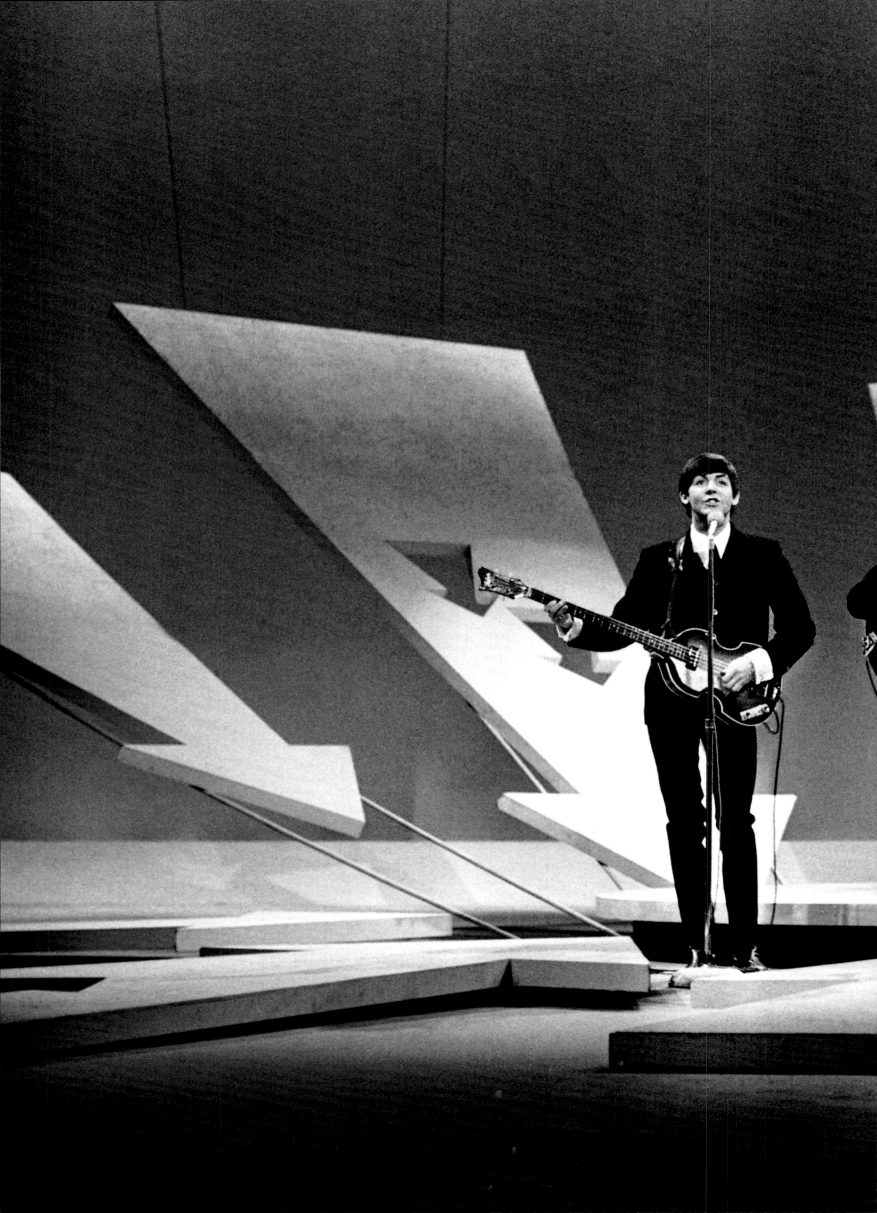

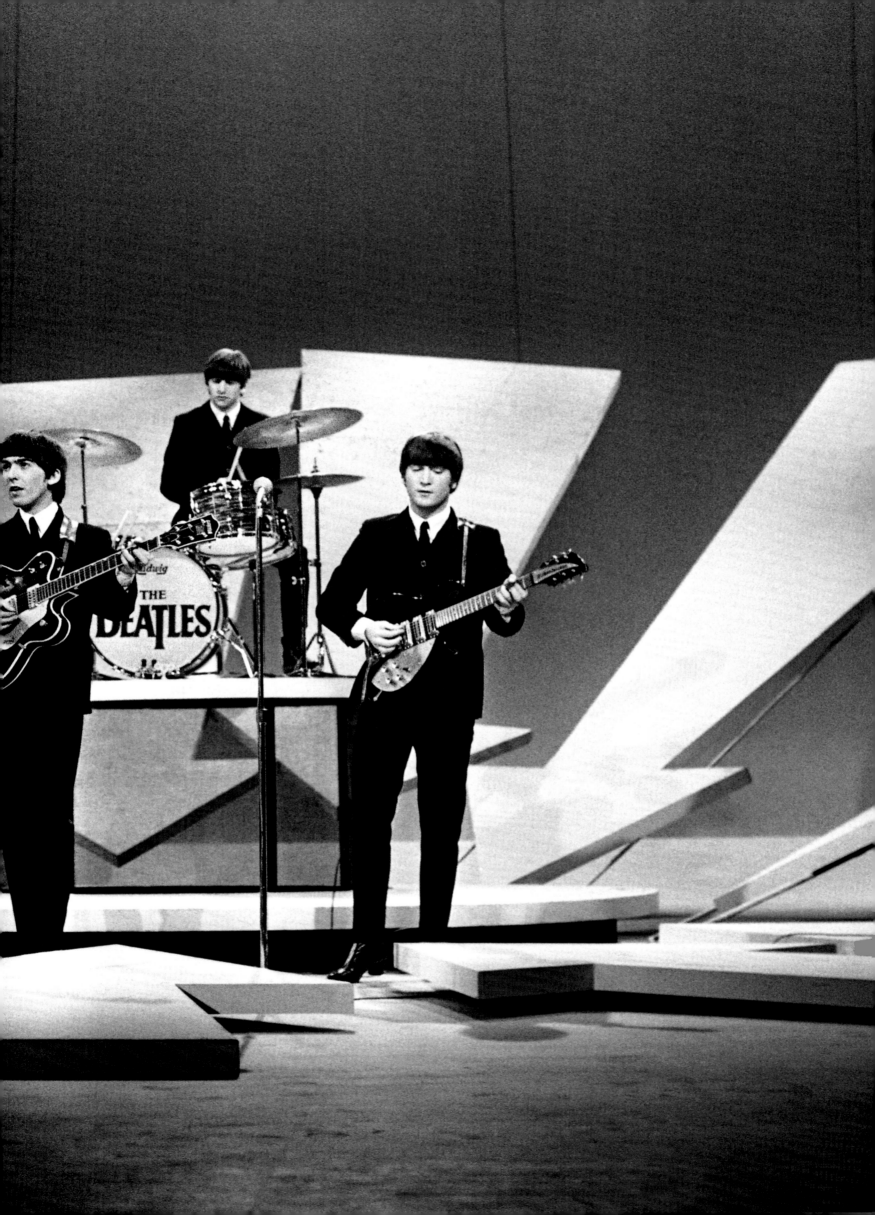

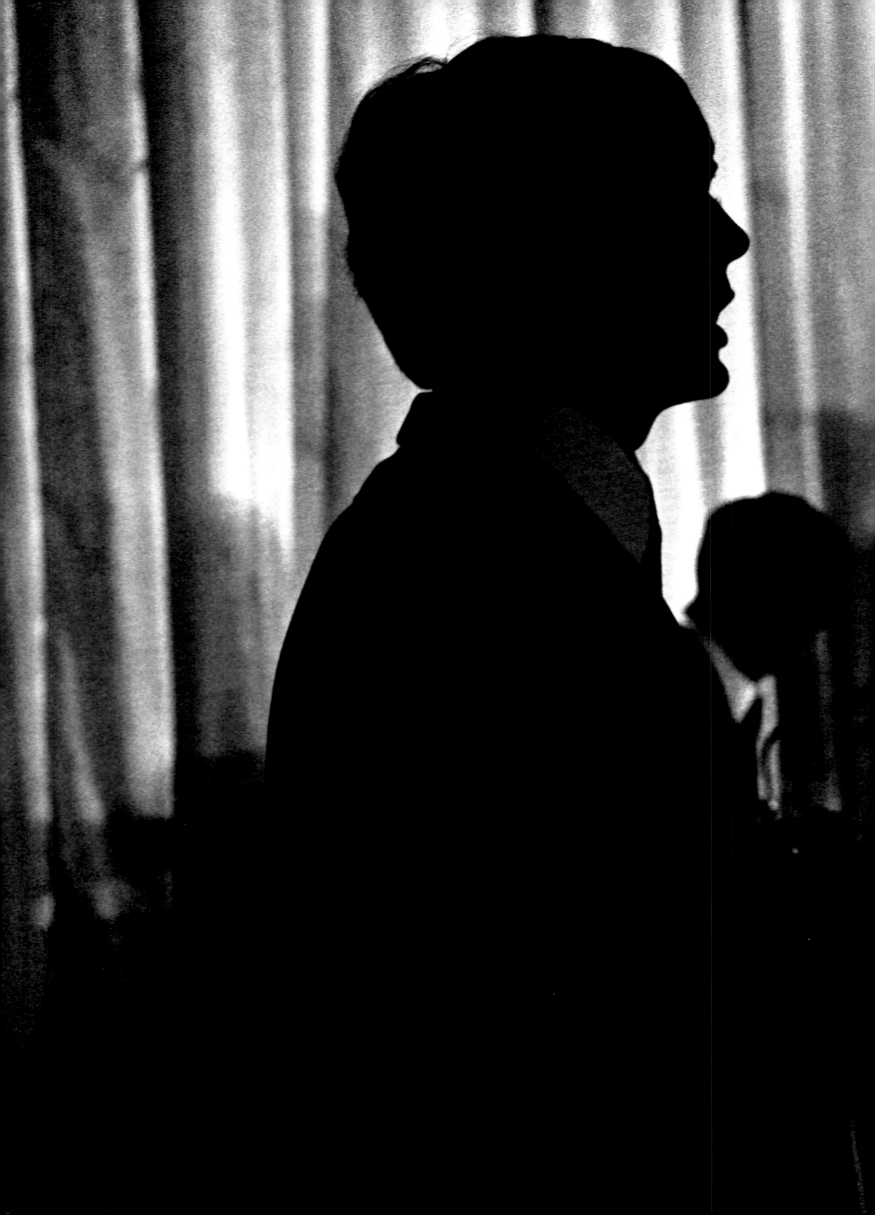

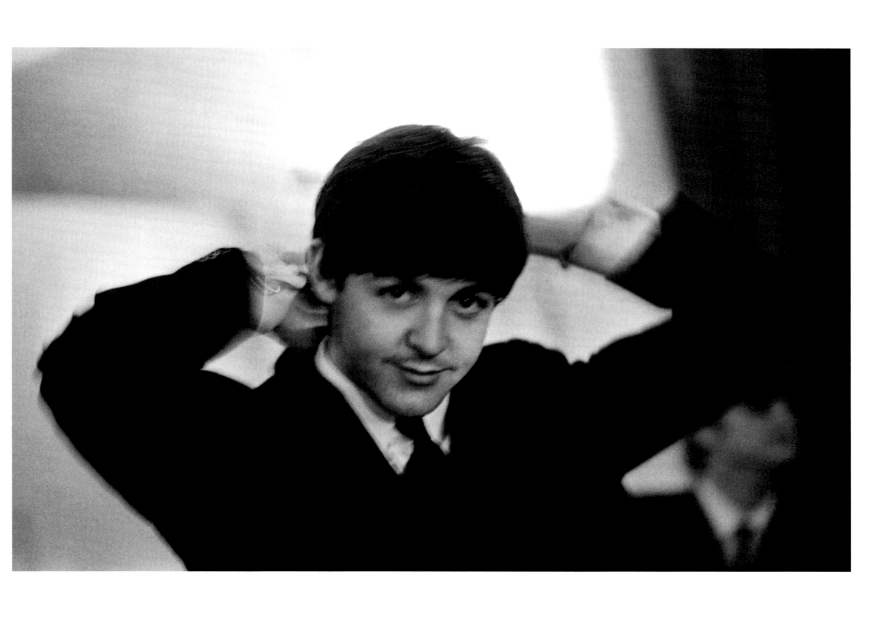

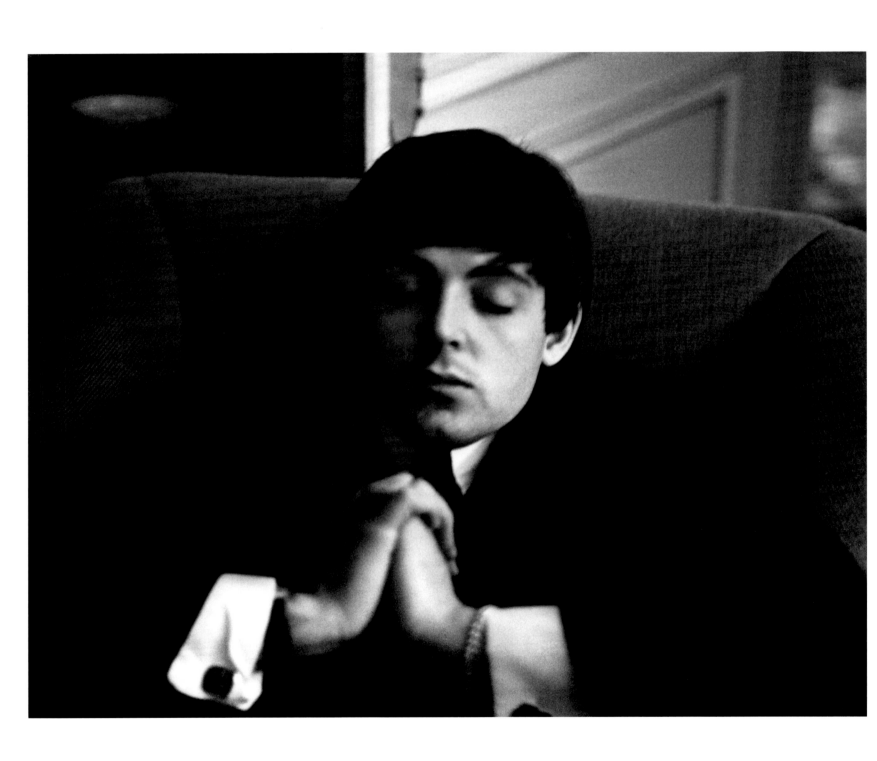

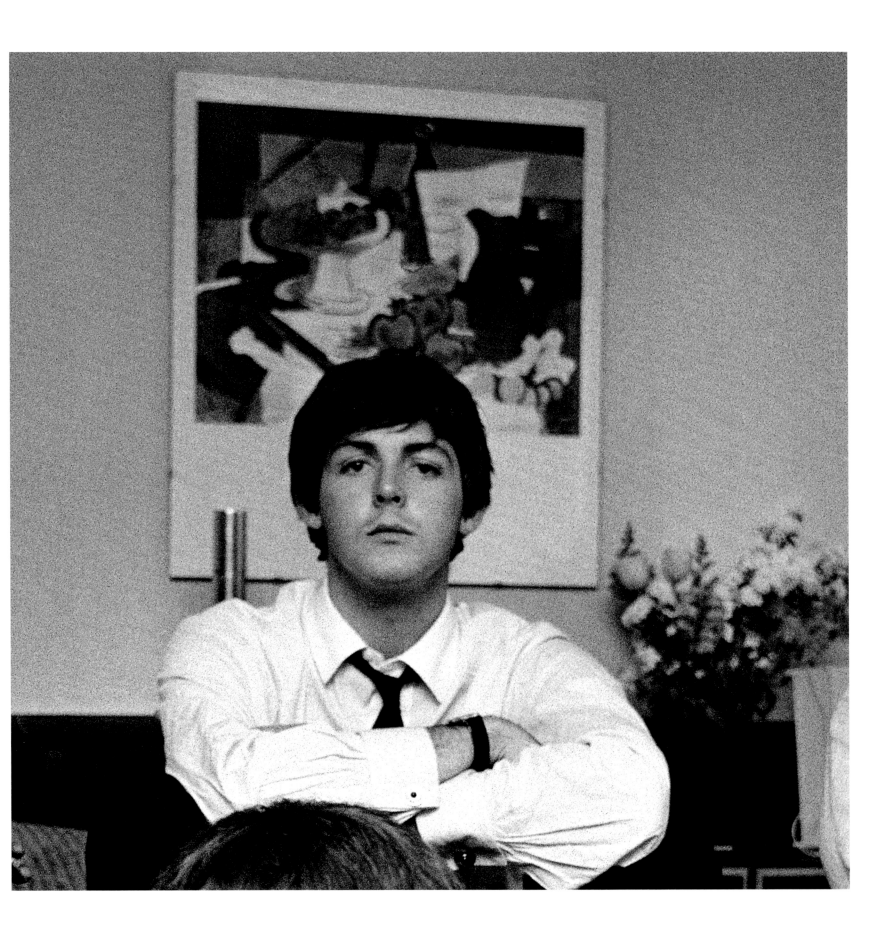

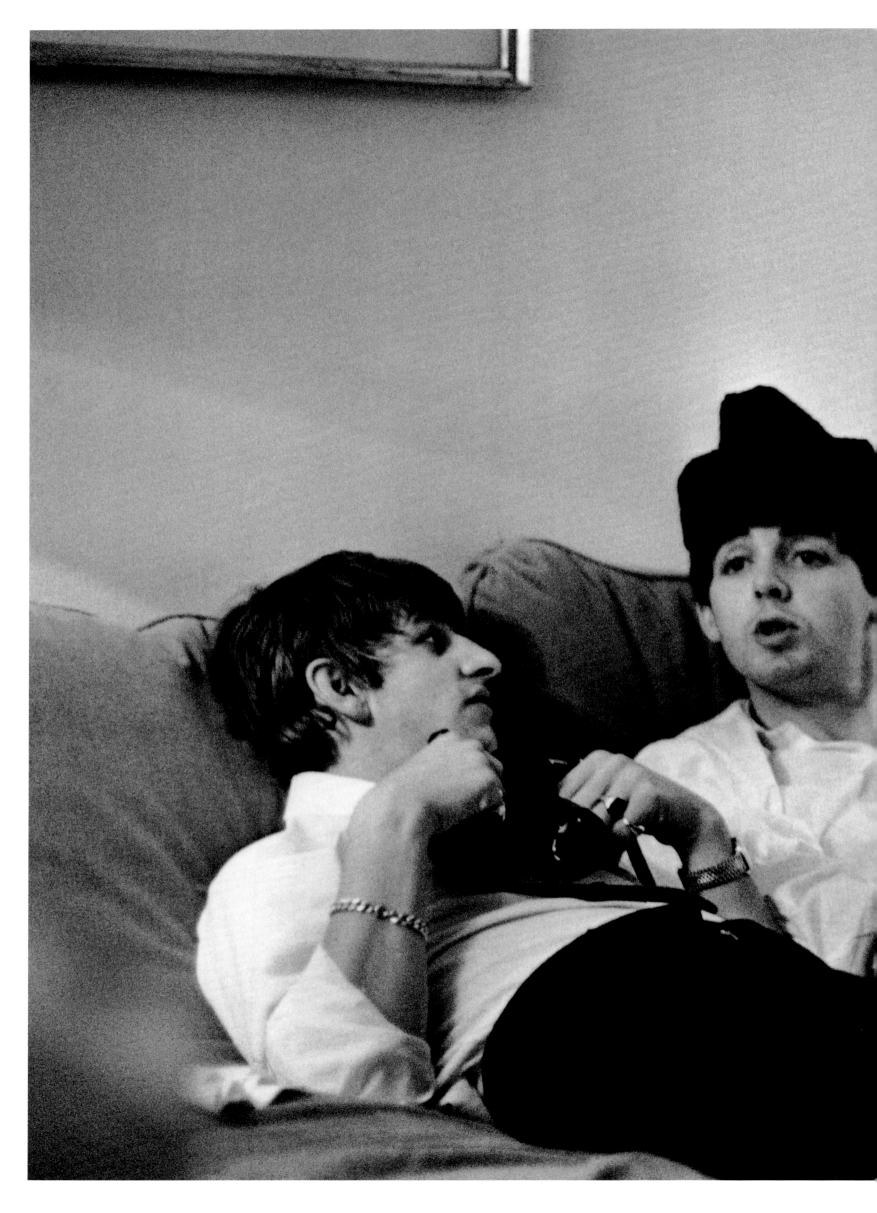

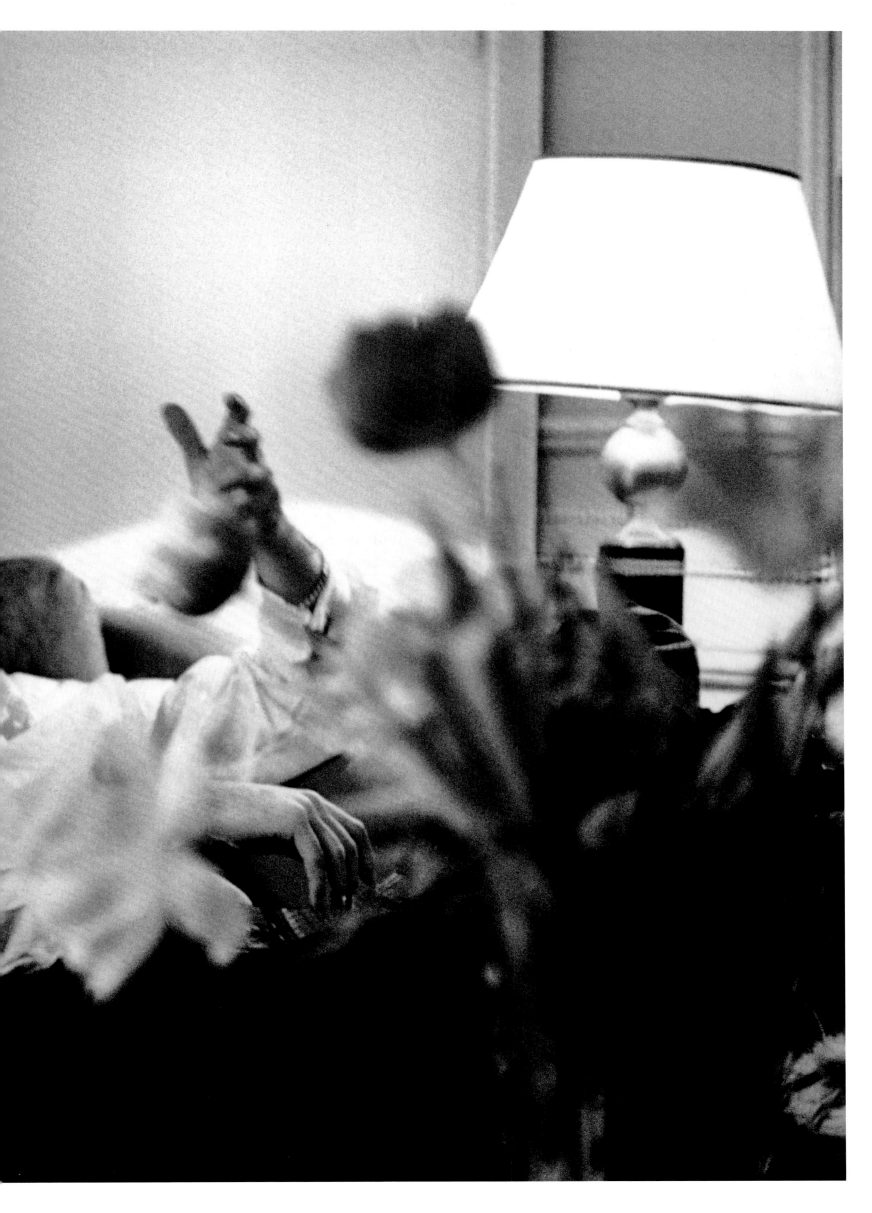

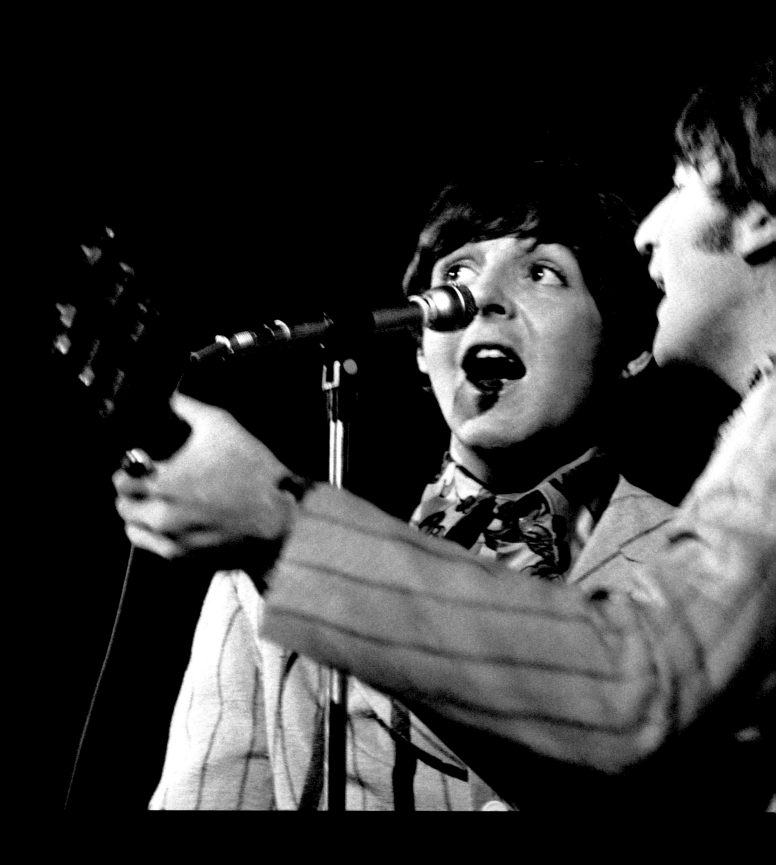

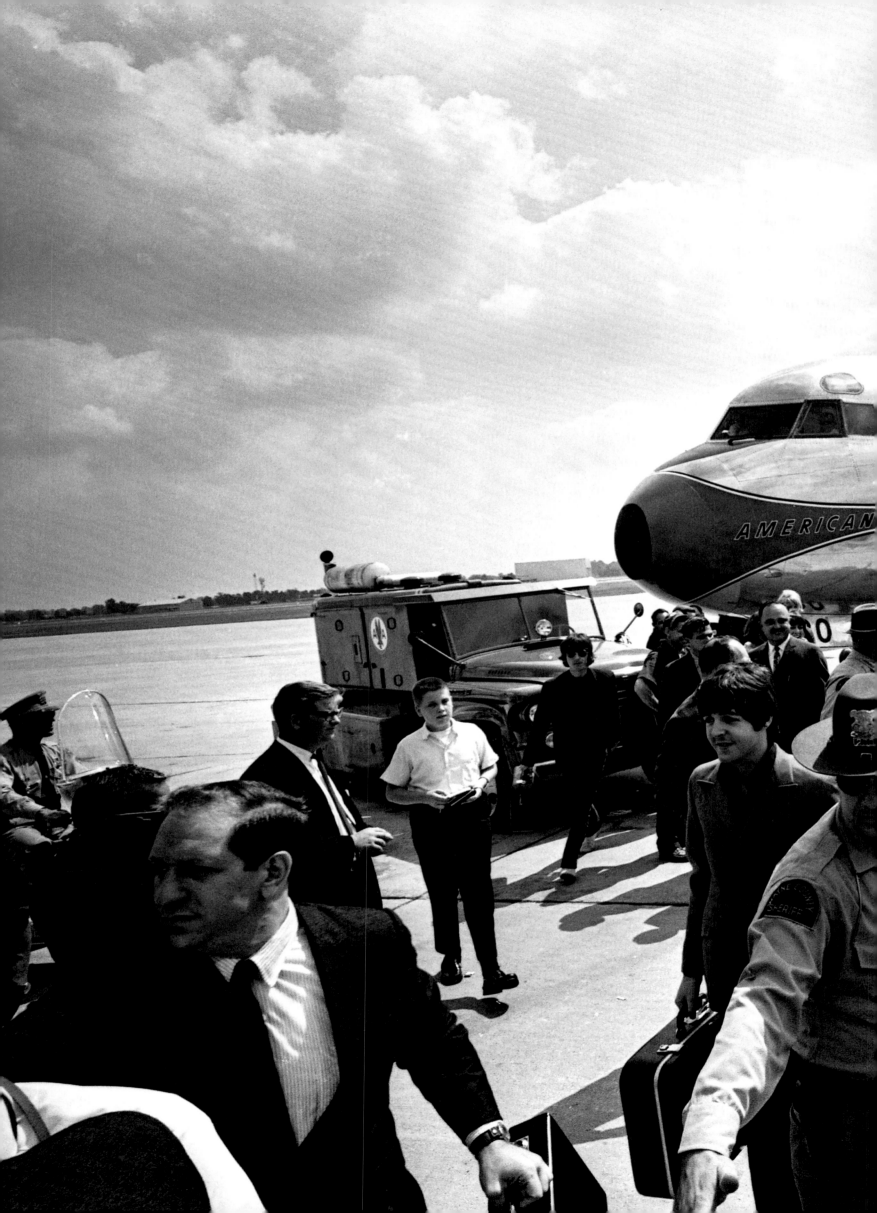

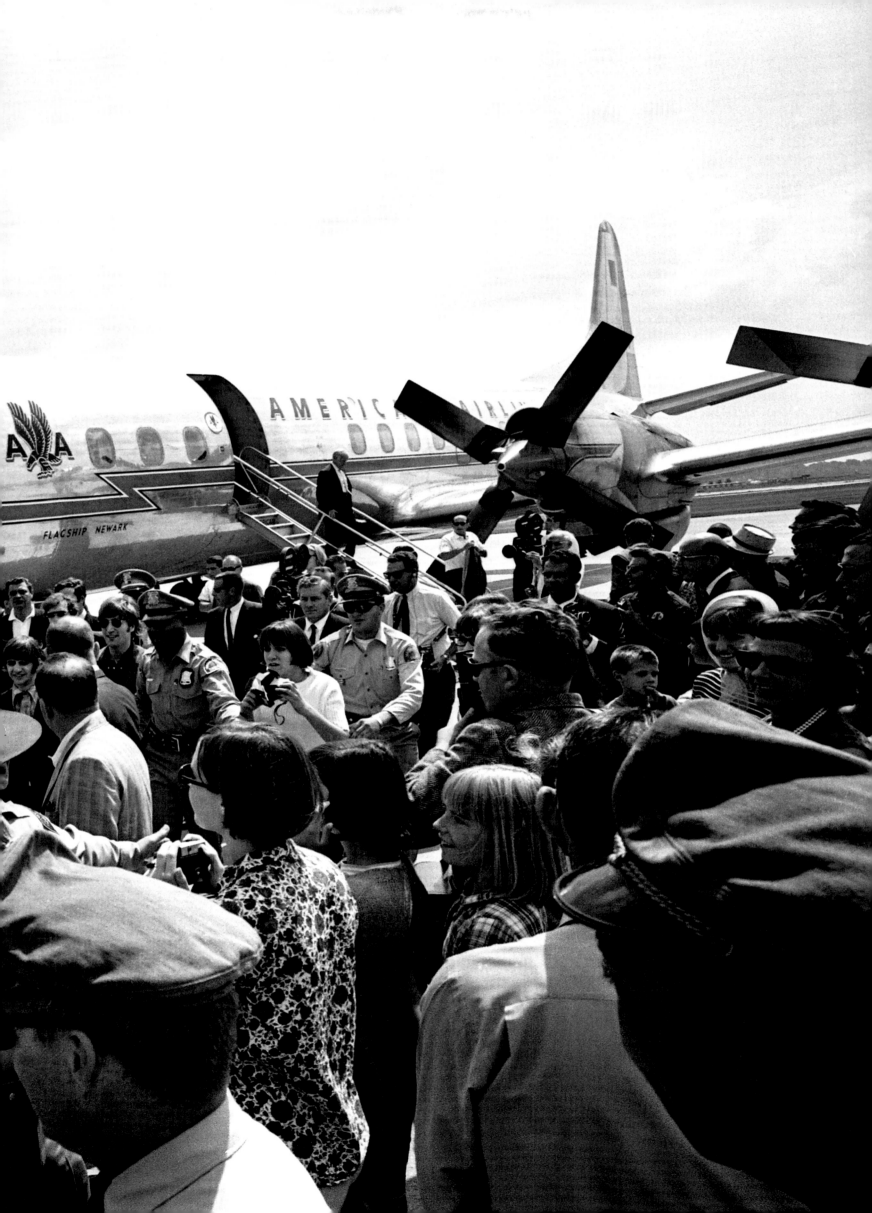

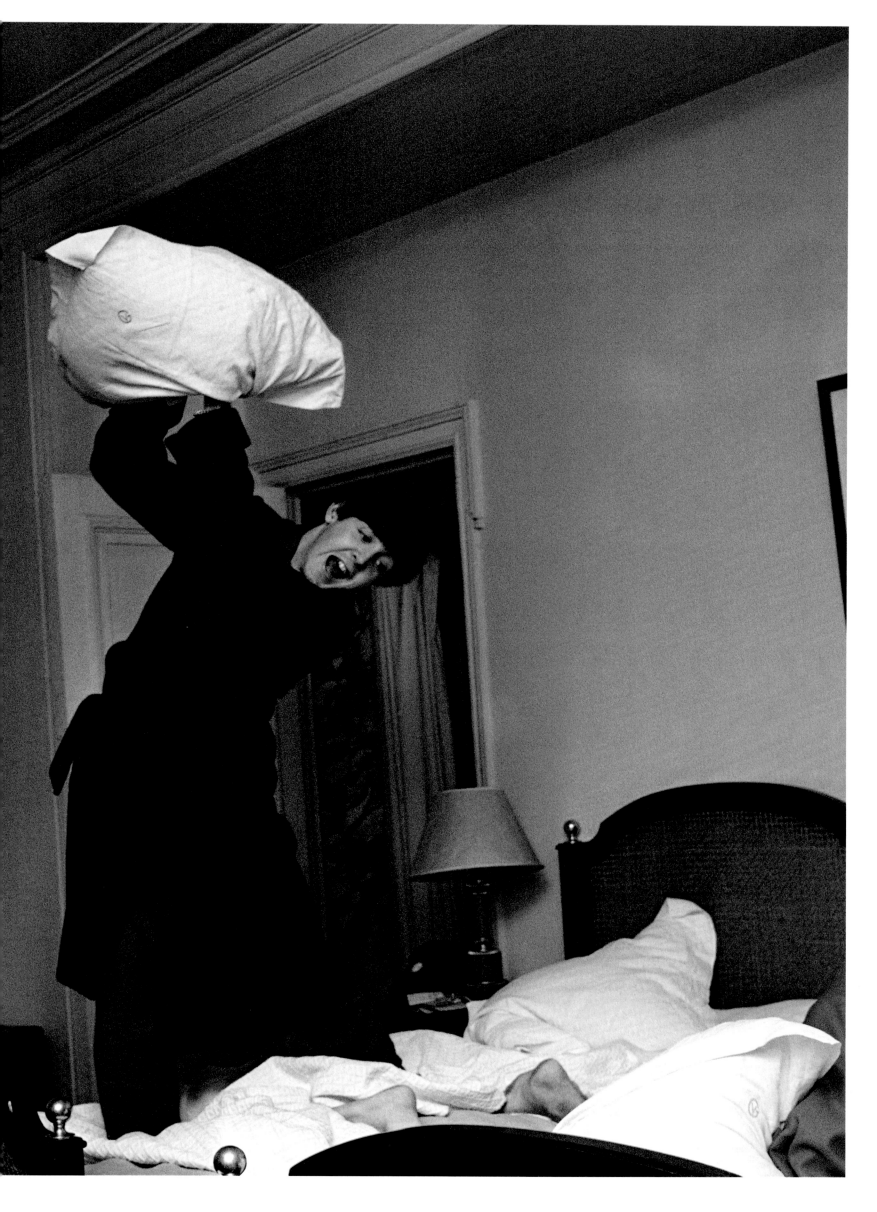

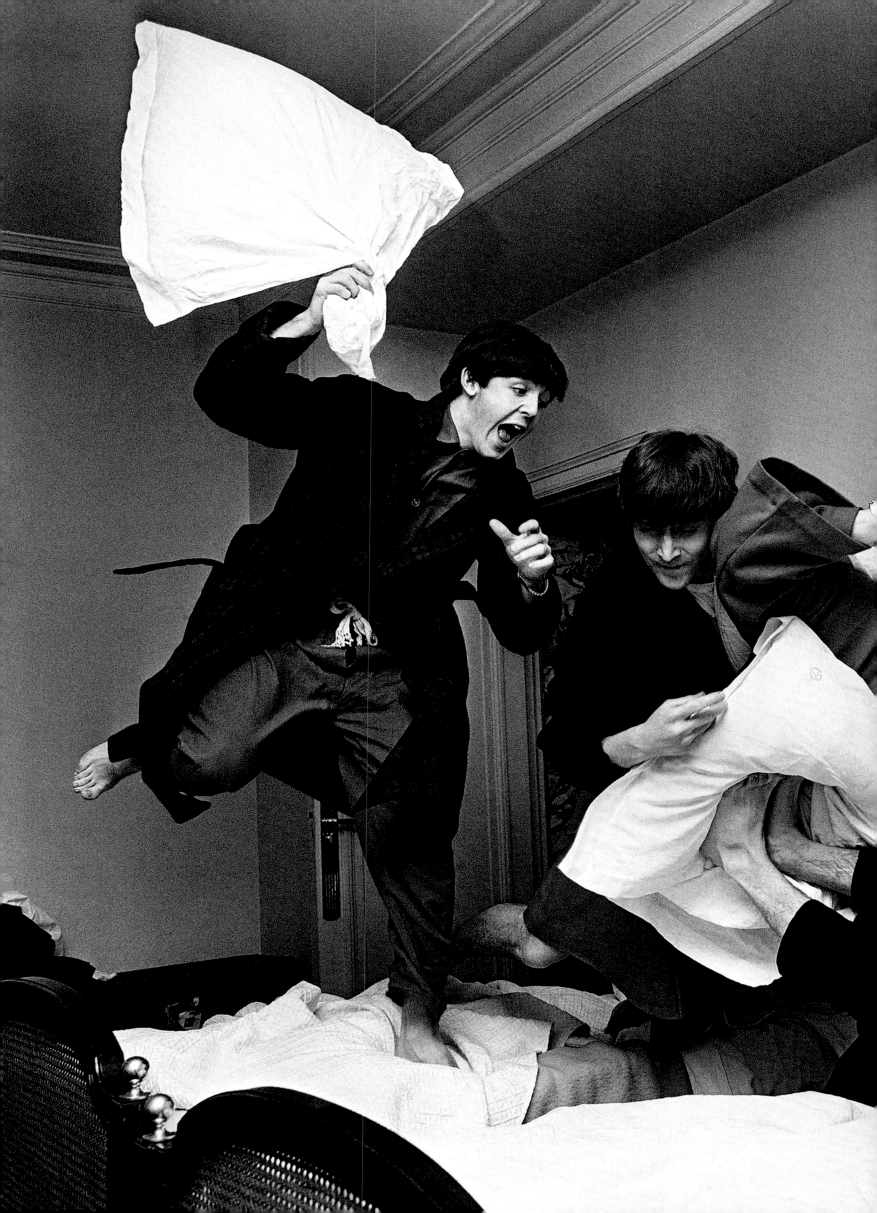

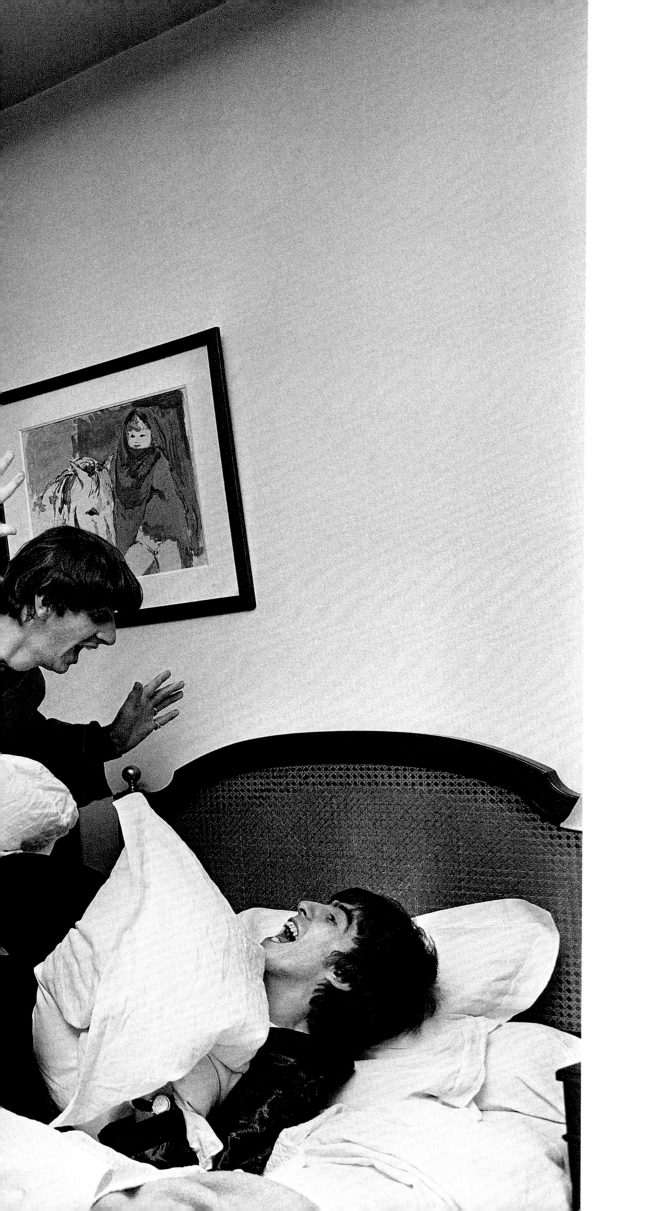

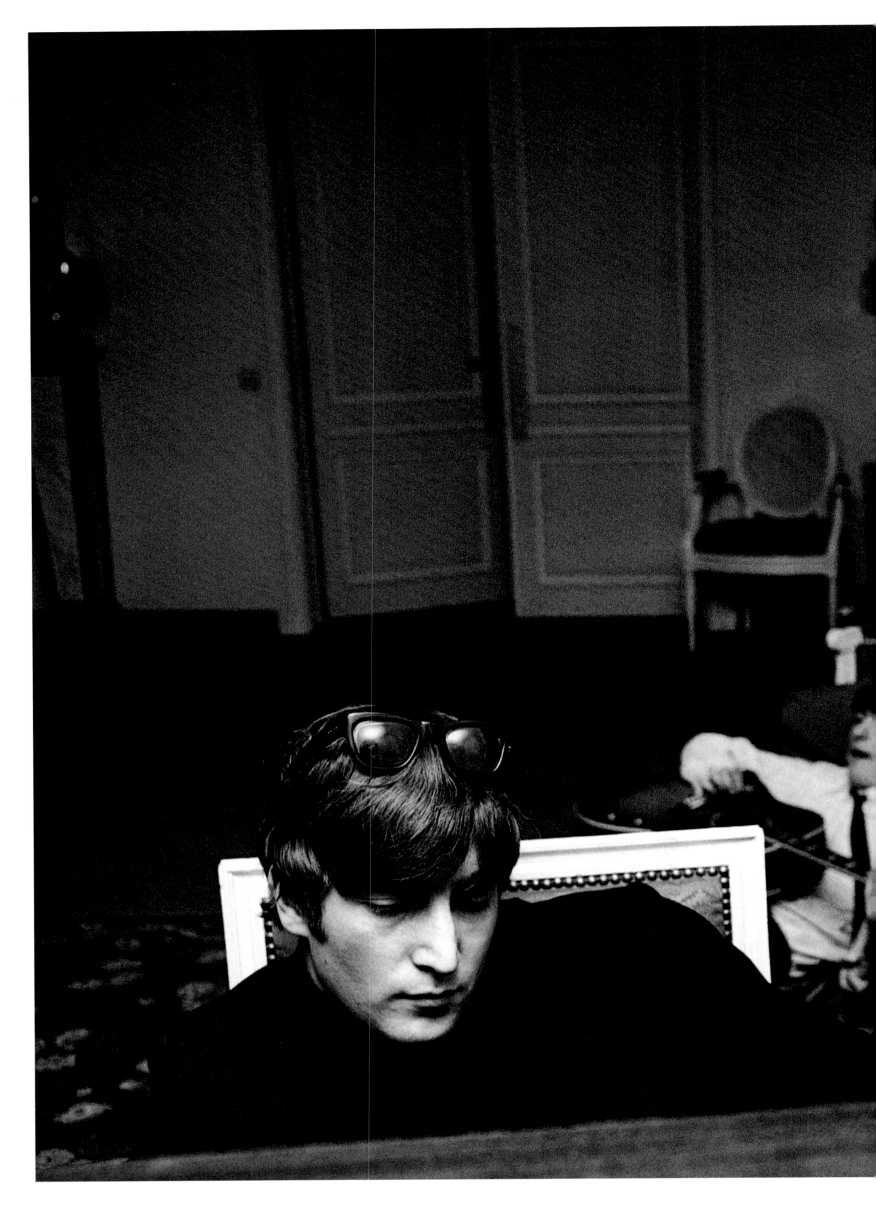

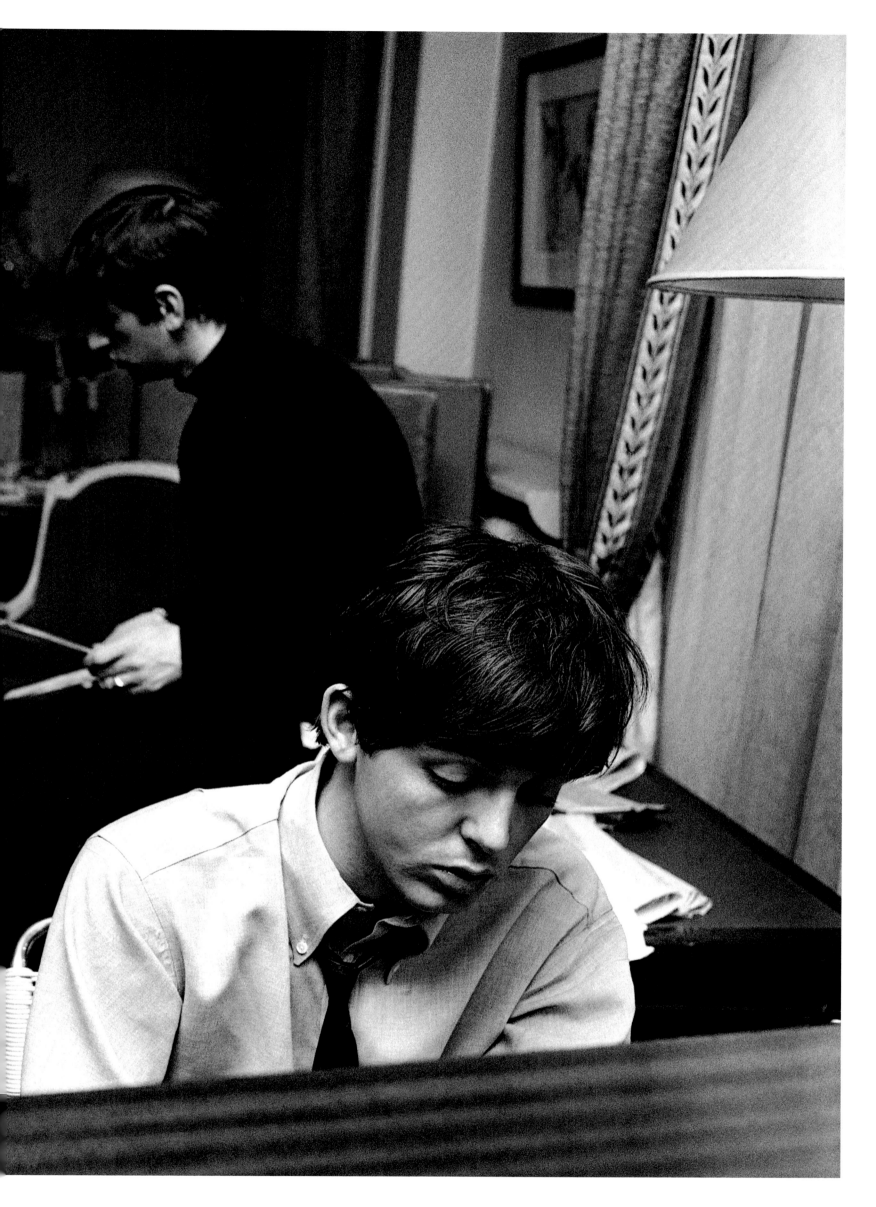

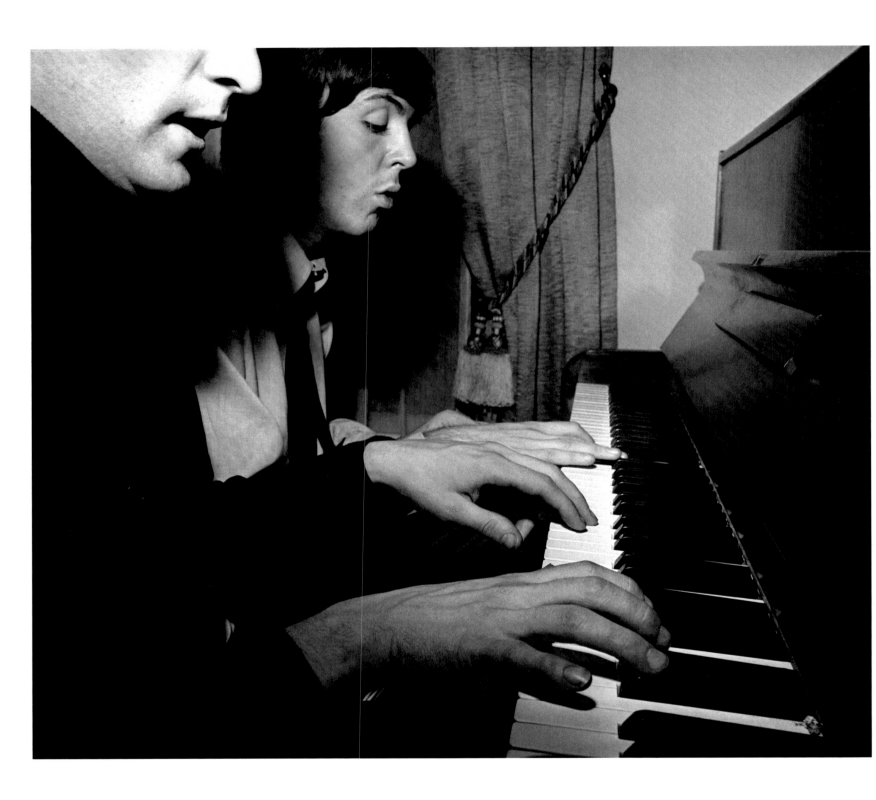

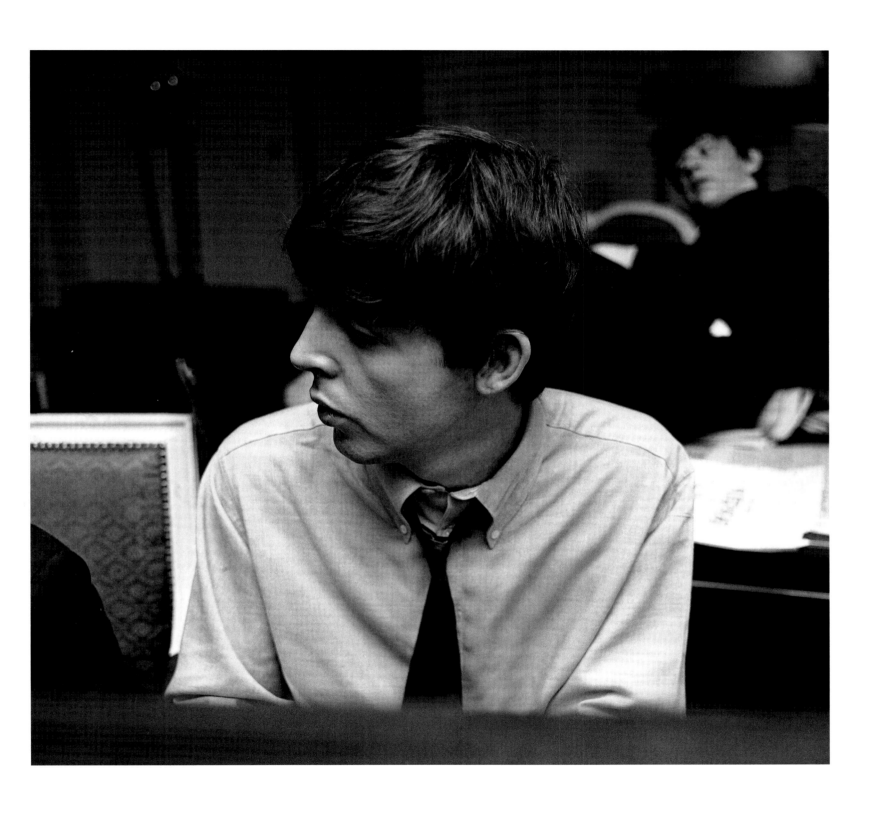

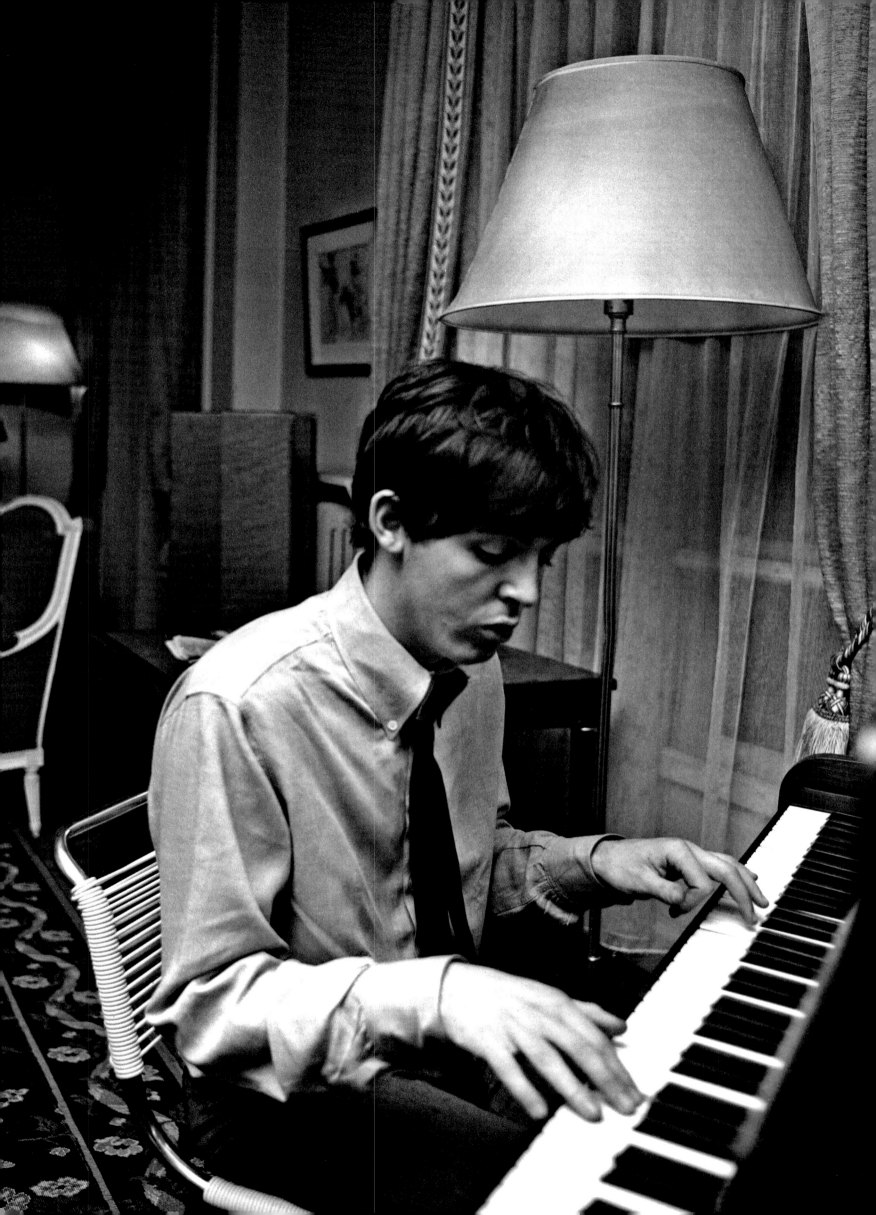

"They were all tired, but a Beatle's vitality keeps him going until the early hours…it is a vitality that often starts a mischievous romp…hiding one another's clothes, providing one Beatle with two left boots. On this night, it was a pillow fight led by Paul."

"Bedtime with The Beatles"
Scottish Daily Express, January 23, 1964

„Sie waren alle müde, aber die Vitalität eines Beatle hält ihn bis in die frühen Morgenstunden auf Trab … Oft brach sich diese Vitalität in wildem Herumalbern ihre Bahn … die Kleidung der anderen verstecken, einem von ihnen zwei linke Schuhe hinstellen. An diesem Abend war es eine Kissenschlacht, angeführt von Paul."

« Ils étaient tous fatigués, mais la vitalité des Beatles les tenait éveillés jusqu'au matin... Elle s'exprimait souvent par des bagarres de gamins... Cacher des vêtements, ne laisser que deux chaussures du pied gauche à l'un d'eux. Cette nuit-là, ce fut une bataille de polochons orchestrée par Paul. »

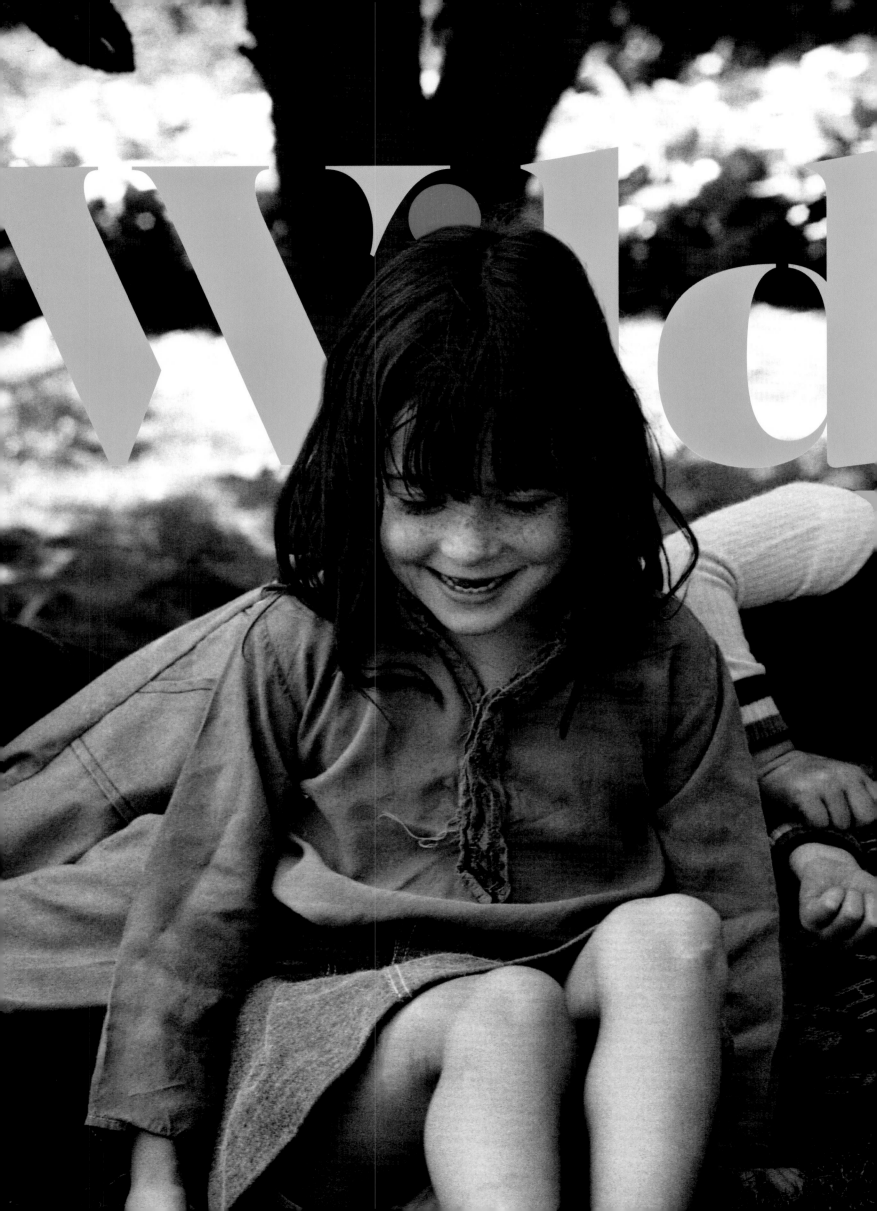

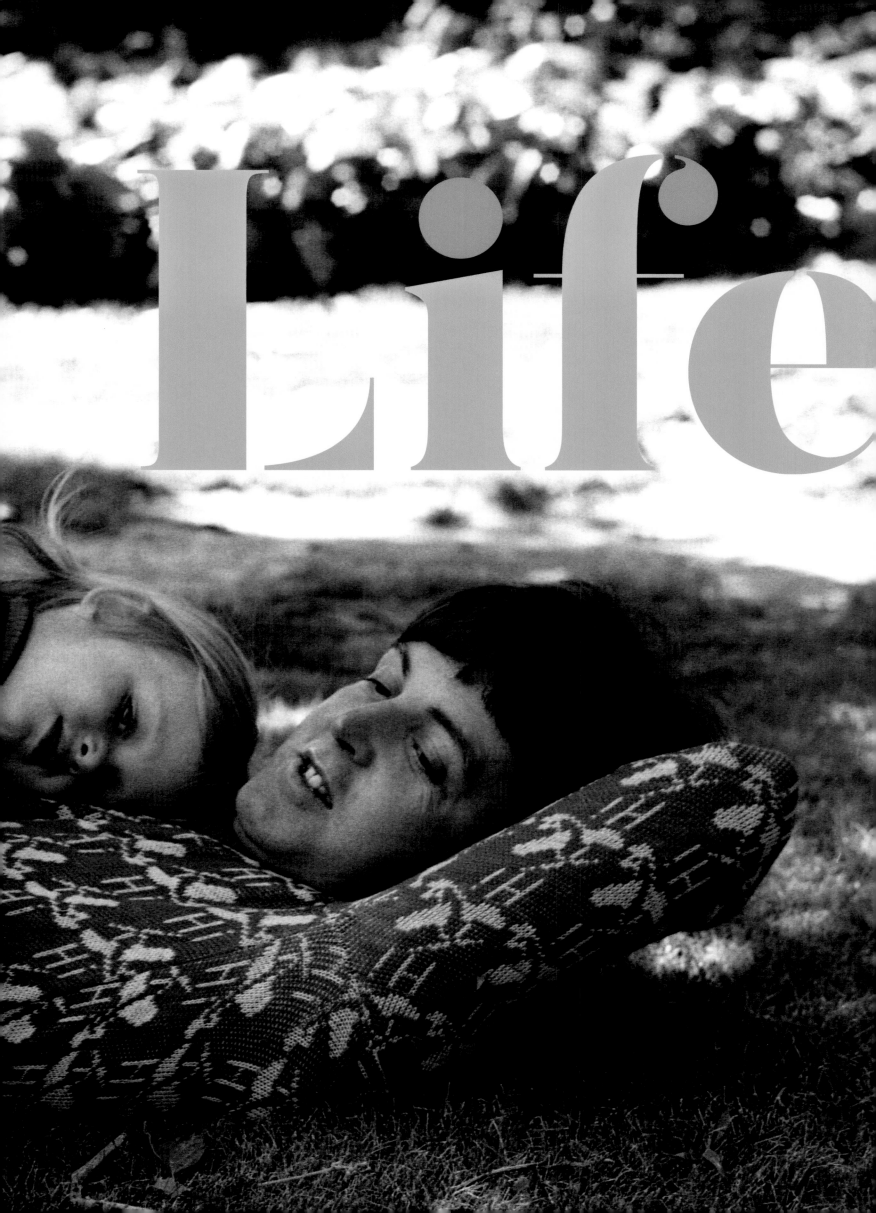

"There is an interesting thing I will say about Paul—when I photographed him—if he agreed he would always follow through and let me do my job and take the photographs I needed. As a photographer Linda was an influence and knew what I wanted and would do everything to help. I really liked her… and so did the other photographers who photographed the couple. That's a fact."

—Harry Benson

„Es gibt da etwas Interessantes über Paul zu erwähnen: Wenn ich ihn fotografierte, blieb er immer bis zum Schluss bei der Stange, ließ mich meine Arbeit tun und die Bilder machen, die ich brauchte. Dass Linda Fotografin war, spielte dabei auch eine Rolle: Sie wusste, was ich wollte, und tat alles zu meiner Unterstützung. Ich mochte sie wirklich sehr gern … genau wie die anderen Fotografen, die das Paar porträtierten. Das ist Tatsache."

«Autre chose intéressante sur Paul: lorsque je le photographiais, s'il était d'accord au départ, il faisait ce qu'il fallait jusqu'à la fin. Il me laissait travailler, prendre ce que je voulais. Elle-même photographe, Linda avait beaucoup d'influence, savait ce que je voulais et faisait tout pour m'aider. Je l'aimais vraiment beaucoup… Comme tous ceux qui ont photographié le couple, sans aucun doute.»

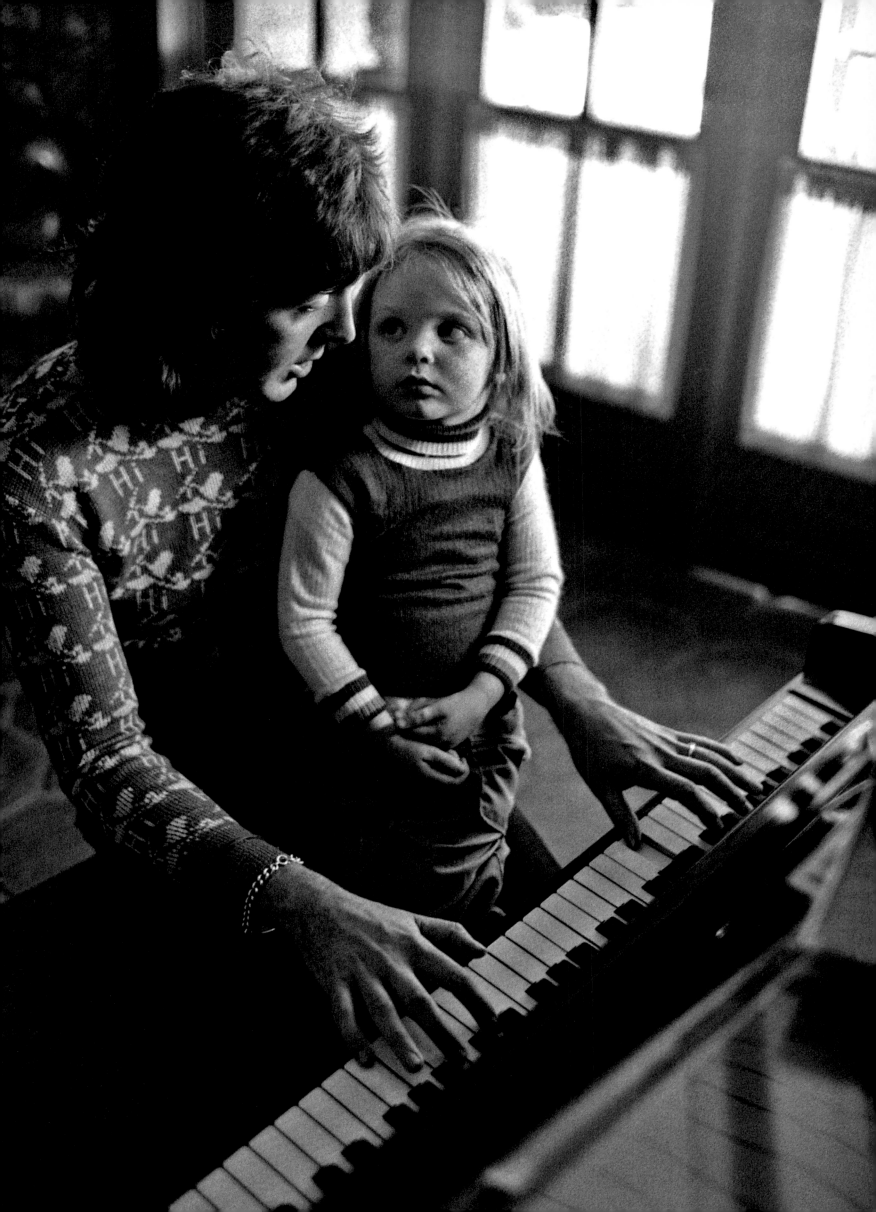

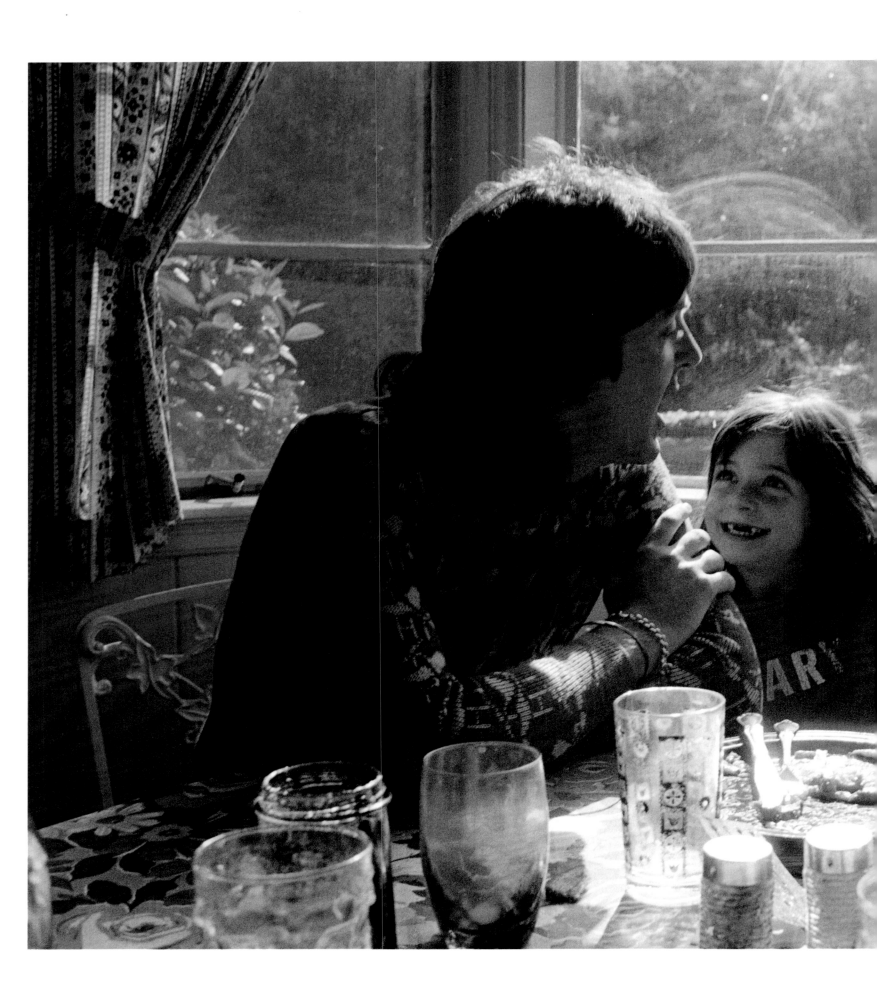

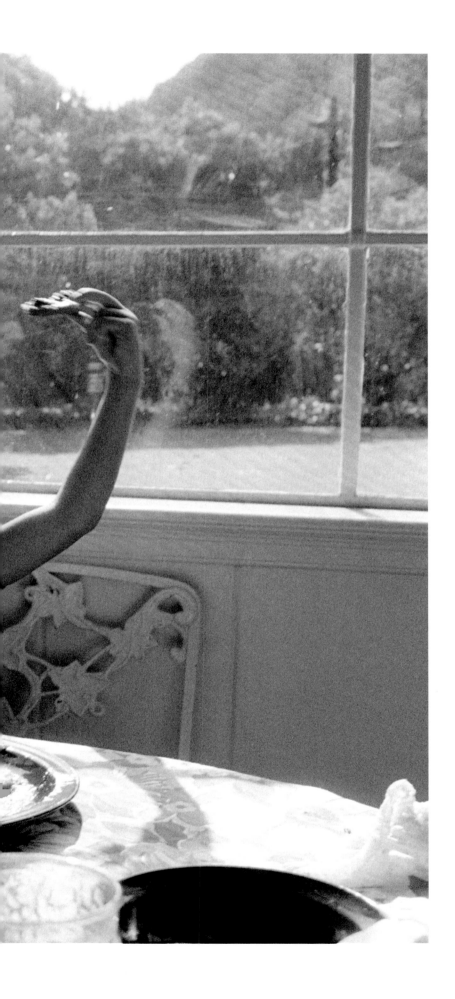

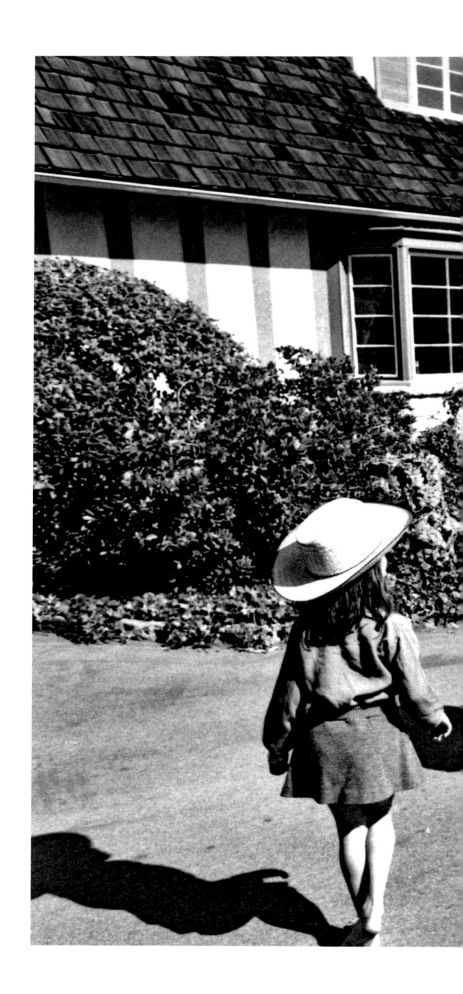

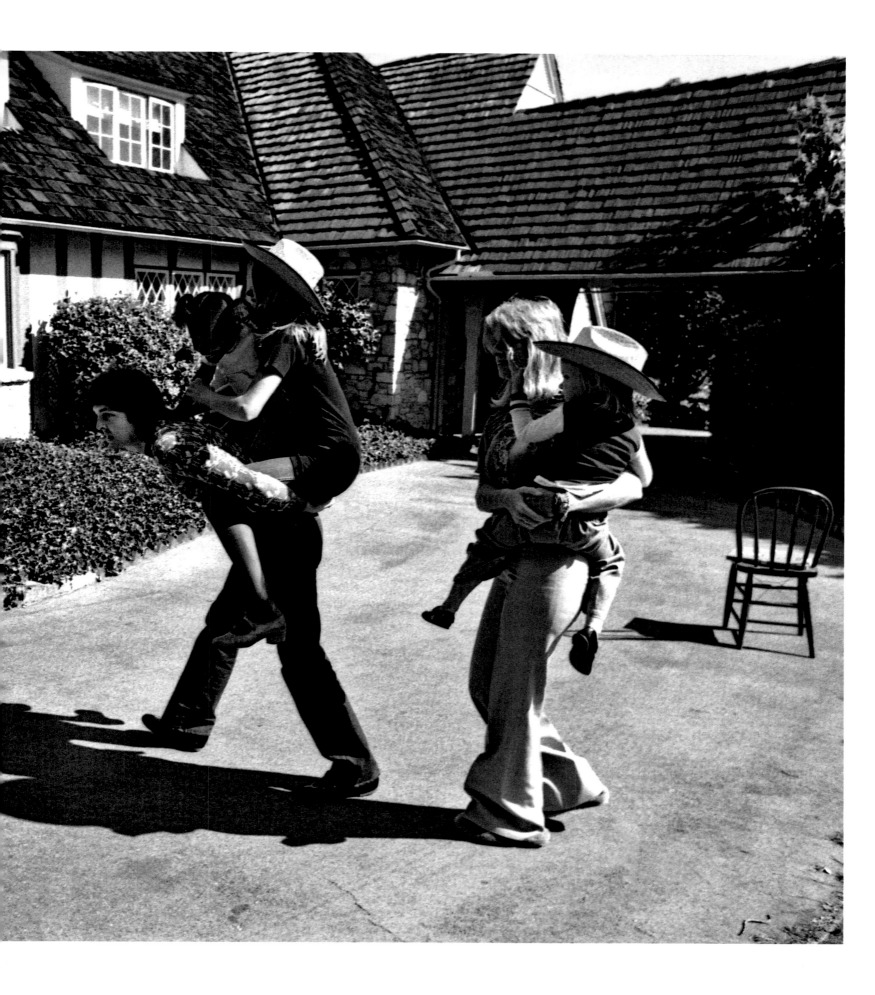

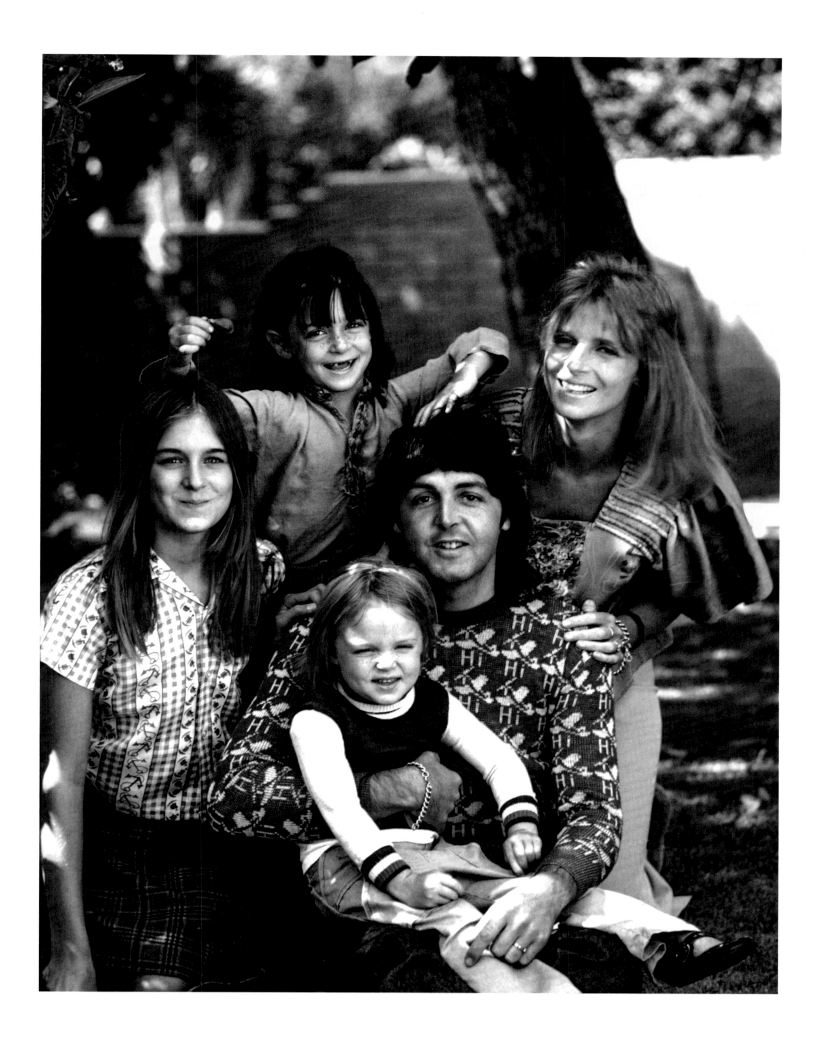

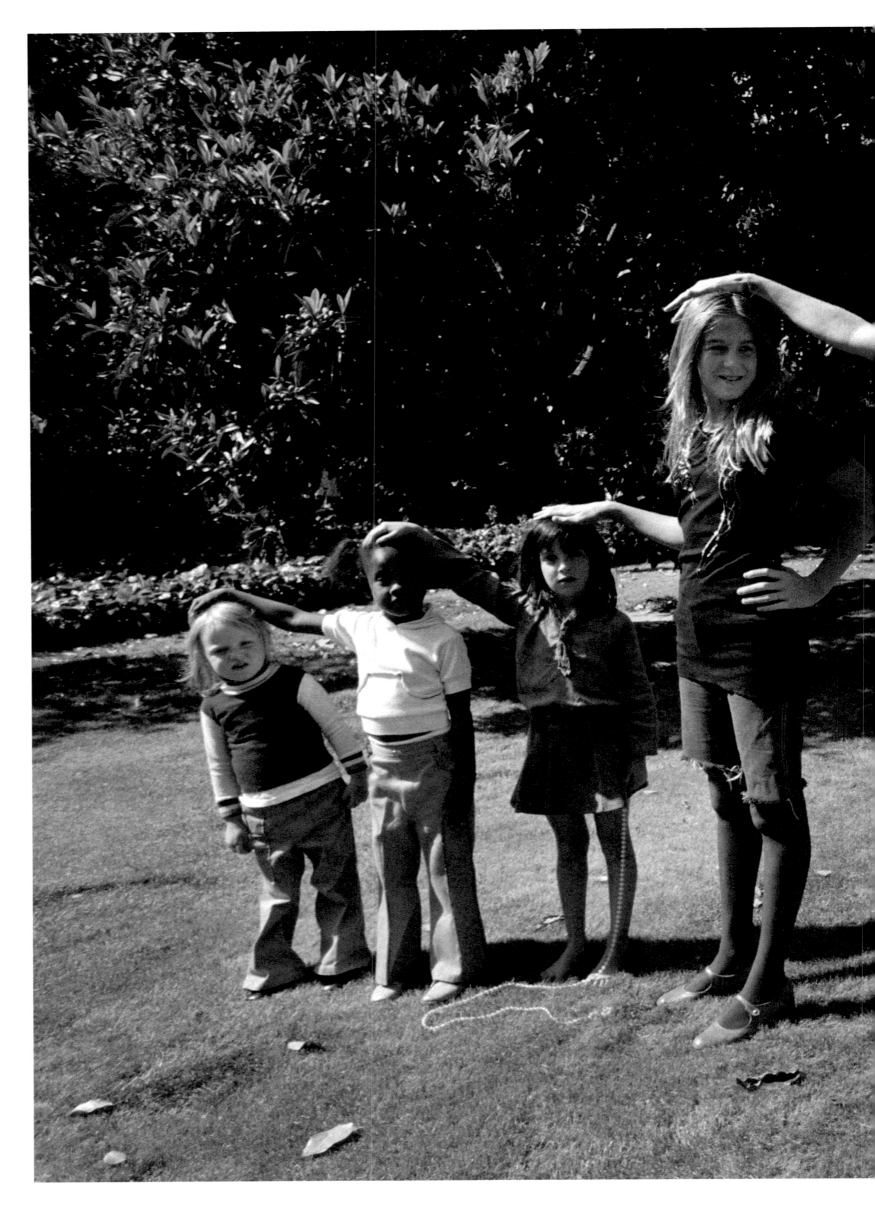

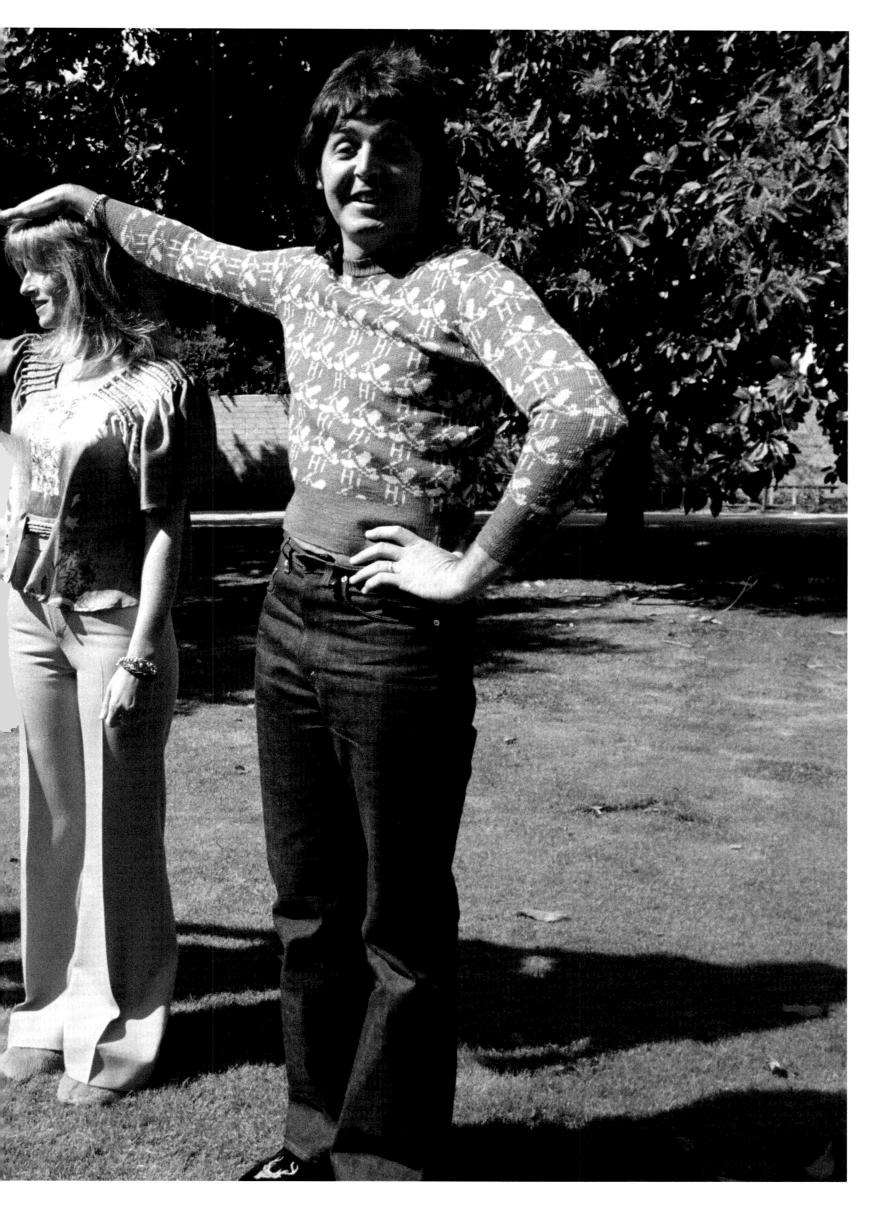

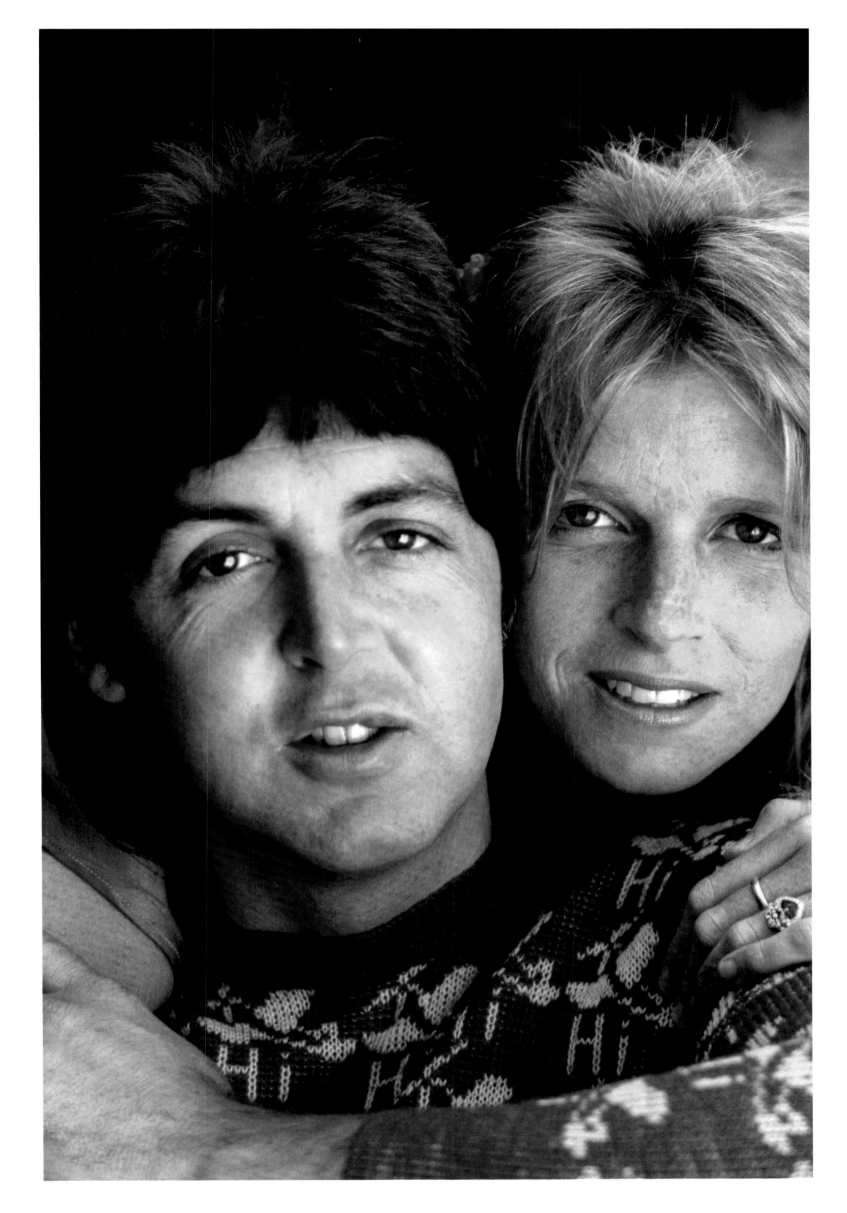

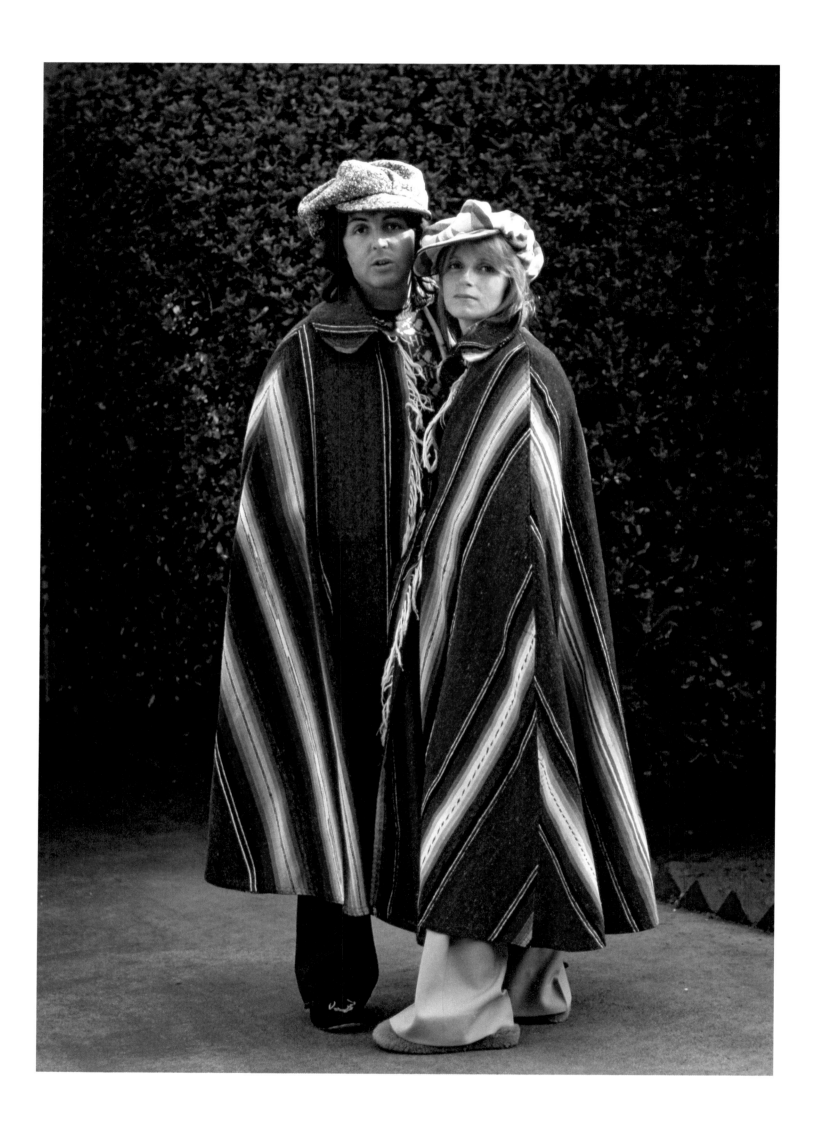

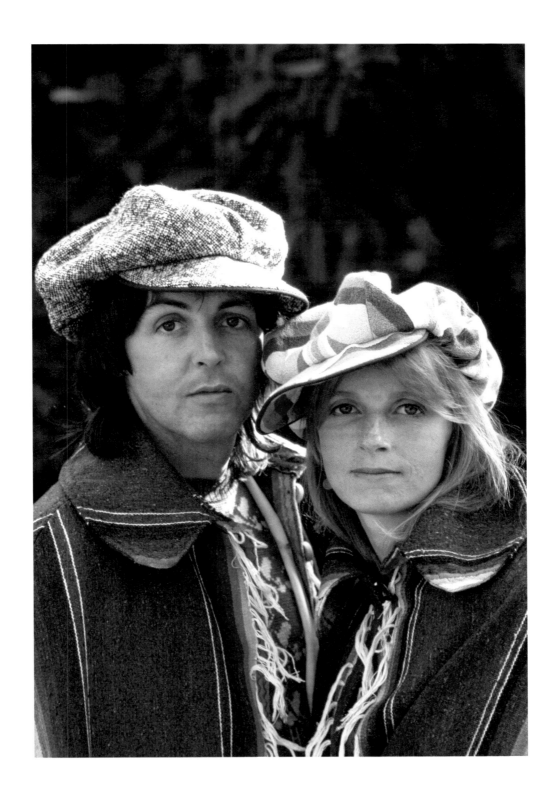

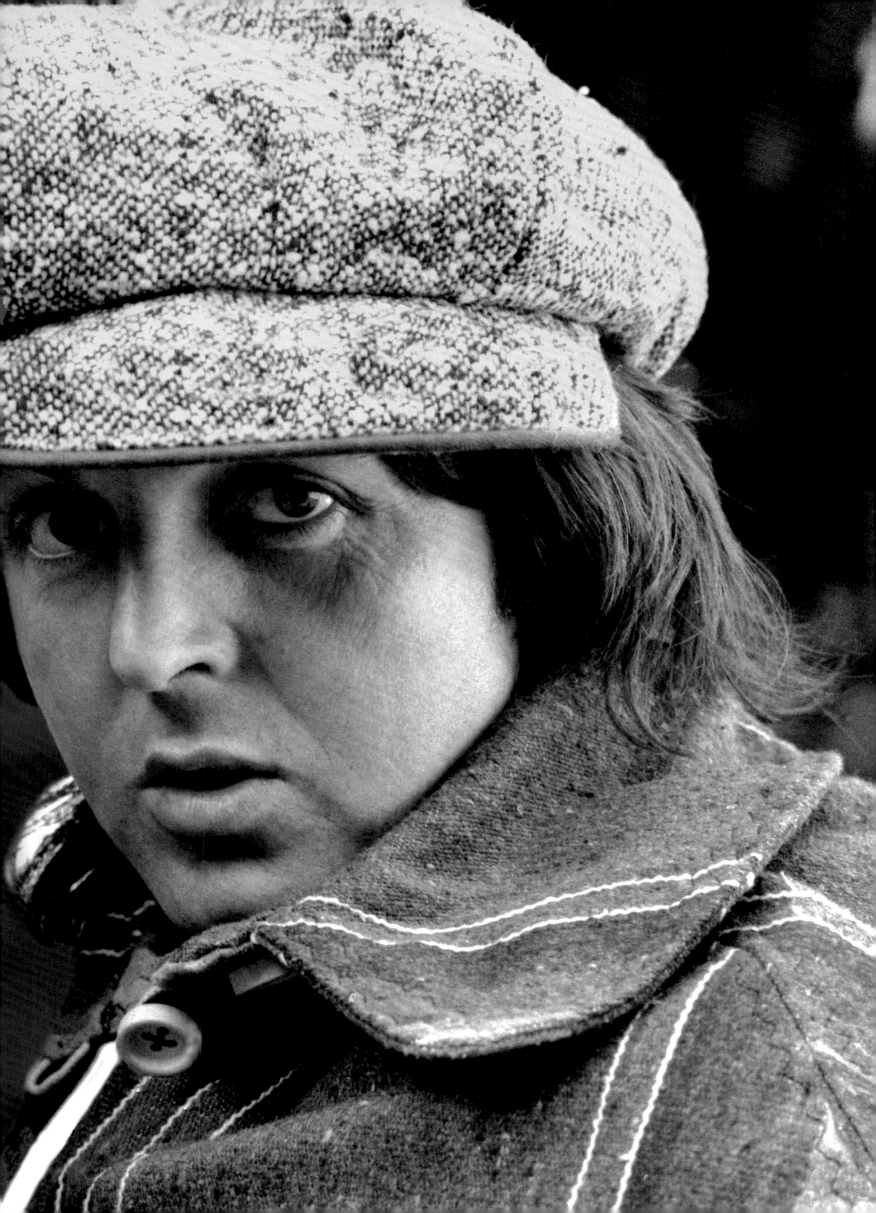

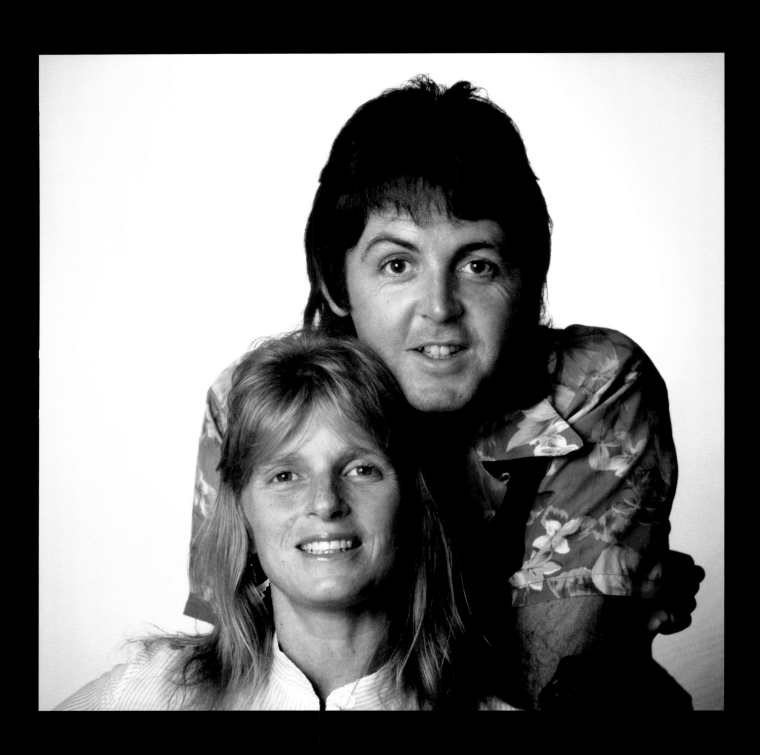

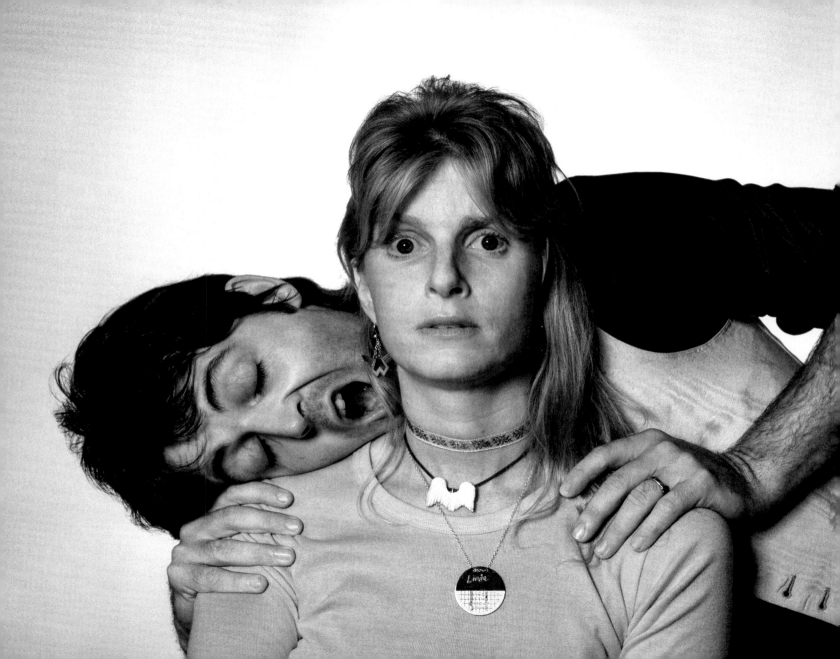

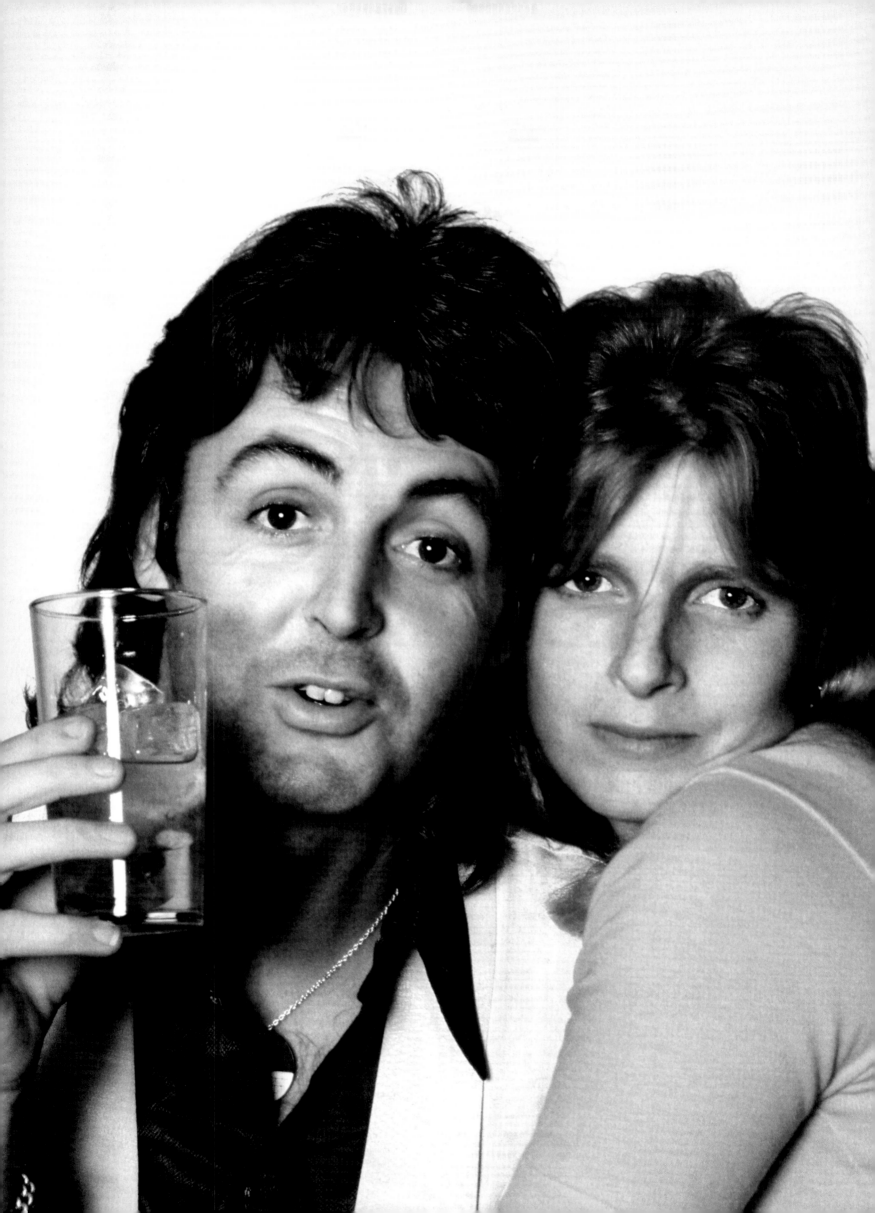

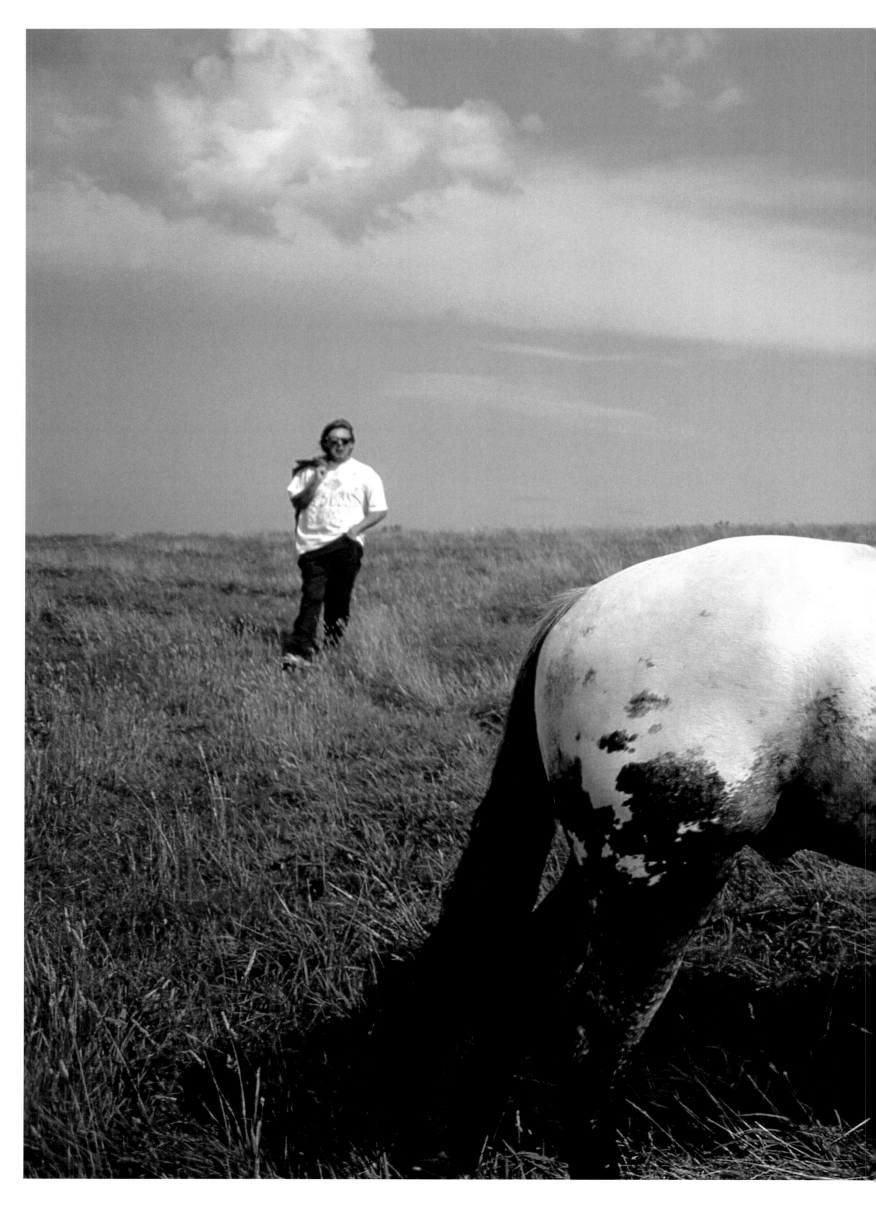

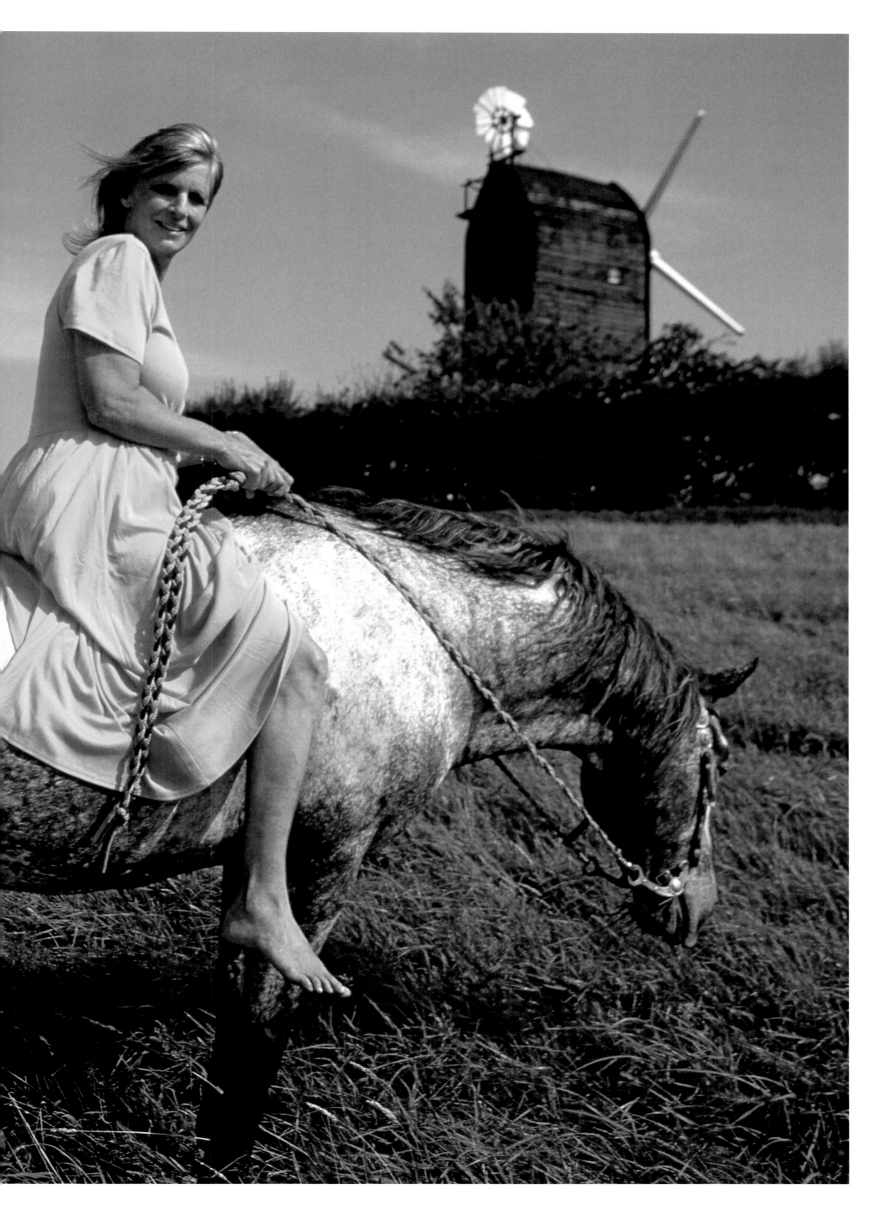

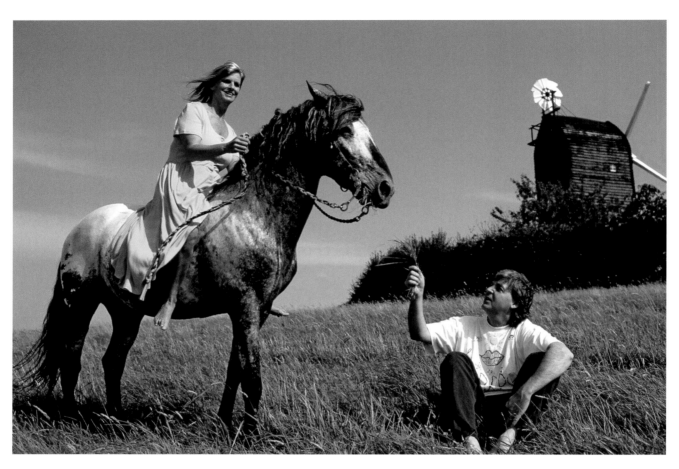

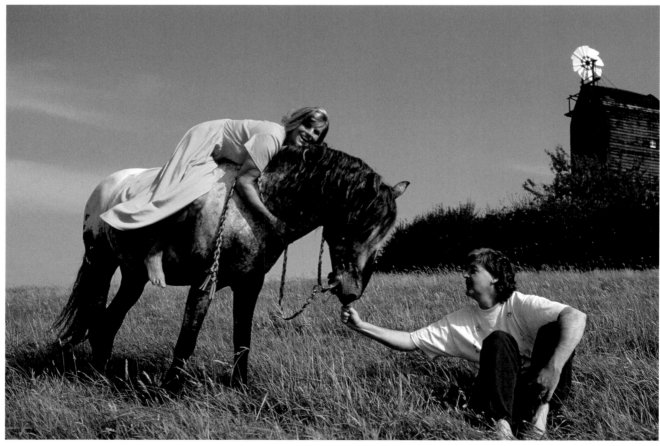

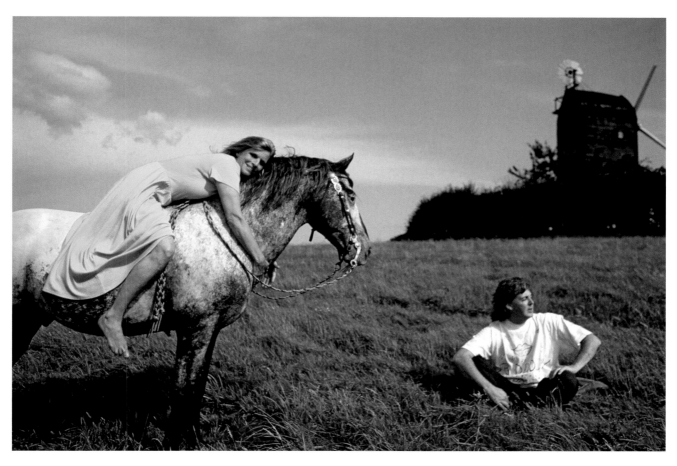

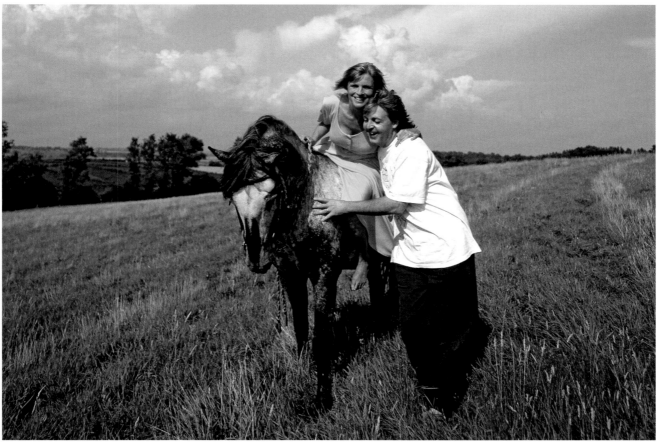

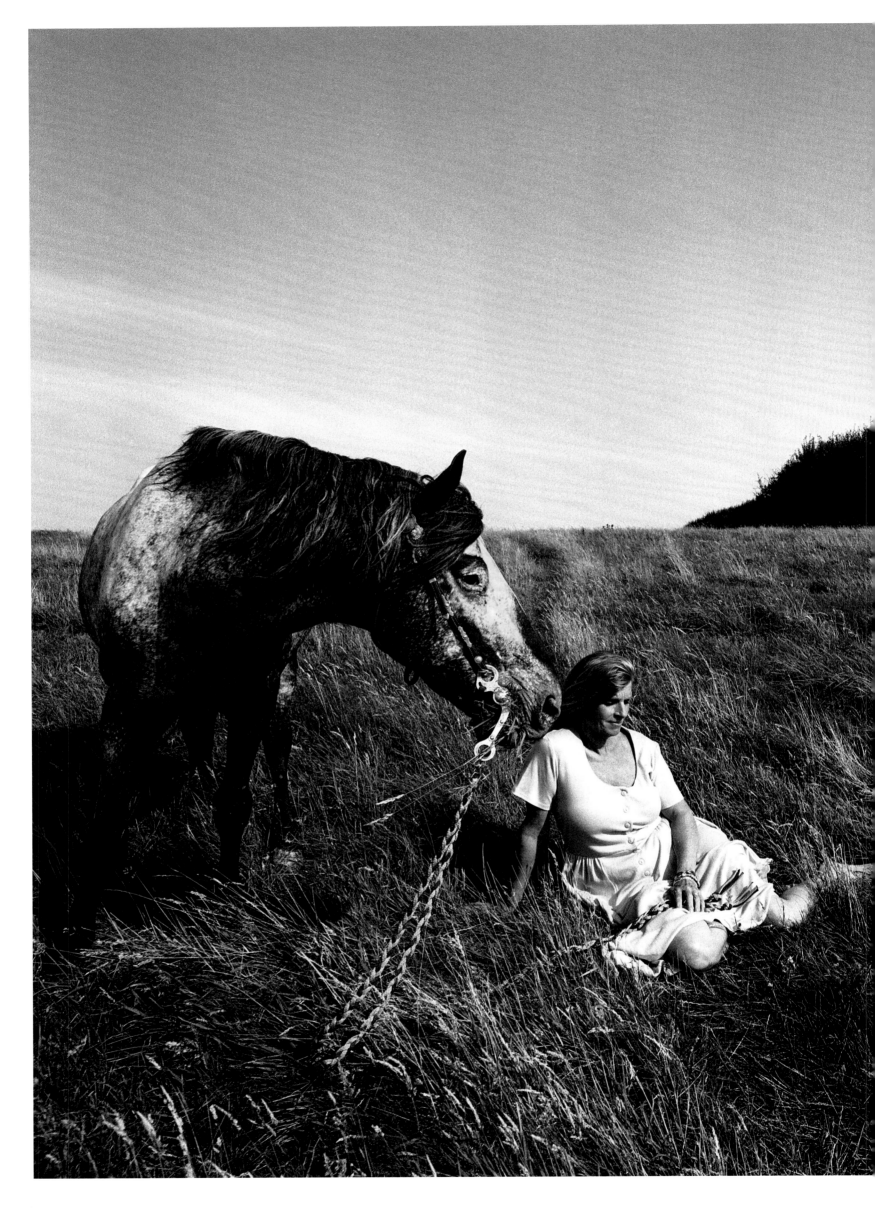

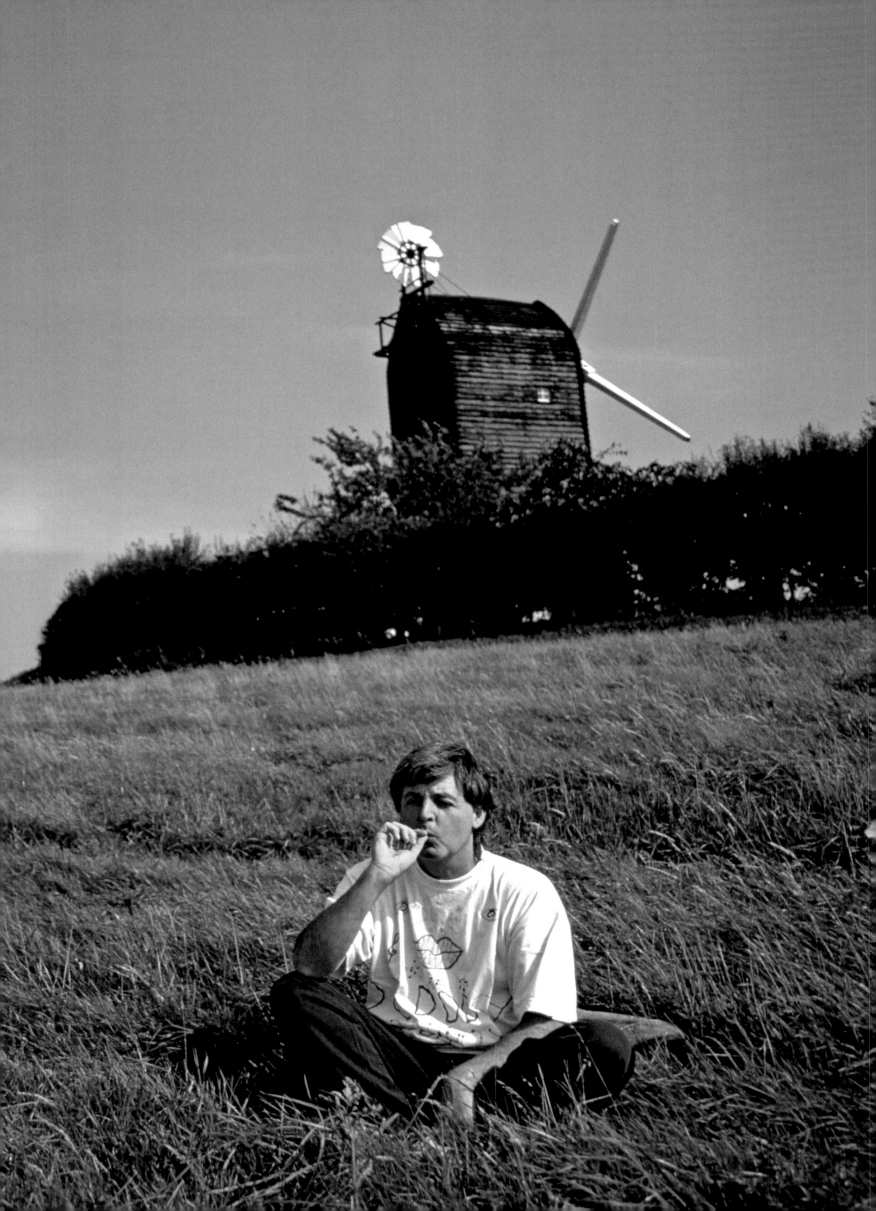

"'Wild life' refers to a home-cooked pastoral existence with Linda
and their three daughters…The McCartneys are setting down
their own roots these days in Argyllshire, Scotland, with a stable
of horses, several dogs, a flock of sheep and a backdrop which
Paul describes as 'so peaceful, the hillsides encourage music.'"

"The McCartneys, Paul & Linda"
People magazine, April 21, 1975

„ ,Wild Life' bezieht sich auf ein Leben auf dem Land wie anno dazumal mit Linda und den drei
Töchtern ... Die McCartneys sind gerade dabei, im schottischen Argyllshire Wurzeln zu schlagen,
mit Stall und Pferden, mehreren Hunden, einer Schafherde und einer, wie Paul sagt, ungemein
friedlichen Landschaft, deren Hügel die Musik inspirieren."

« L'album *Wild Life* renvoie la vie à la campagne avec Linda et leurs trois filles... Les McCartney ont
planté leurs racines en Écosse, dans l'Argyllshire, avec une écurie pour leurs chevaux, plusieurs chiens,
un troupeau de brebis et un environnement que Paul décrit comme "si paisible, où les coteaux invitent à la
musique". »

Band on

the Run

"The party on the *Queen Mary* docked in Long Beach, California, was a great night — one to remember — filled with stars everywhere you turned — from the Sinatra Rat Pack singer Dean Martin and former actor turned senator George Murphy to legends like Bob Dylan and Michael Jackson. Paul gave me the exclusive to the party — I was the only photographer who was there."

— Harry Benson

„ Die Party an Bord der *Queen Mary*, die vor Long Beach im Dock lag, war grandios – ein denkwürdiger Abend mit Stars, wohin man auch blickte, von Dean Martin aus Sinatras Rat Pack über Senator George Murphy, einen ehemaligen Schauspieler, bis zu Legenden wie Bob Dylan und Michael Jackson. Paul gewährte mir die Exklusivrechte – ich war der einzige Fotograf auf der Party."

« La soirée sur le *Queen Mary* amarré à Long Beach en Californie fut fantastique, une de ces nuits mémorables, avec une foule de stars comme Dean Martin du Rat Pack de Sinatra, George Murphy, ancien acteur devenu sénateur, ou des légendes vivantes dont Bob Dylan et Michael Jackson. Paul m'en avait donné l'exclusivité. J'étais le seul photographe sur place. »

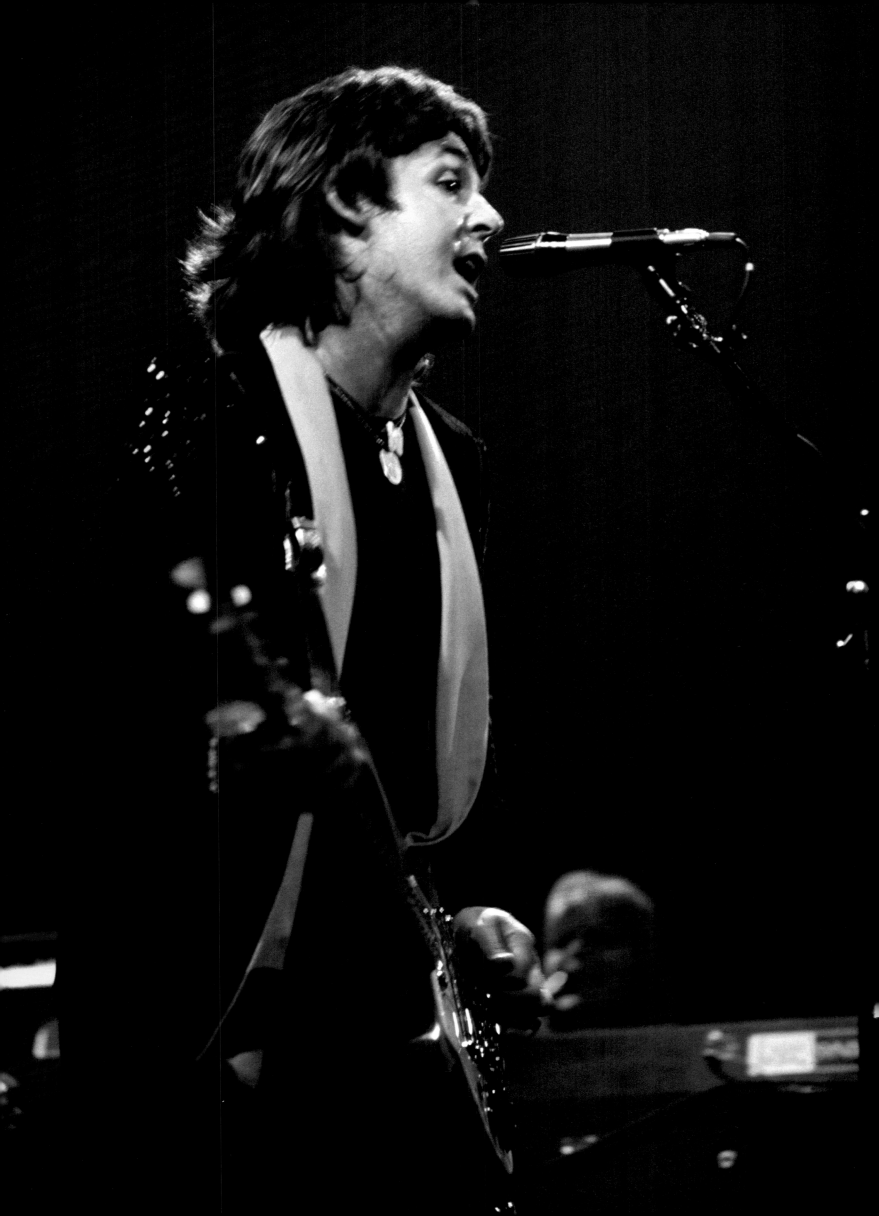

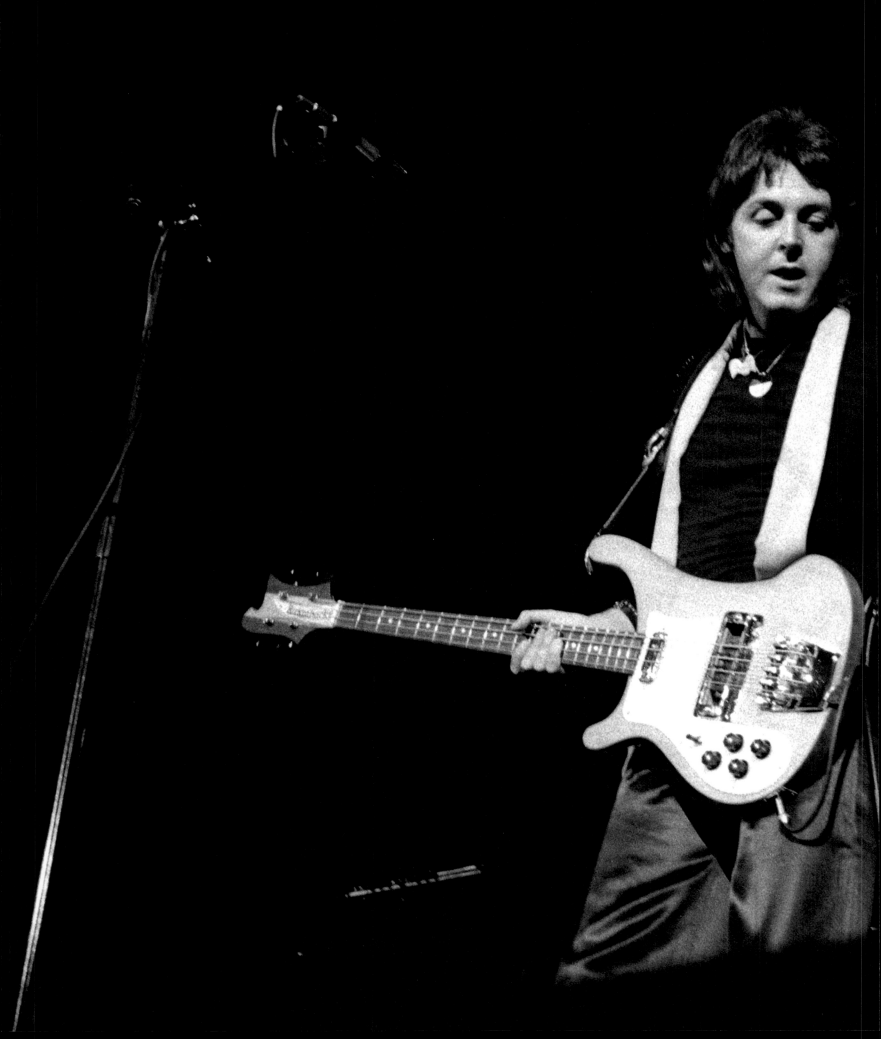

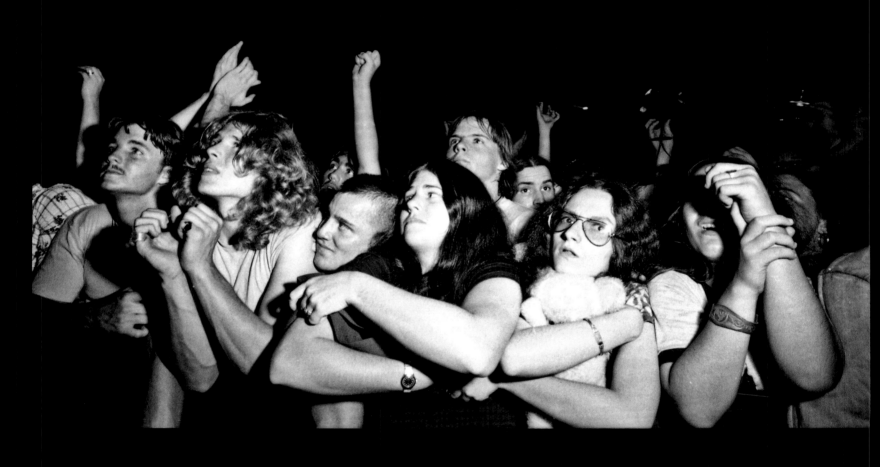

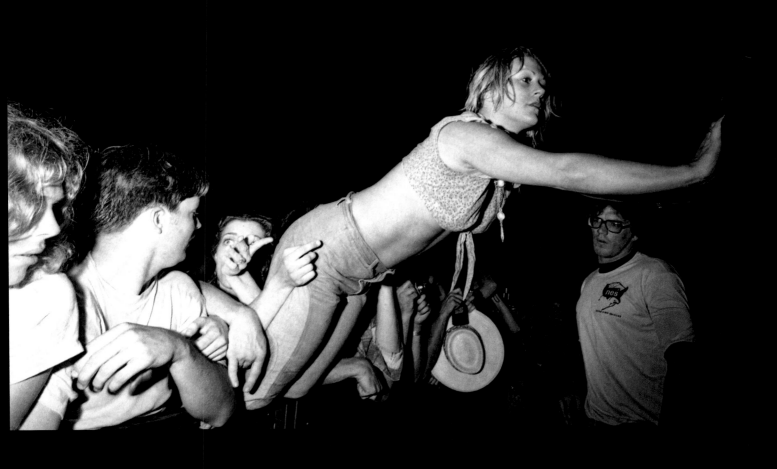

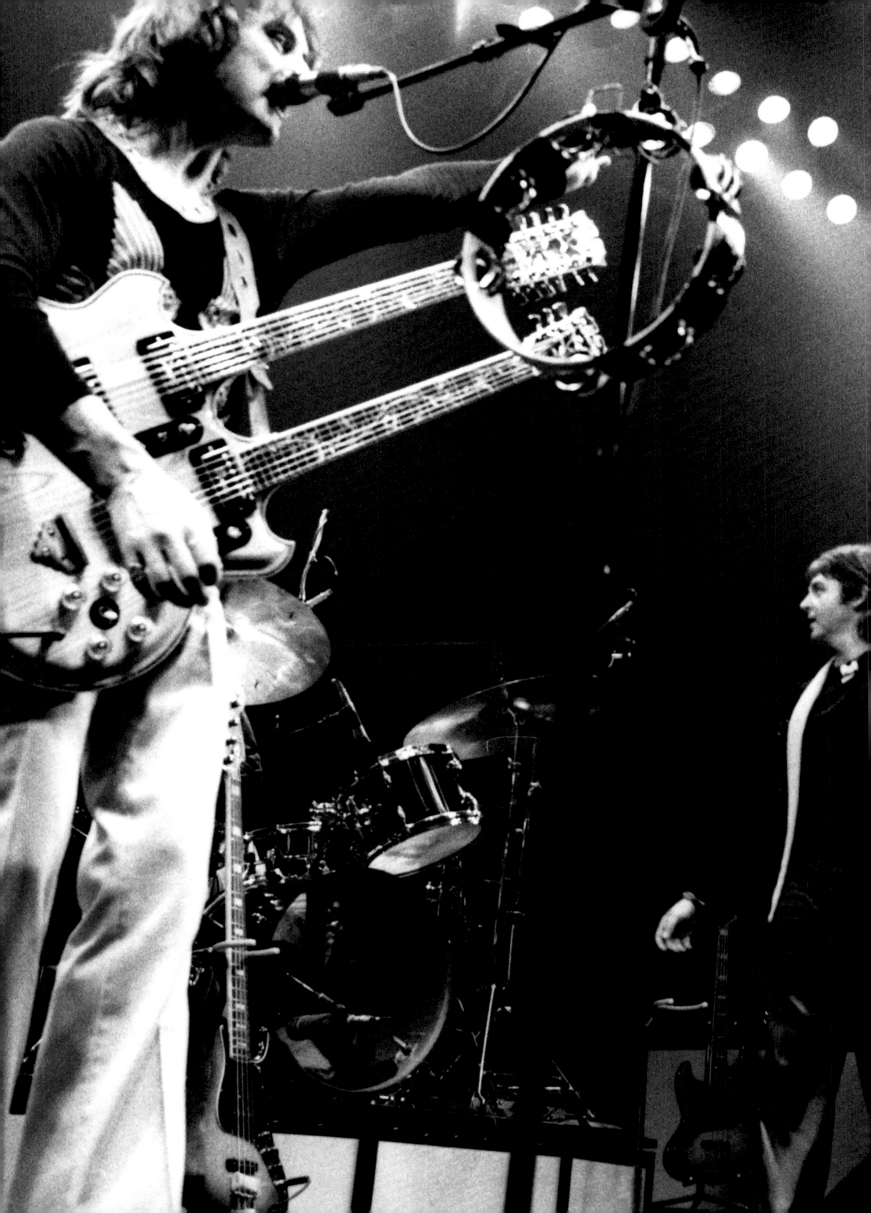

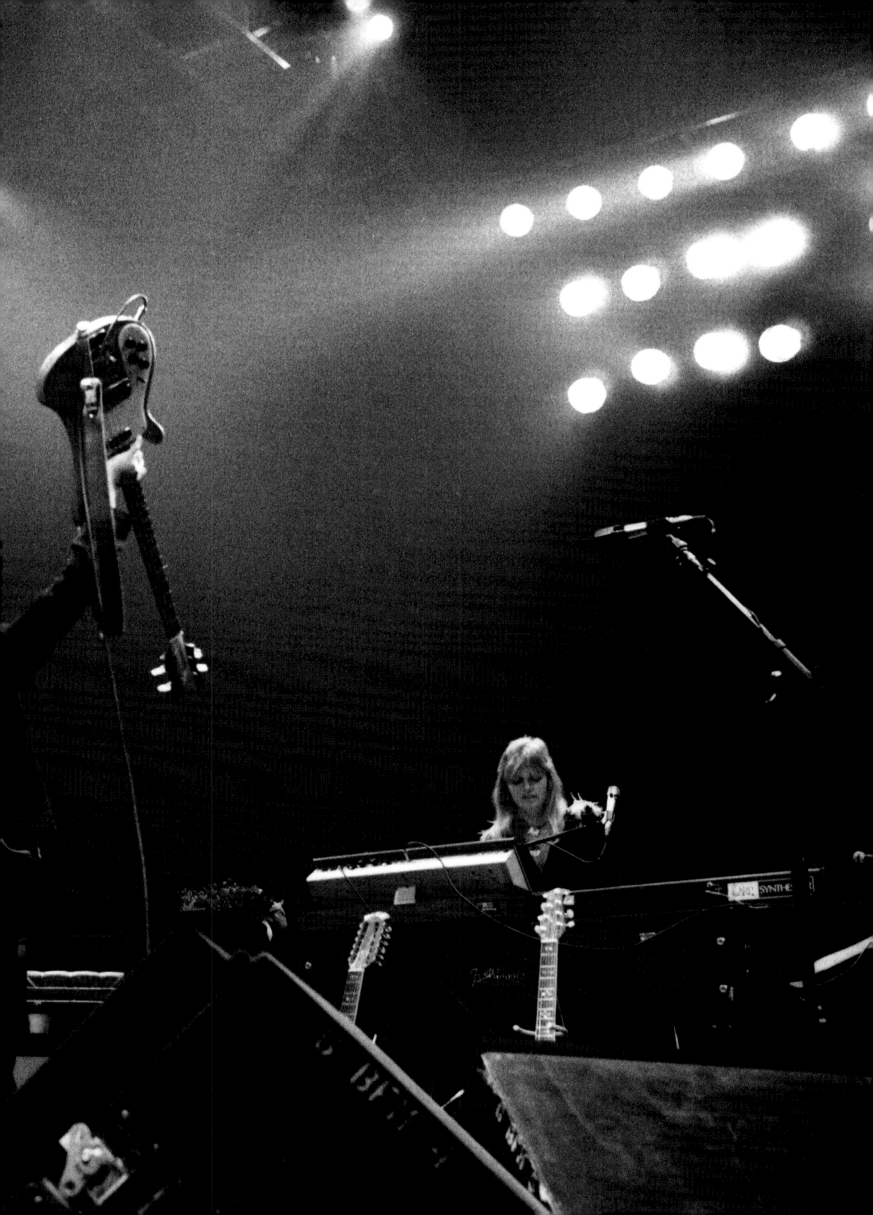

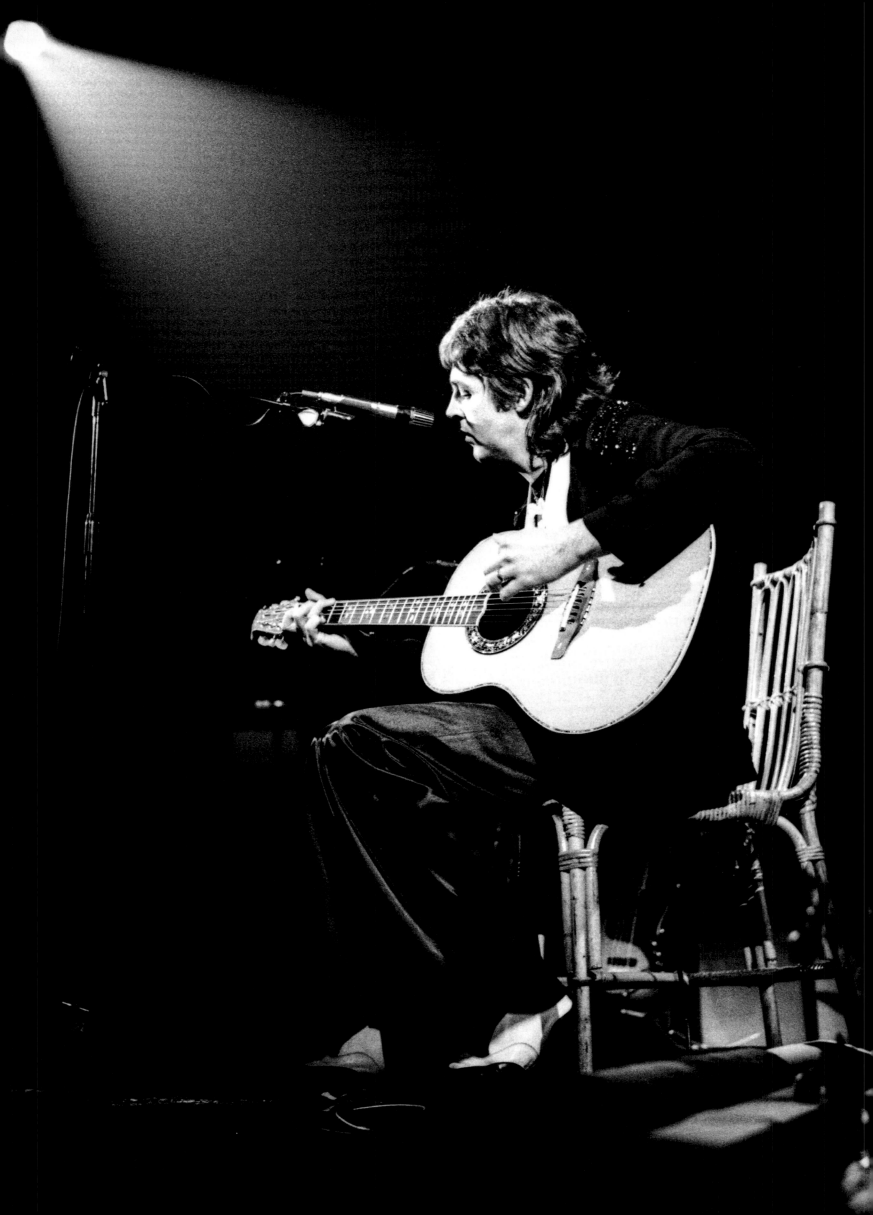

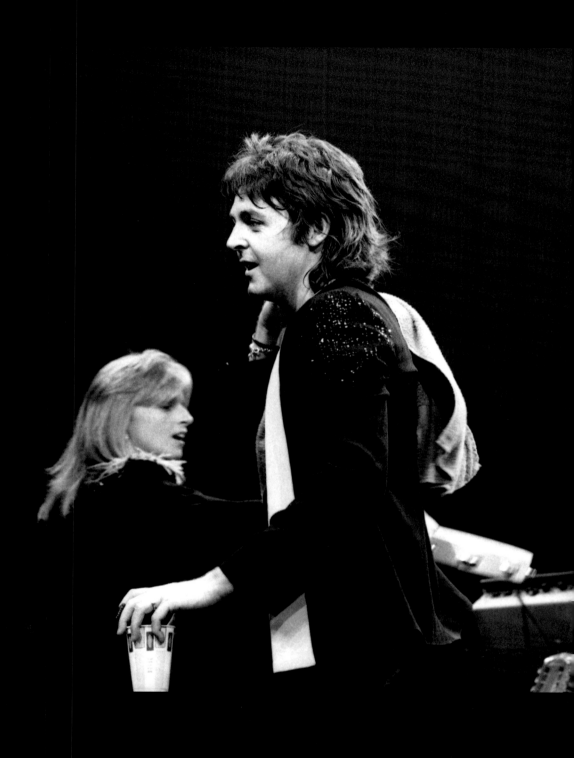

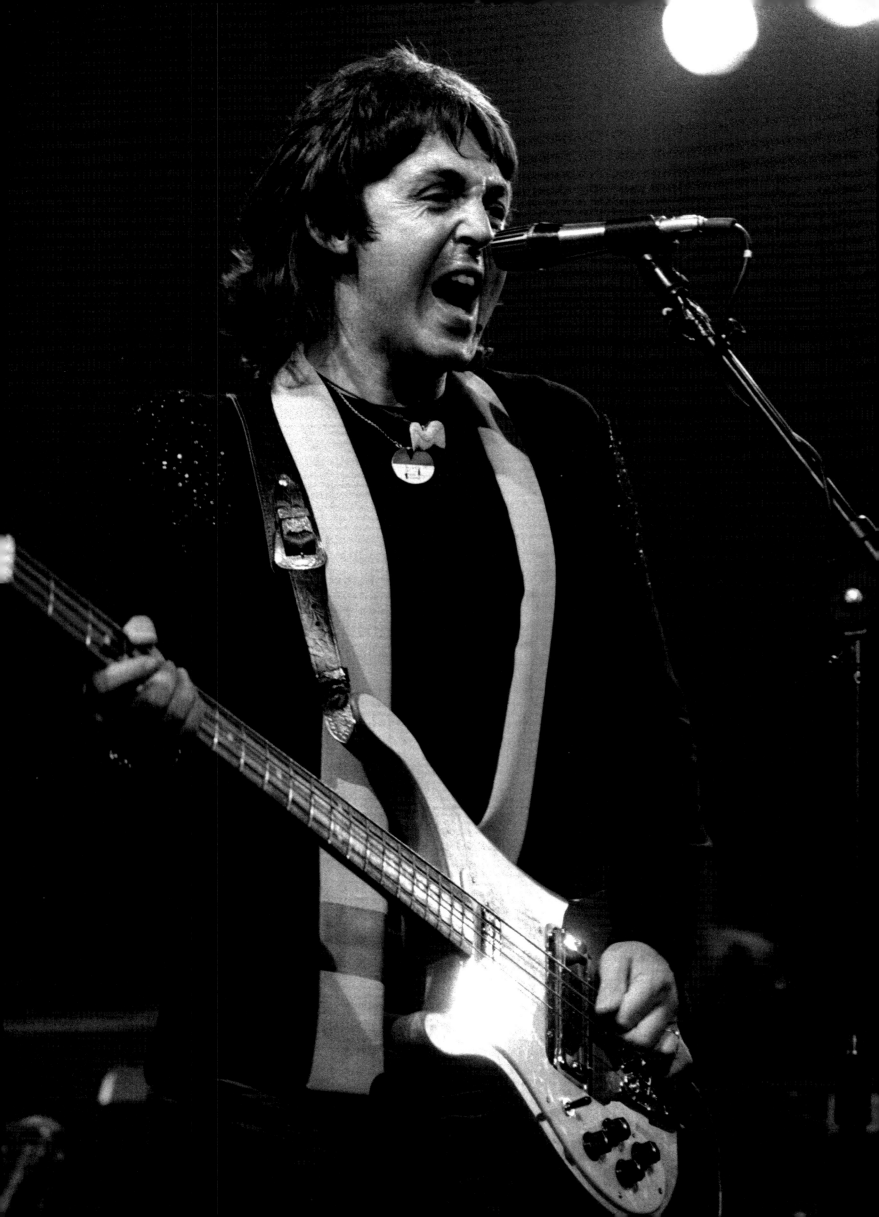

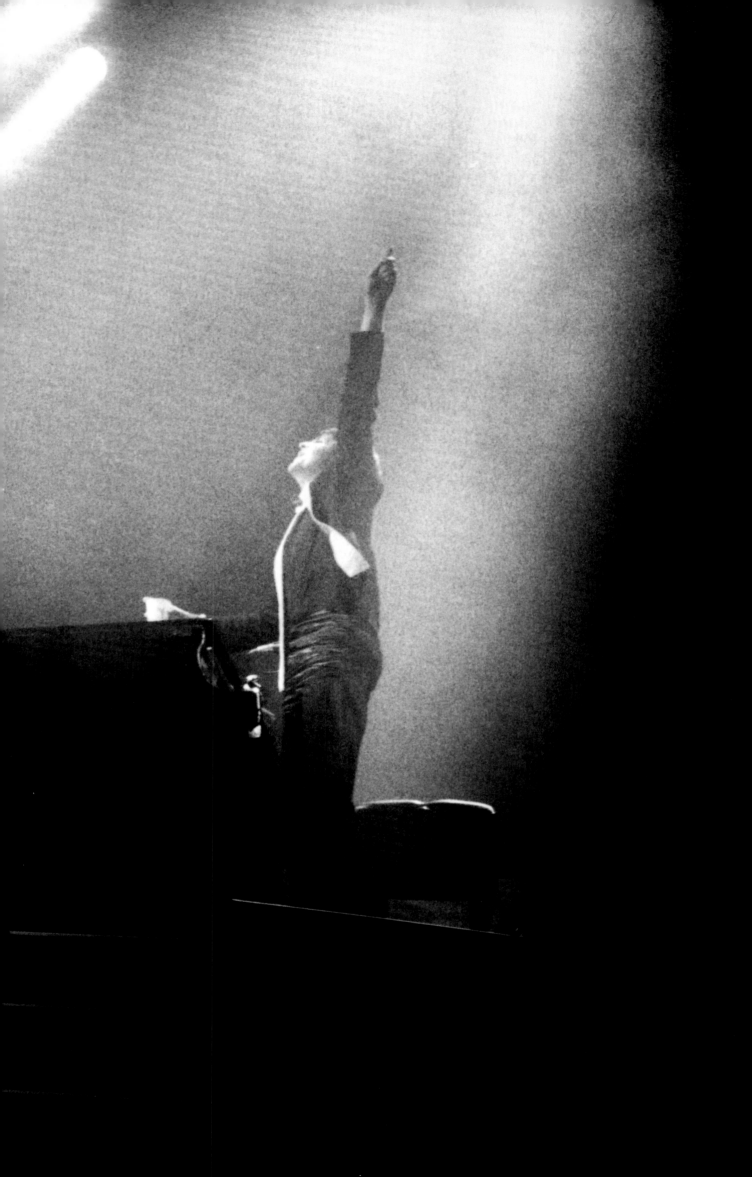

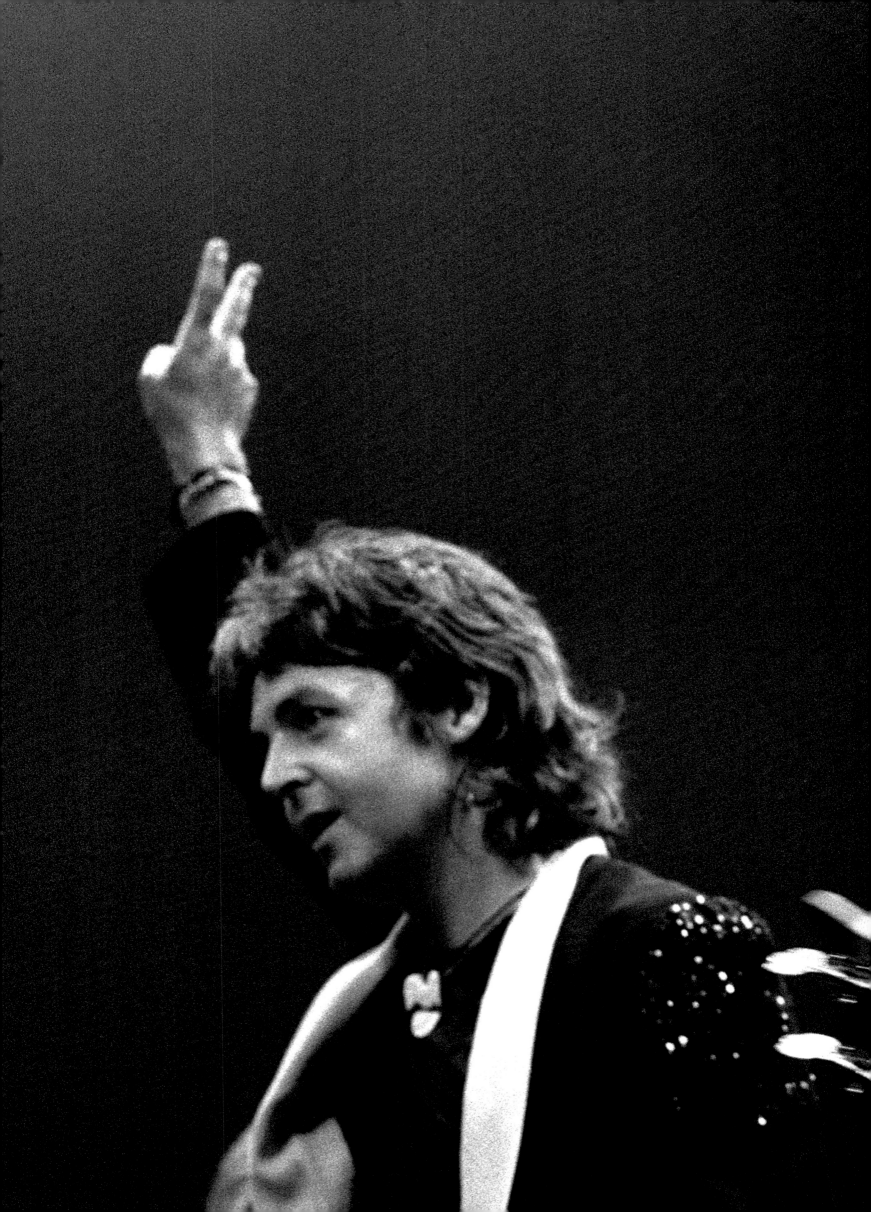

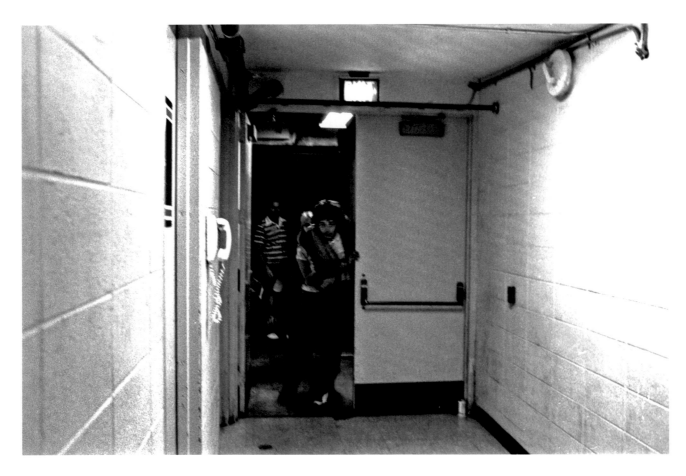

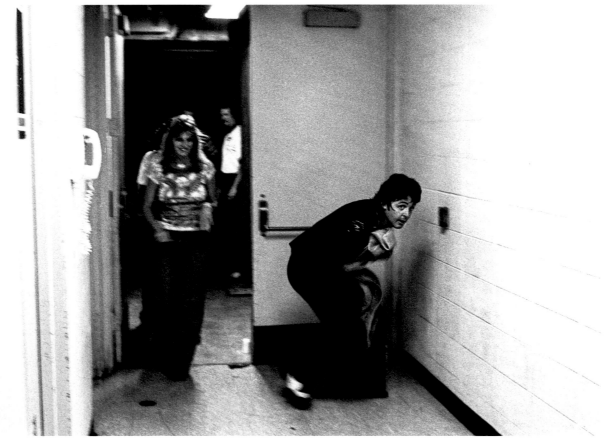

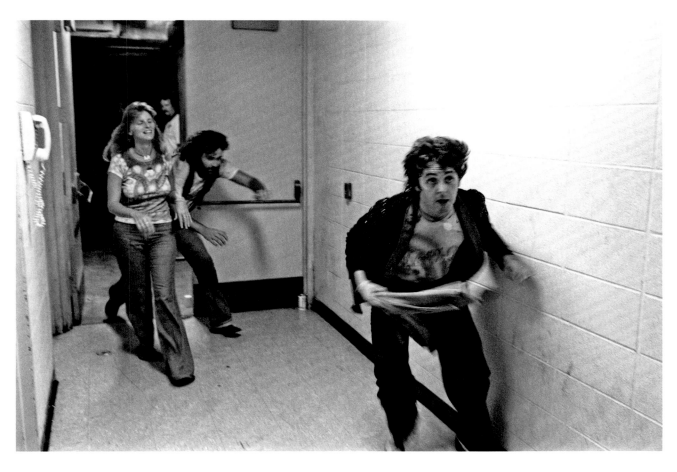

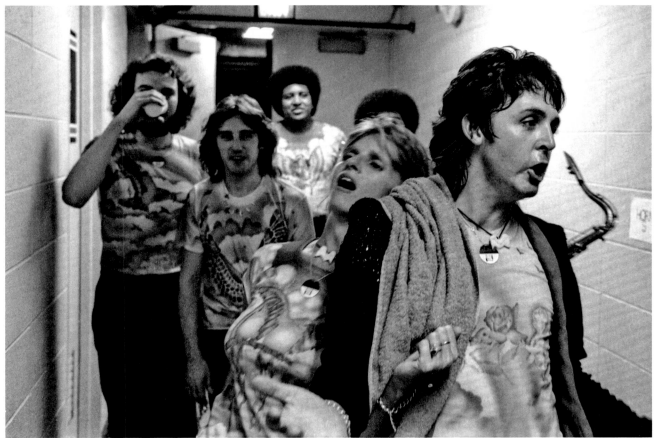

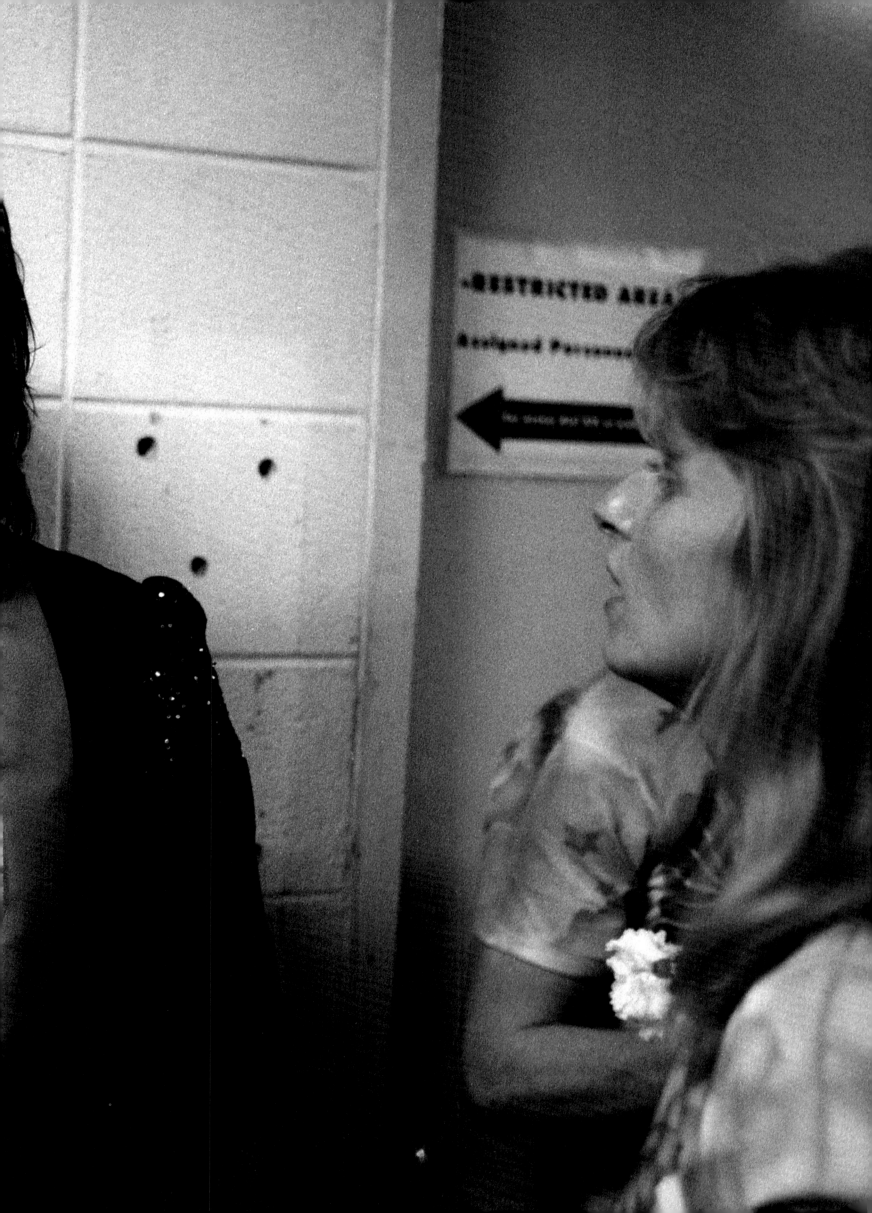

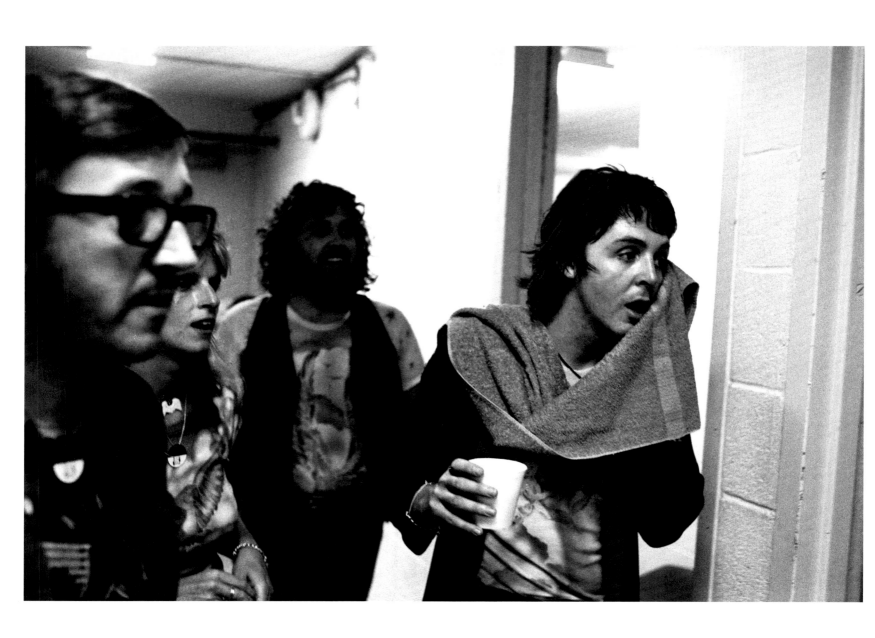

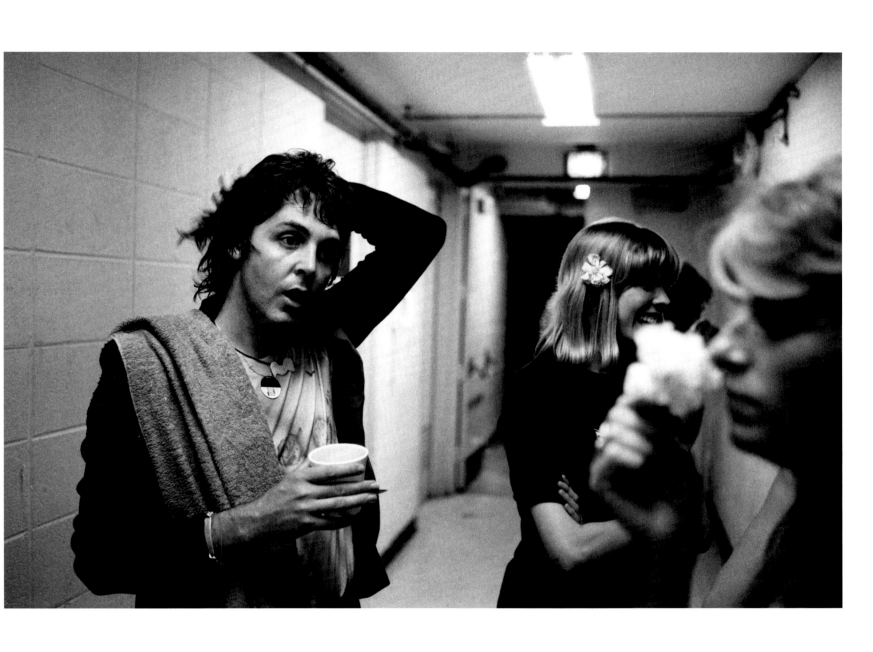

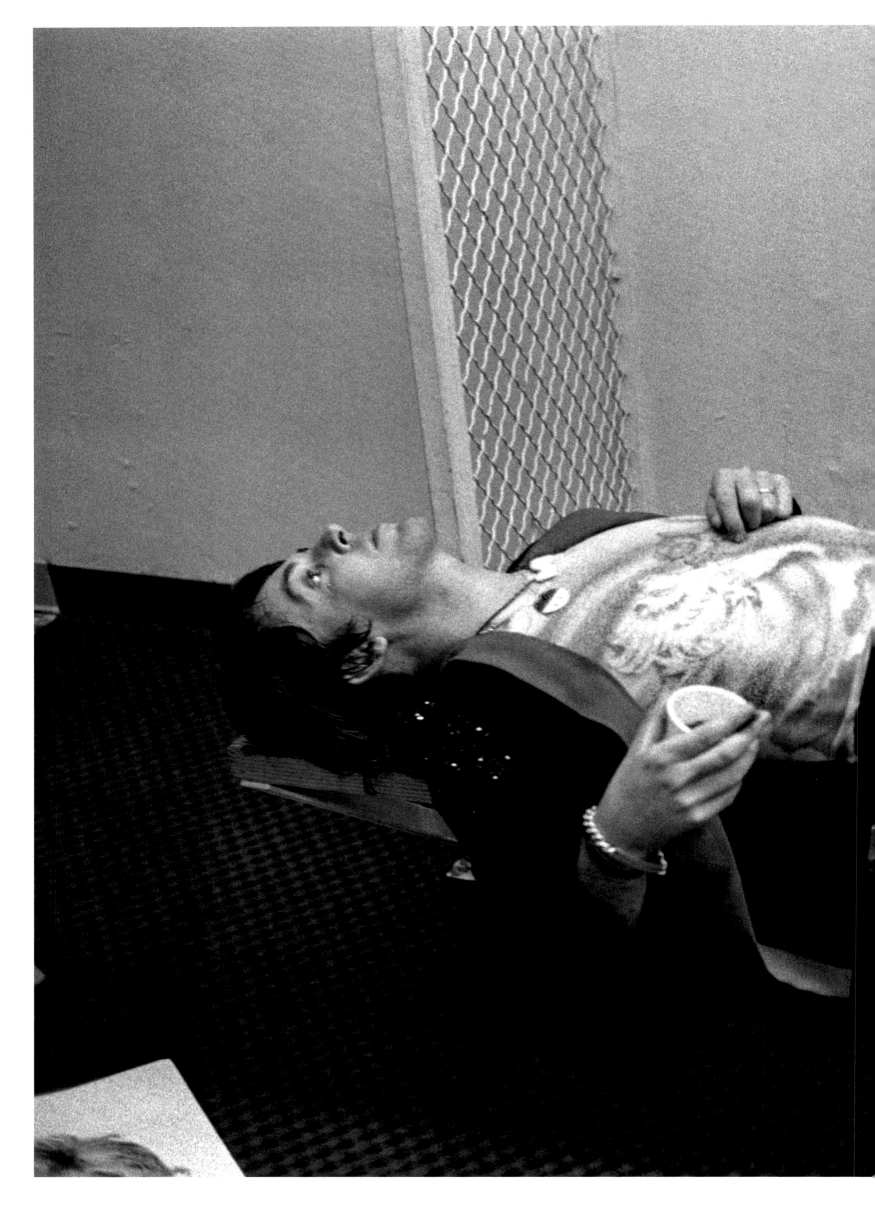

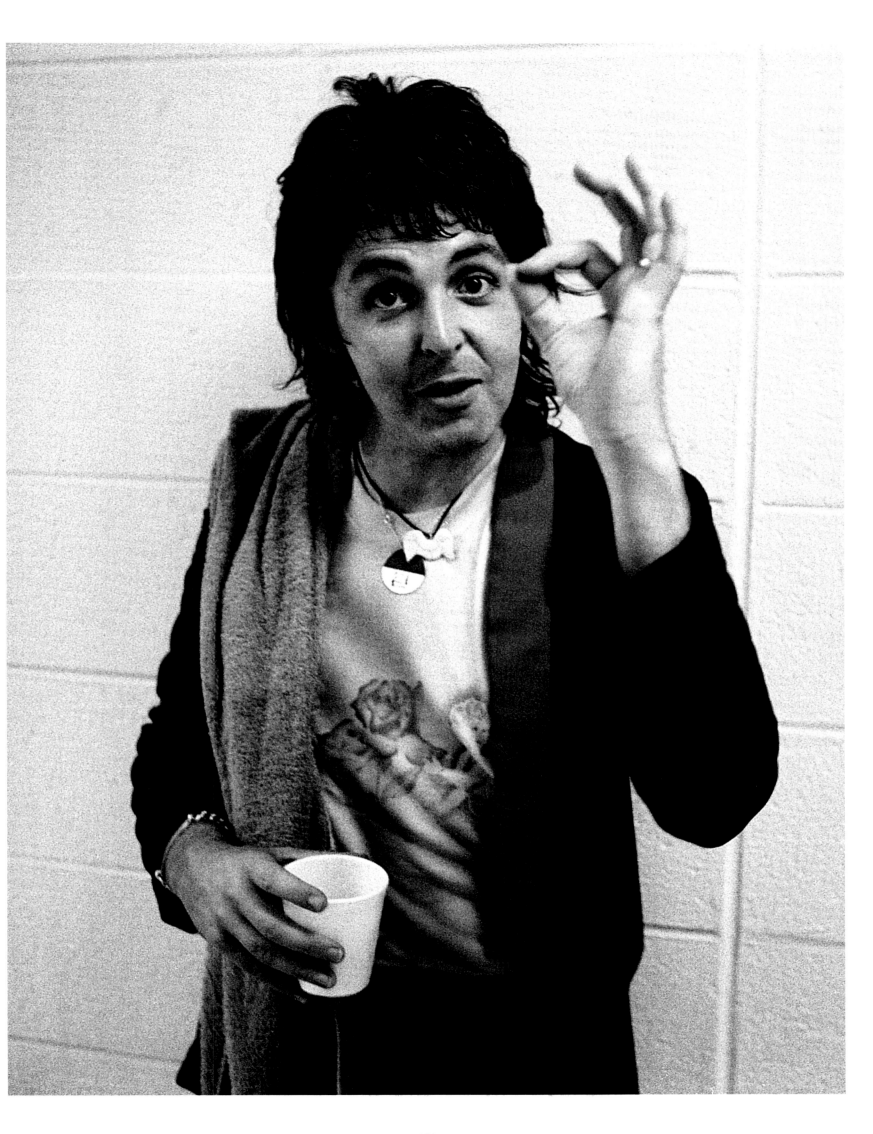

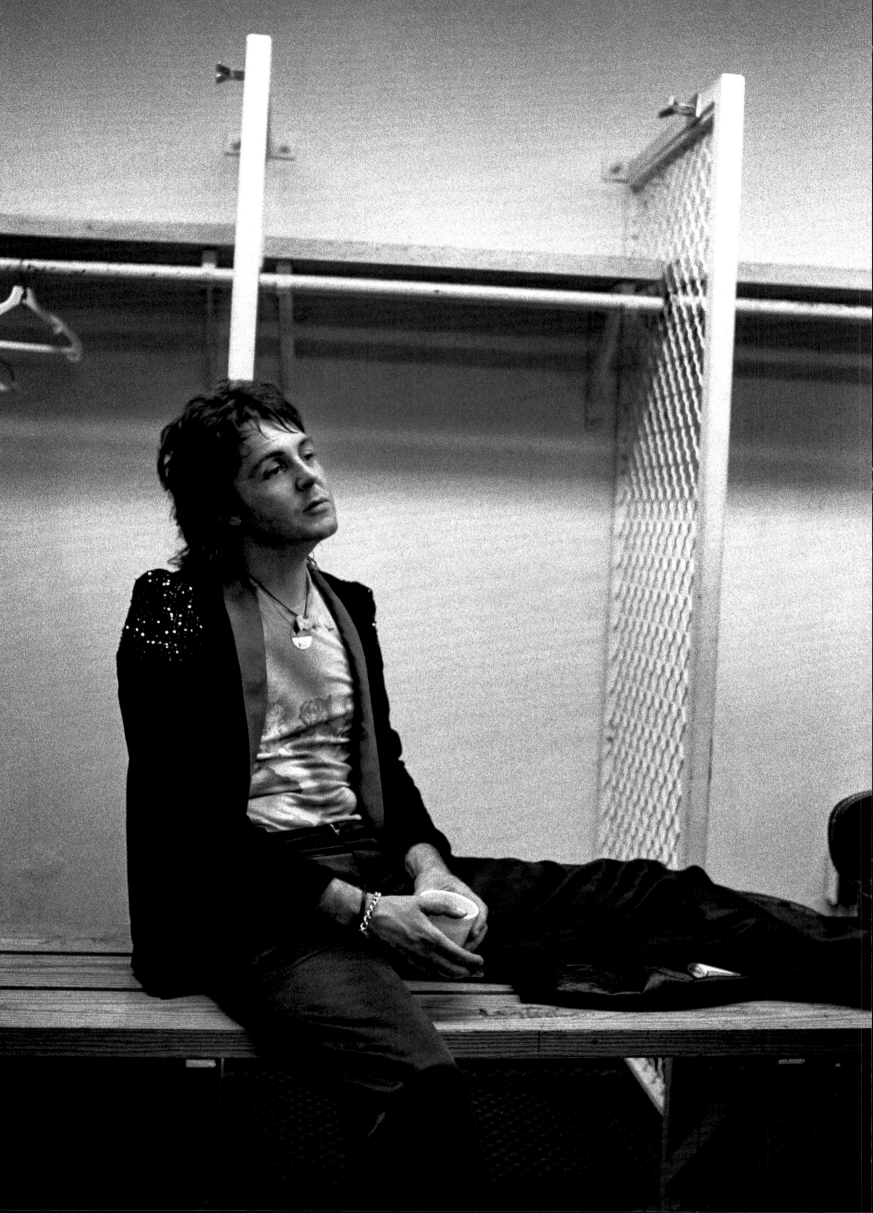

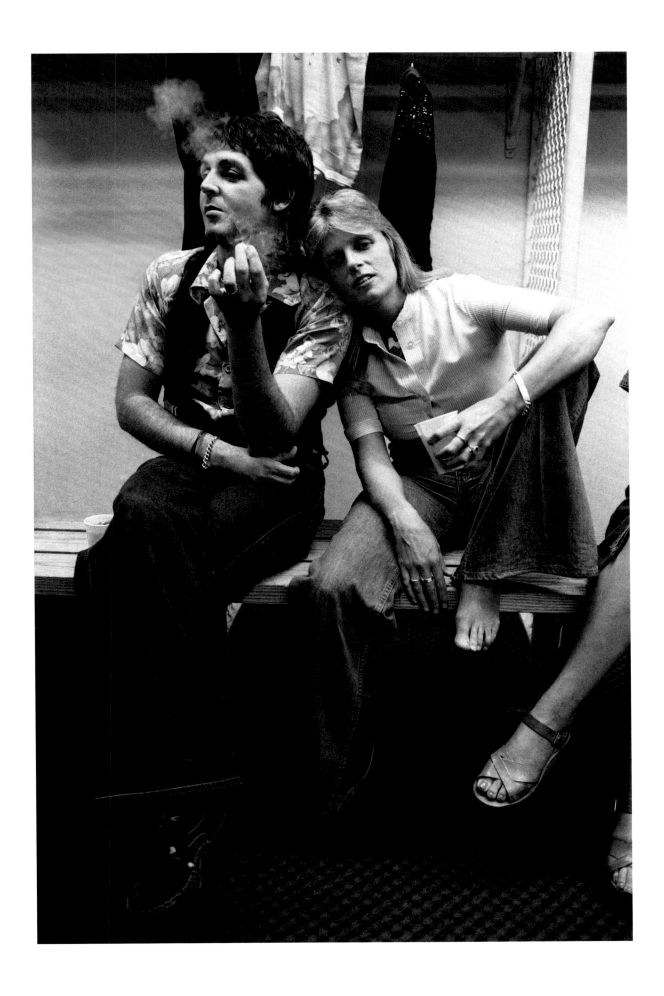

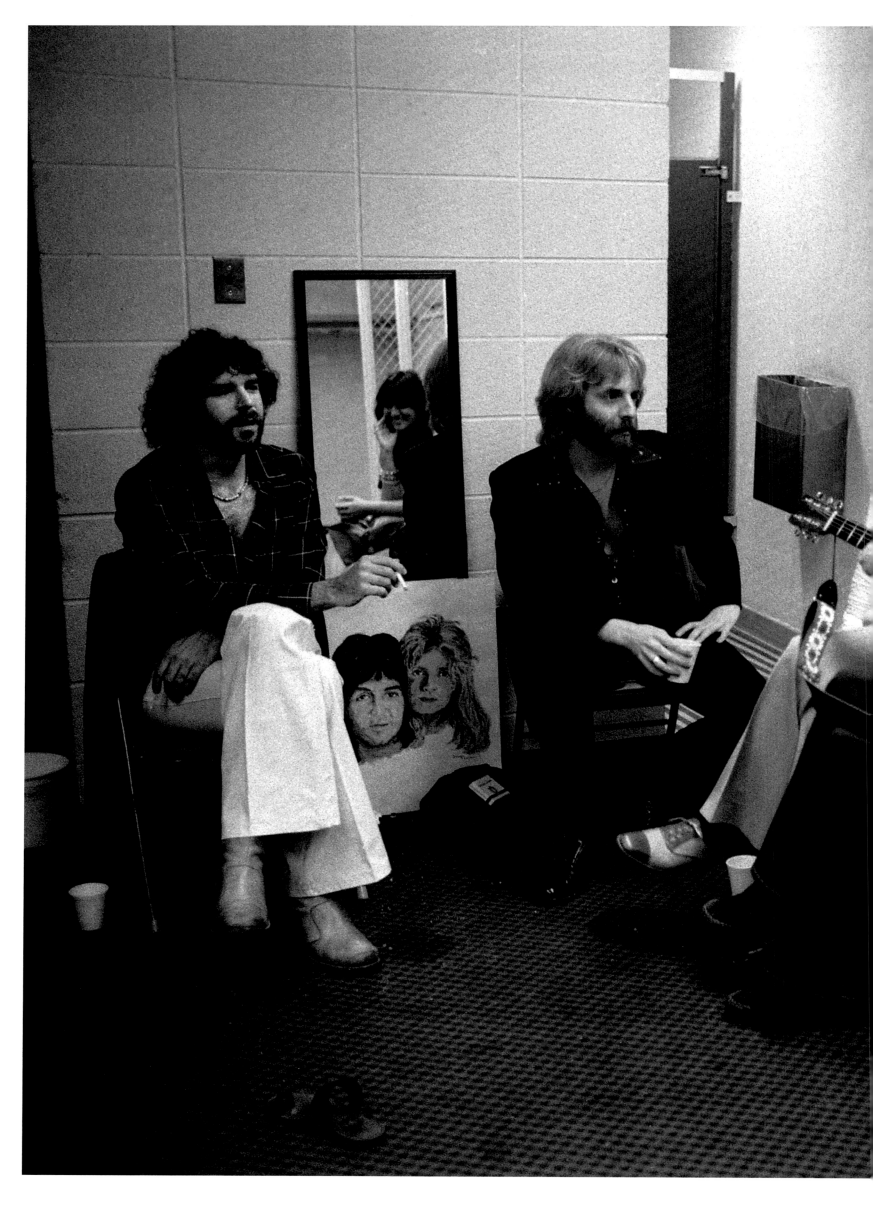

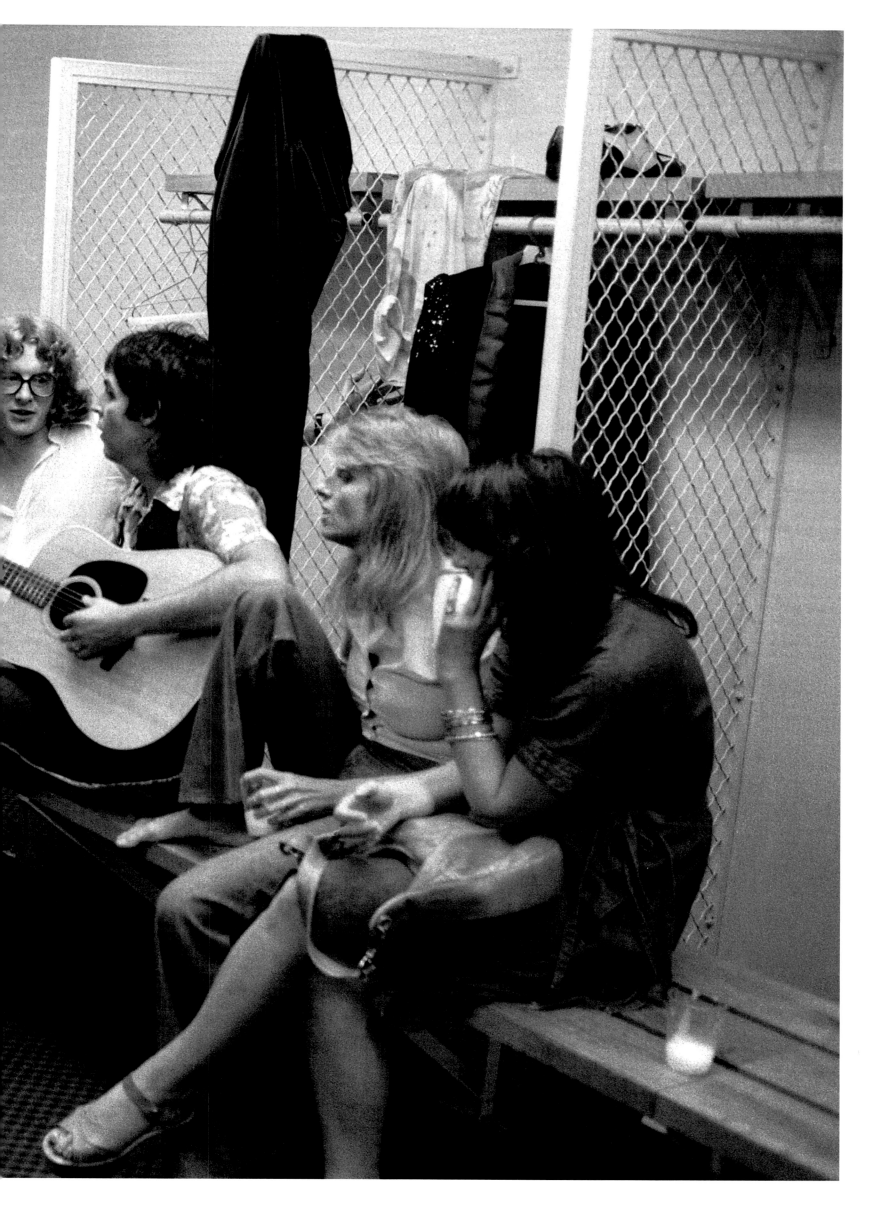

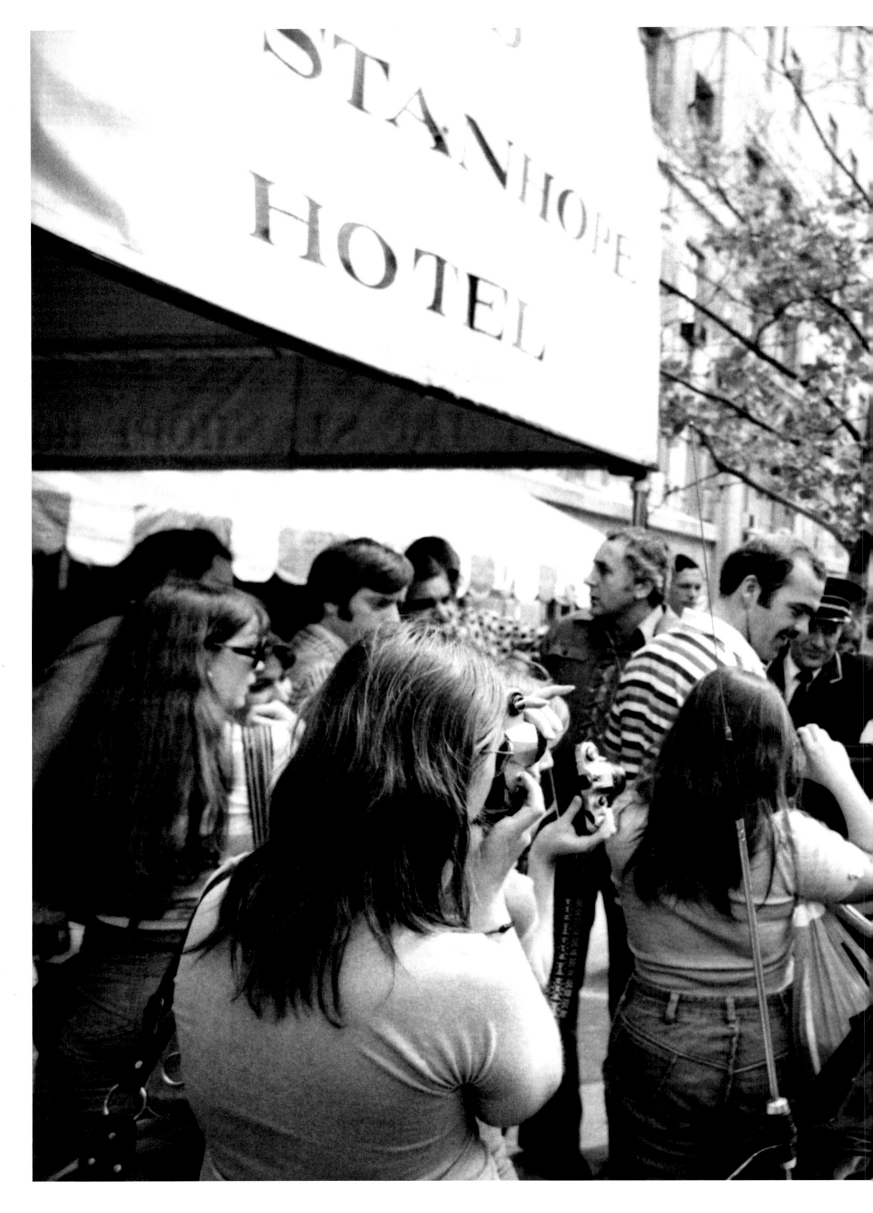

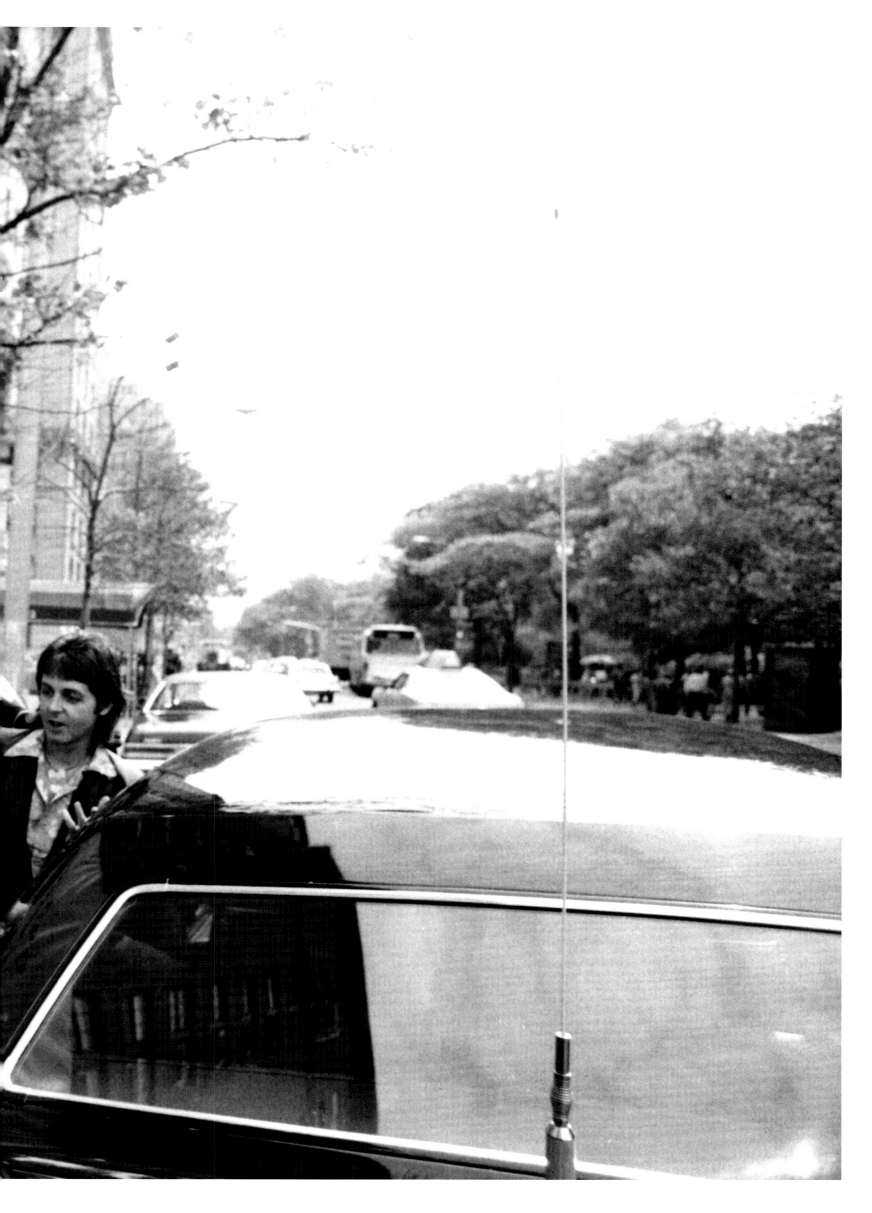

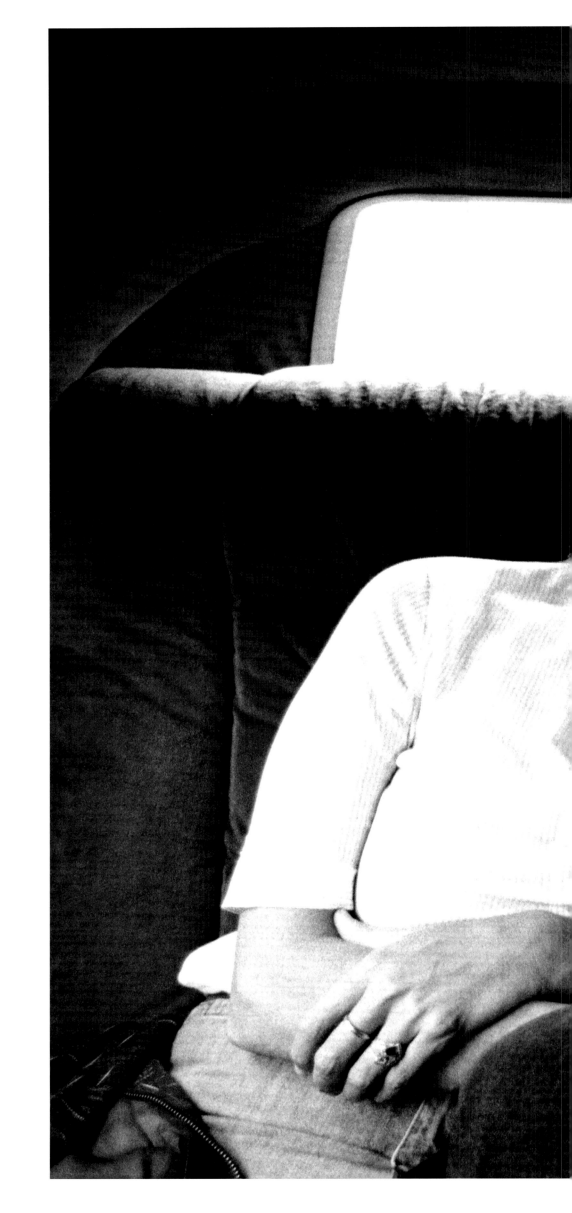

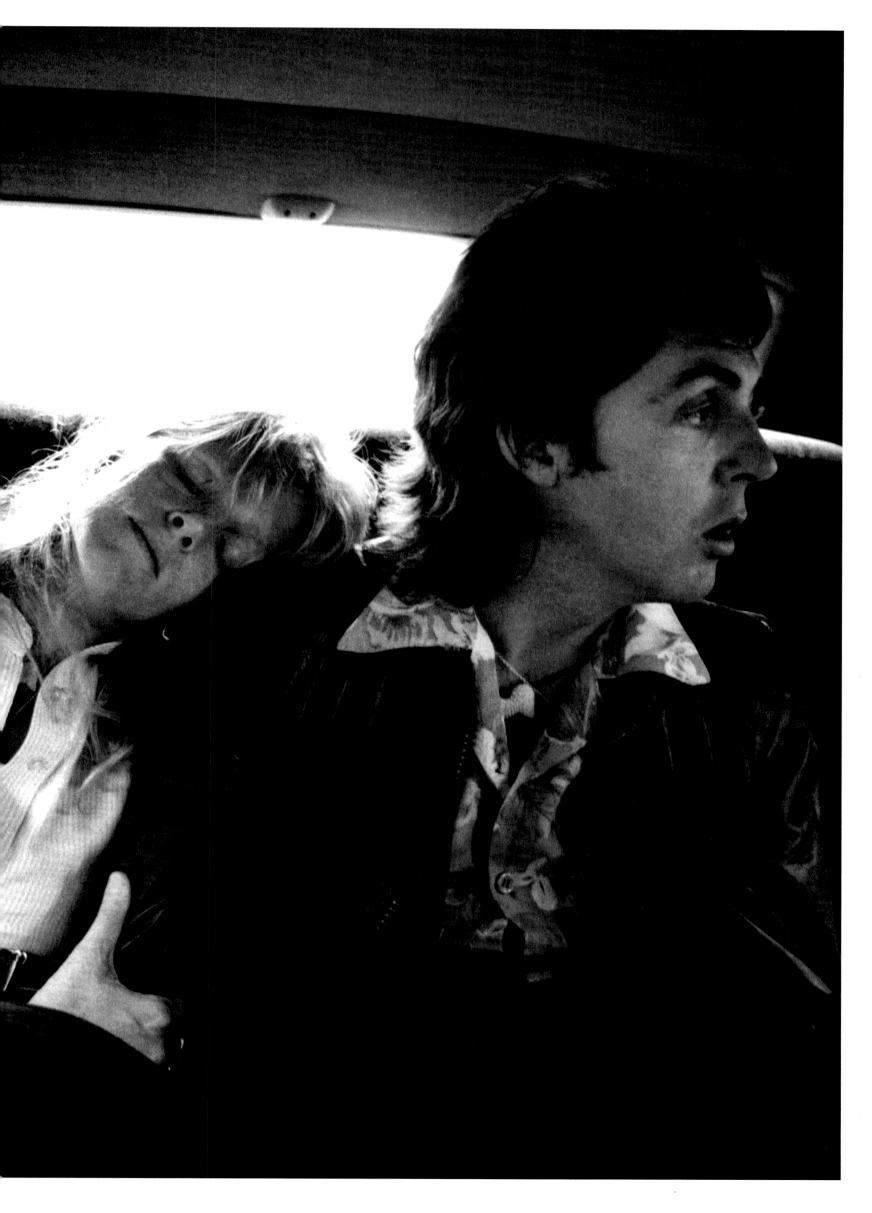

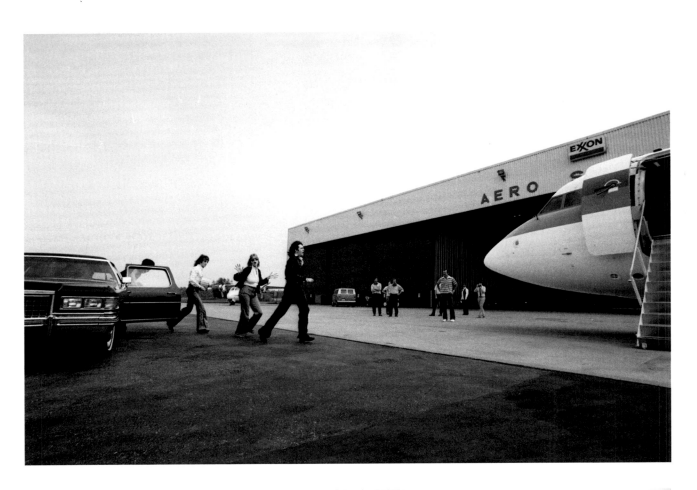

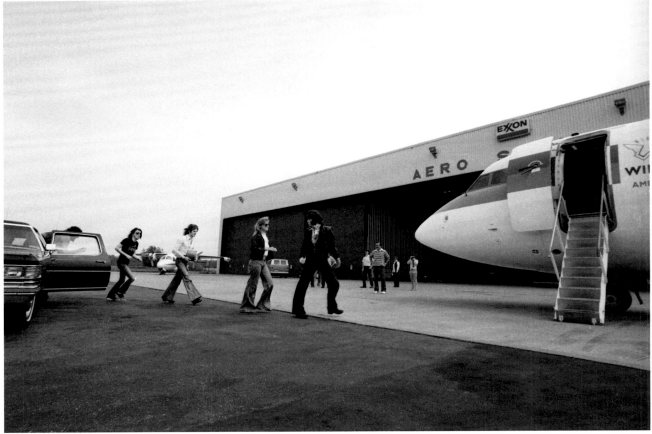

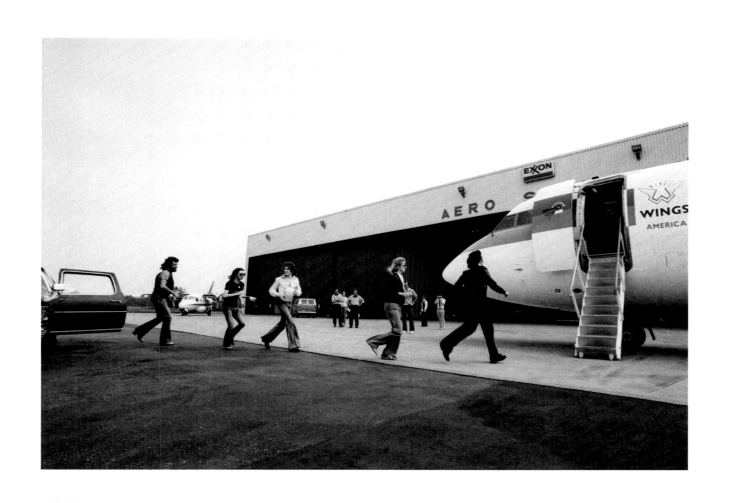

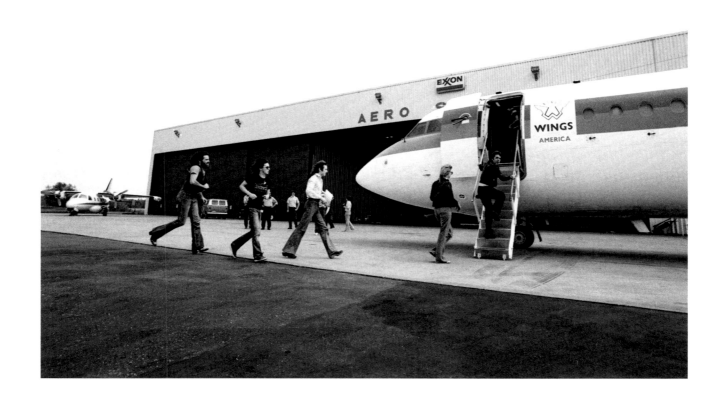

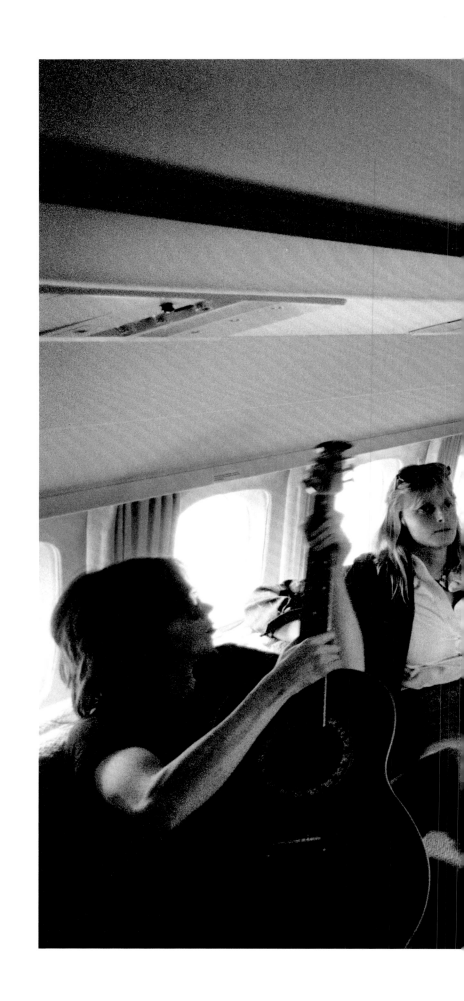

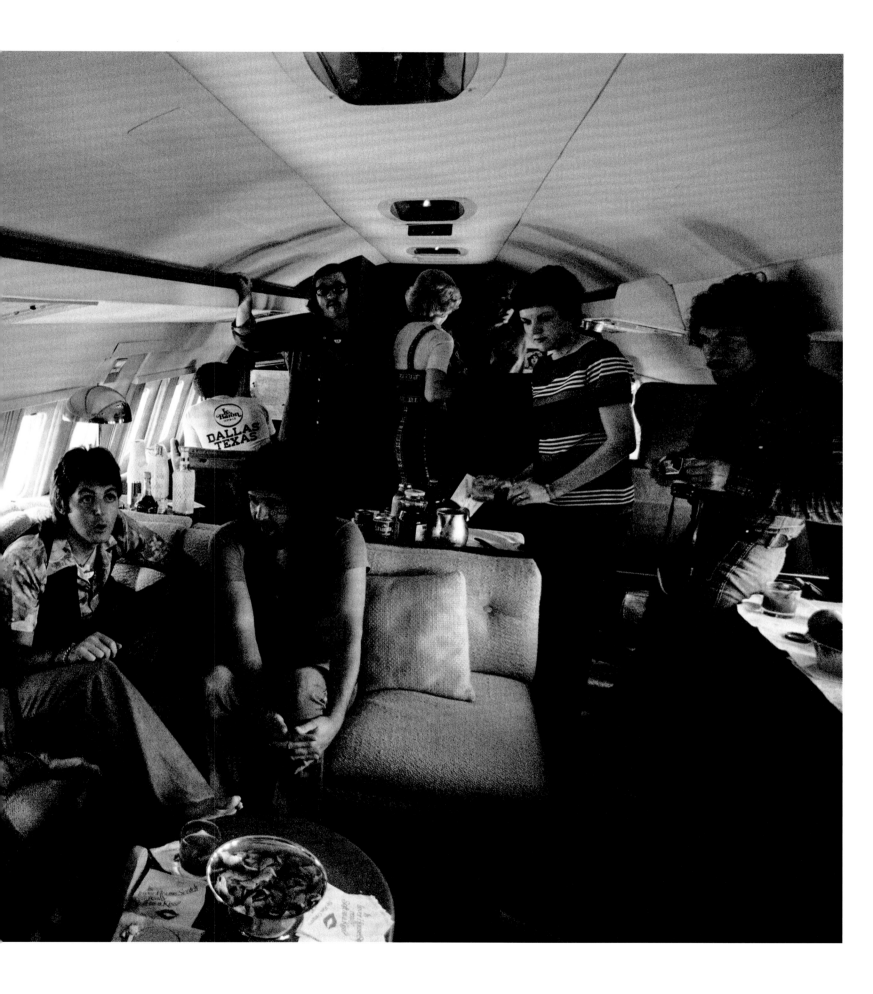

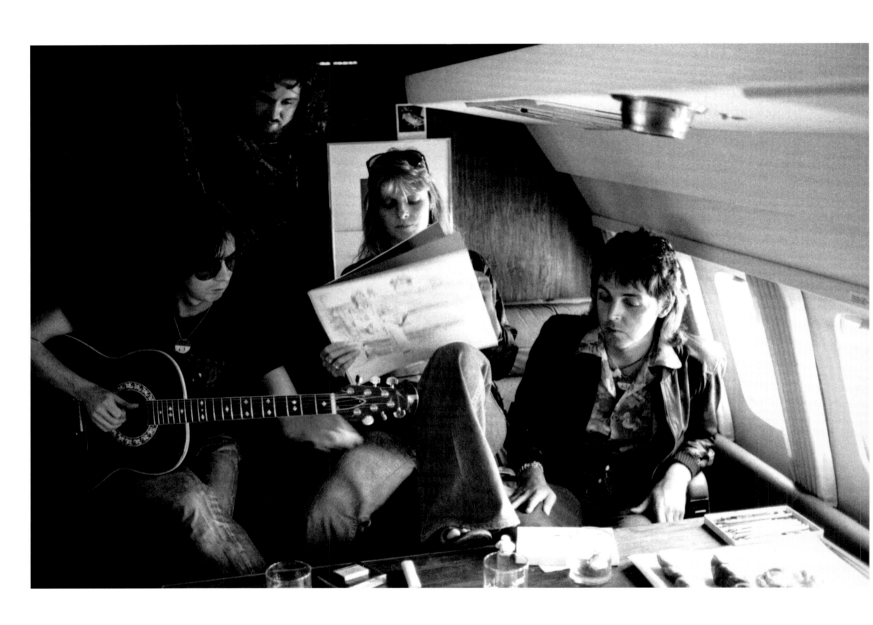

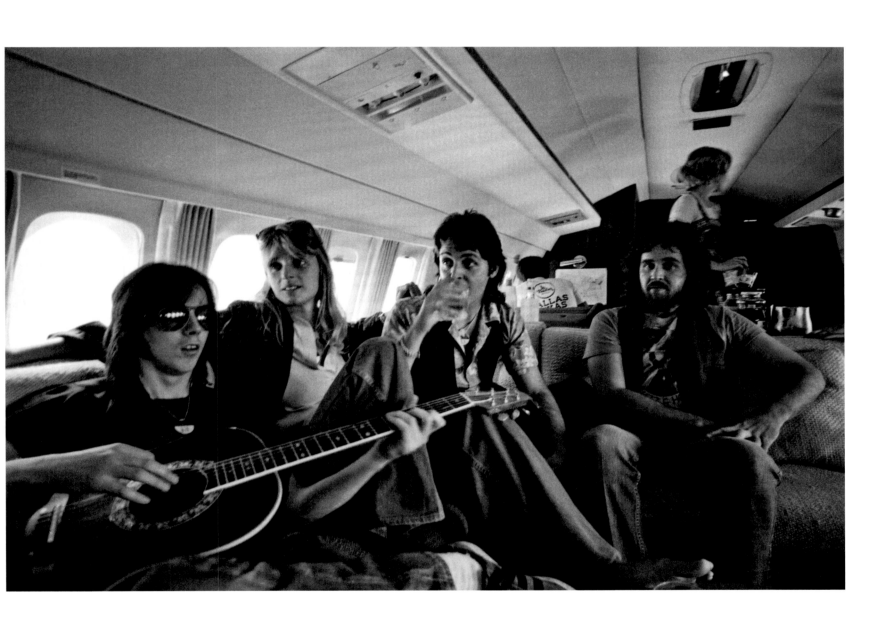

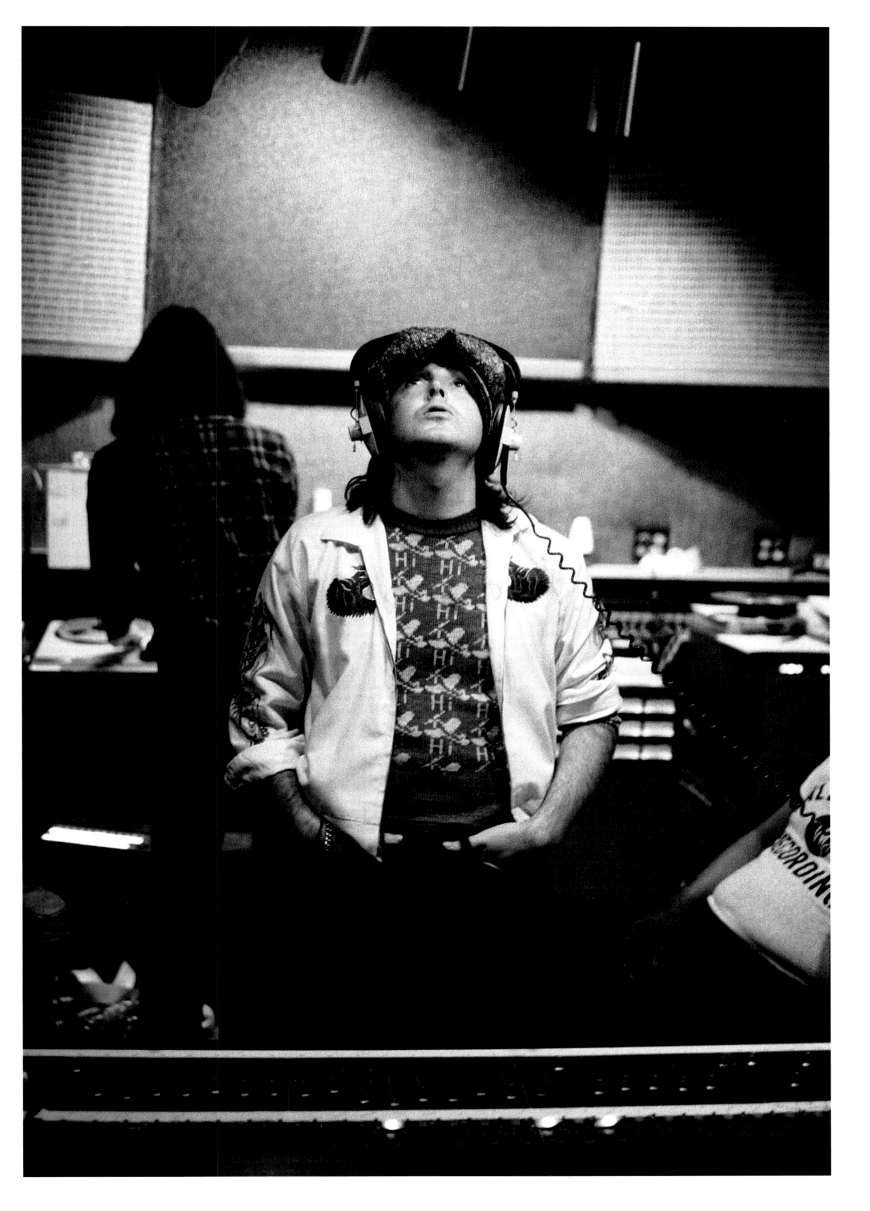

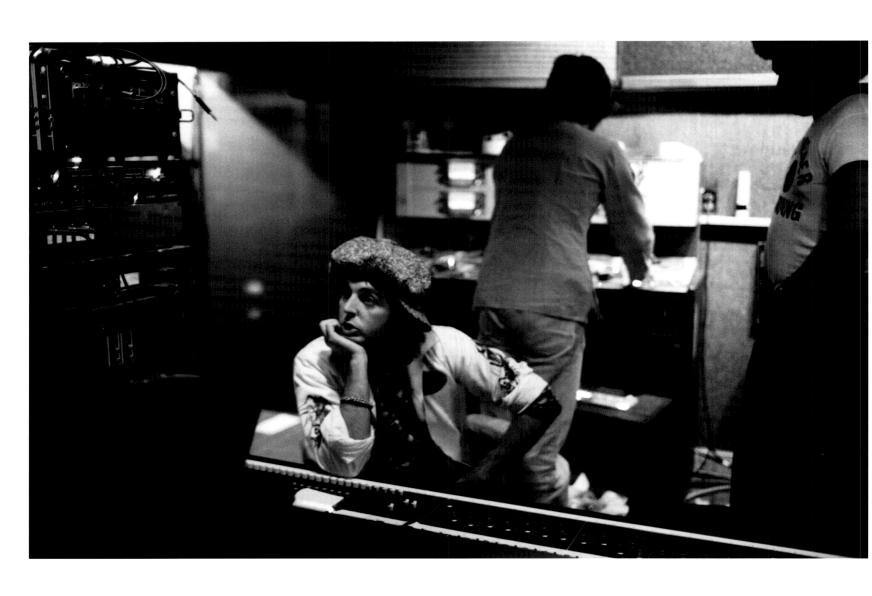

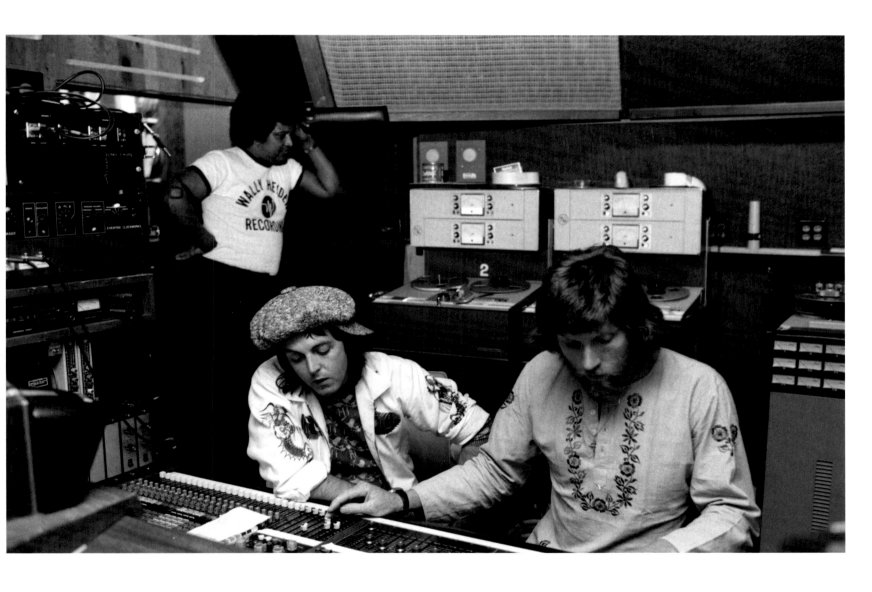

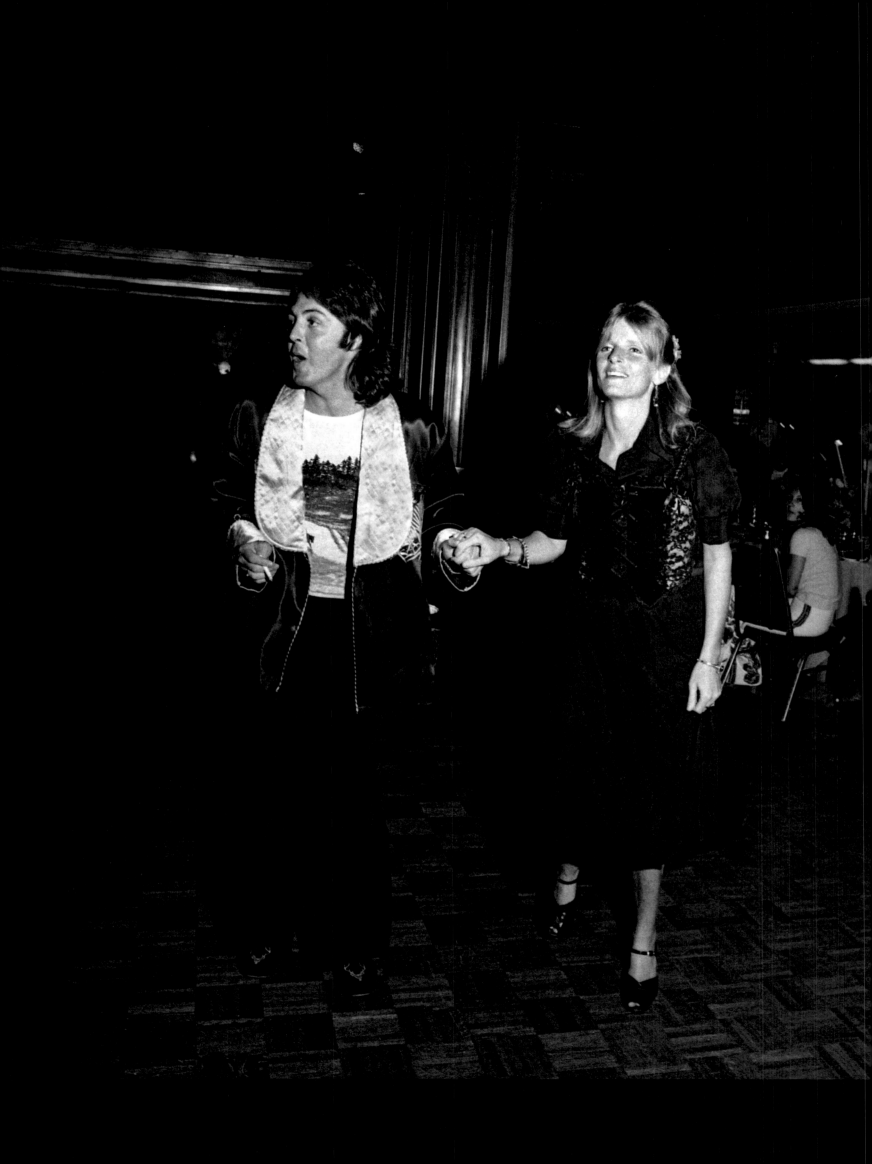

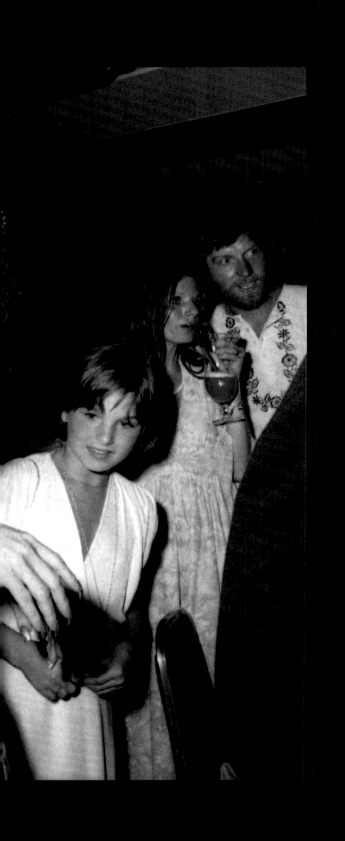

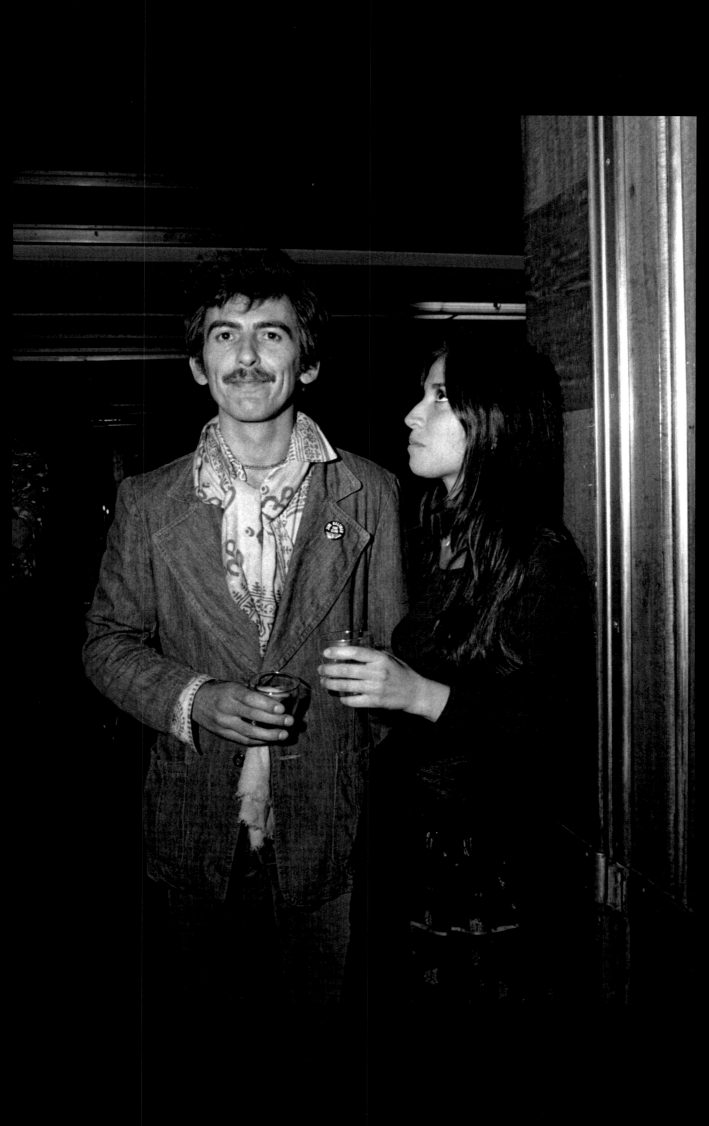

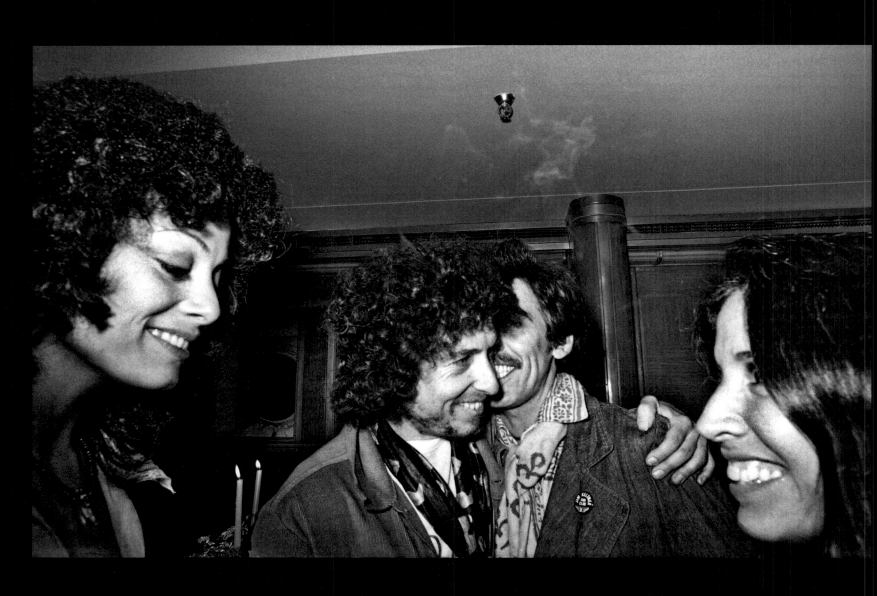

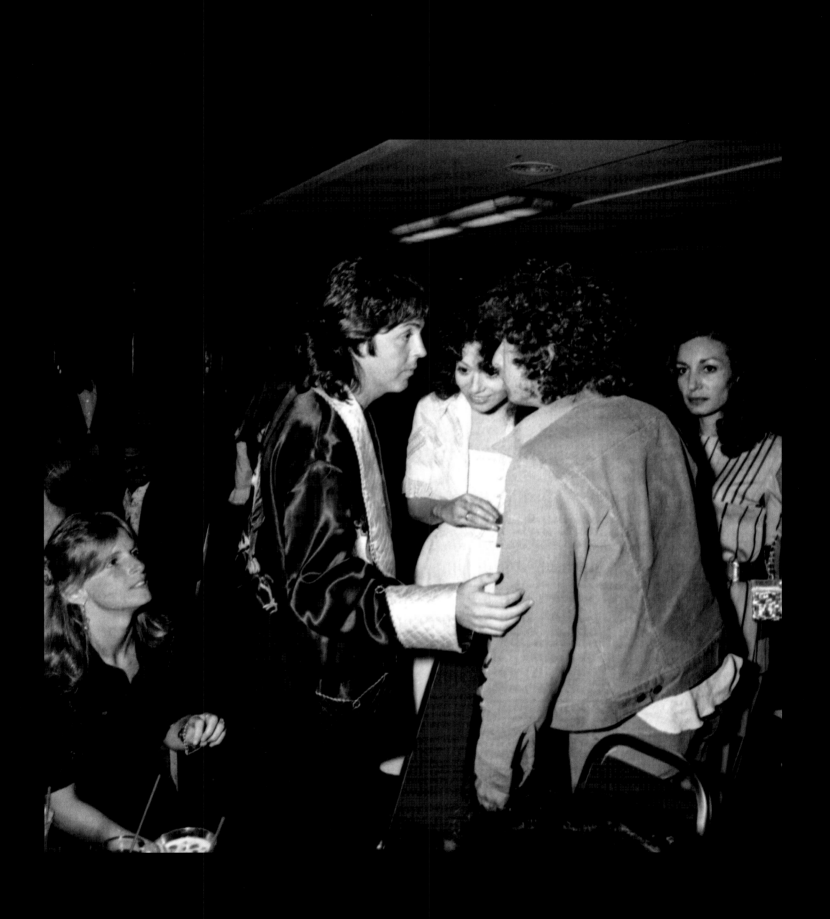

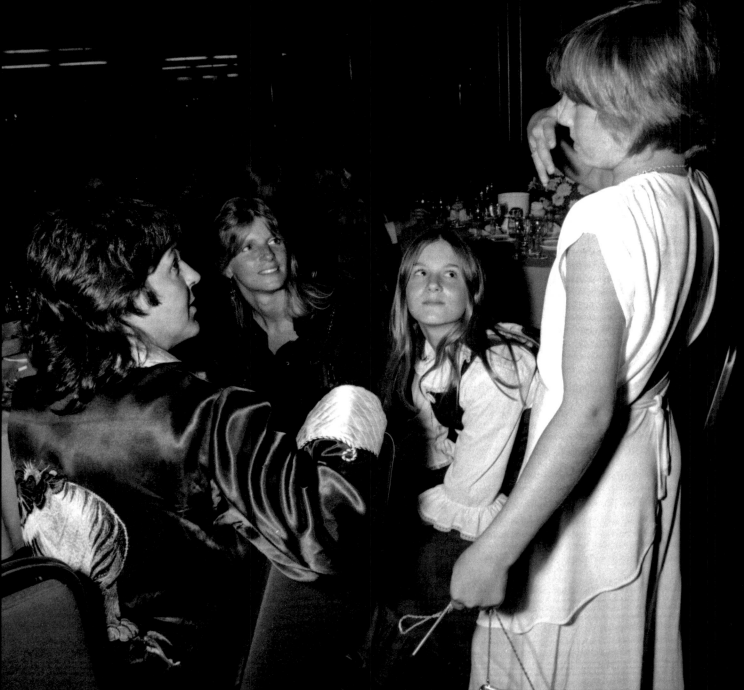

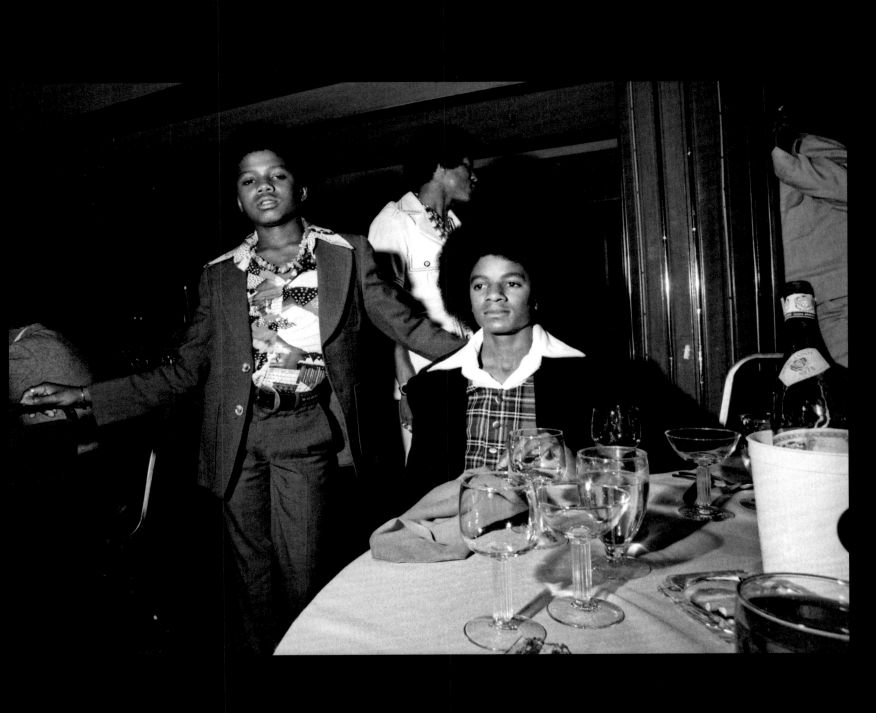

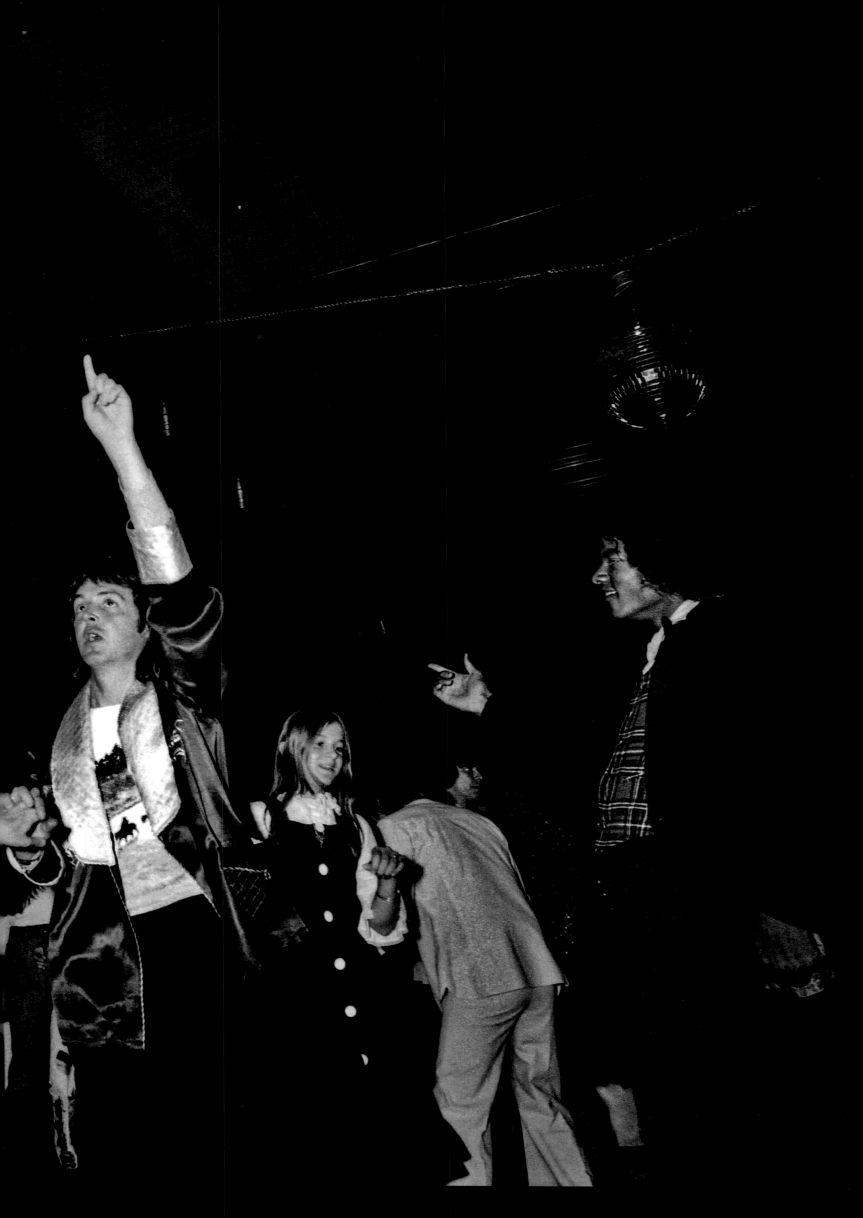

"It seems like yesterday's come round again. Paul McCartney sits alone, stage center, angling slightly forward in a straight-backed chair as he holds his six-string Ovation guitar, playing the first sinuous chords, softly easing into the familiar words…The song is a good 10 years old. The place goes up for grabs: the collective memory of a generation is galvanized into sweet lyric communion; 16,500 fans in Atlanta's Omni arena stand."

"McCartney Comes Back"
Time magazine, May 31, 1976

„ ‚Yesterday' scheint wiedererwacht zu sein. Paul McCartney sitzt allein in der Mitte der Bühne, beugt sich auf dem Stuhl mit gerader Lehne leicht nach vorn und spielt auf seiner sechssaitigen Ovation-Gitarre die ersten Akkorde an, um dann sanft mit den bekannten Worten einzusetzen … Der Song ist gut zehn Jahre alt. Das Publikum geht voll mit: Die kollektive Erinnerung einer Generation manifestiert sich in einer lyrischen Kommunion; 16500 Fans in der Omni-Sportarena von Atlanta stehen."

« "Yesterday" revient. Paul McCartney est assis sur une chaise à dossier droit, seul, au centre de la scène, légèrement penché en avant, tenant sa guitare Ovation à six cordes. Il joue les premiers accords qui se transforment peu à peu en paroles, si familières... La chanson a bien dix ans. La foule se lève, s'en empare, la mémoire de toute une génération se cristallise en une communion lyrique : 16500 fans debout dans la salle omnisports The Omni à Atlanta. »

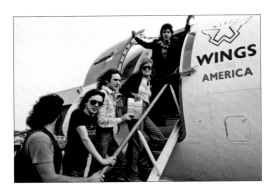

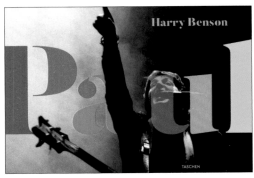

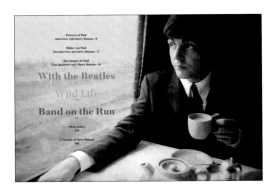

2–3
Left to right: Band members Joe English, Jimmy McCulloch, Denny Laine, along with Linda and Paul board the *Wings Over America* plane at NYC's LaGuardia Airport on their way to their next concert in Cincinnati. May 26, 1976.

Mit den Bandmitgliedern Joe English, Jimmy McCulloch und Denny Laine (von links) brechen Linda und Paul mit der *Wings Over America* vom New Yorker Flughafen LaGuardia zu ihrem Konzert in Cincinnati auf. 26. Mai 1976.

De gauche à droite : Joe English, Jimmy McCulloch, Denny Laine, Linda et Paul embarquant dans l'avion *Wings Over America* à l'aéroport LaGuardia à New York, en route pour un concert à Cincinnati. 26 mai 1976.

4–5
Paul during a performance, 1976.

Paul auf der Bühne, 1976.

Paul en concert, 1976

6–7
Having a cup of tea while filming *A Hard Day's Night* on a train at Paddington Station. London, 1964.

Bei den Dreharbeiten zu *A Hard Day's Night* genehmigt sich Paul im Zug an der Paddington Station eine Tasse Tee. London, 1964.

Pause-thé dans le train à la gare de Paddington pendant le tournage de *A Hard Day's Night*. Londres, 1964.

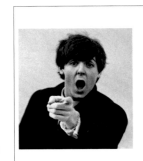

8
Preparing for the Beatles arrival for their first visit to New York on February 7, 1964, Paul has a shave.

Paul rasiert sich, bevor die Beatles am 7. Februar 1964 zum ersten Mal in New York ankommen.

Paul se rase avant l'arrivée des Beatles pour leur première venue à New York le 7 février 1964.

10
An original Beatles Pillow Fight contact sheet, George V Hotel, Paris, printed in January 1964. Taken the night "I Want to Hold Your Hand" landed on the US charts.

Genau an dem Abend, an dem die Beatles sich im Pariser Hotel George V diese Kissenschlacht lieferten, landete „I Want to Hold Your Hand" in den US-Charts. Original-Kontaktabzug aus dem Januar 1964.

Planche contact de la bataille de polochons des Beatles à l'hôtel George V à Paris, tirée en janvier 1964 et prise la nuit où « I Want to Hold your Hand » apparut au hit-parade américain.

12
An animated Paul shouts and points at Harry Benson while visiting New York City's Central Park. February 1964.

Bei einem Besuch im New Yorker Central Park zeigt ein quirliger Paul auf Harry Benson. Februar 1964.

Un Paul contrarié pointe Harry Benson du doigt en criant lors d'une visite de Central Park à New York. Février 1964.

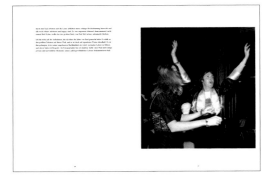

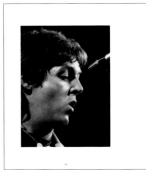

15
Four frames of relaxing backstage after a concert. Phoenix, Arizona, June 18, 1976.

Vier Bilder zeigen Paul backstage beim Entspannen nach einem Konzert. Phoenix, 18. Juni 1976.

Quatre images de détente en coulisse après un concert. Phoenix, Arizona, 18 juin 1976.

17
Paul and Linda whoop it up on the dance floor at their wrap party aboard the famed *Queen Mary* liner to celebrate the release of the *Venus and Mars* album. Long Beach, California, March 24, 1975.

Bei der Release-Party aus Anlass der Veröffentlichung von *Venus and Mars* an Bord des berühmten Luxusliners *Queen Mary* tanzen Paul und Linda ausgelassen. Long Beach, 24. März 1975.

Paul et Linda en pleine action sur la piste de danse de leur réception donnée à bord du fameux *Queen Mary* pour célébrer la sortie de l'album *Venus and Mars*. Long Beach, Californie, 24 mars 1975.

18
On stage during a *Wings Over America* concert. USA, 1976.

Auf der Bühne bei der Tour *Wings Over America*. USA, 1976.

En scène pendant la tournée *Wings Over America*. États-Unis, 1976.

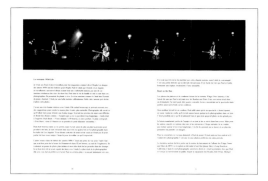

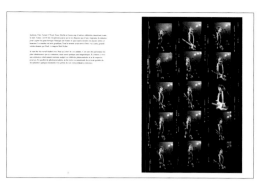

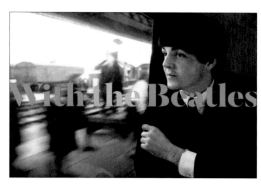

20–21

On stage during a *Wings Over America* concert. USA, 1976.

Paul bei einem Konzert auf der Tour *Wings Over America*. USA, 1976.

Paul sur scène pendant la tournée *Wings Over America*. États-Unis, 1976.

23

Contact sheet of an animated Paul on stage during a *Wings Over America* performance. USA, 1976.

Kontaktabzug von Paul in Aktion bei einem Konzert der Tour *Wings Over America*. USA, 1976.

Planche contact noir et blanc de Paul en action sur scène. Tournée *Wings Over America*. États-Unis, 1976.

24–25

During the filming of *A Hard Day's Night* on a train leaving Paddington Station. Paul sits quietly by the window. London, 1964.

Bei den Dreharbeiten zu *A Hard Day's Night*, als der Zug gerade den Bahnhof Paddington verlässt. Paul sitzt ruhig am Fenster. London, 1964.

Pendant le tournage de *A Hard Day's Night*, Paul regarde tranquillement par la fenêtre de son train quittant la gare de Paddington. Londres, 1964.

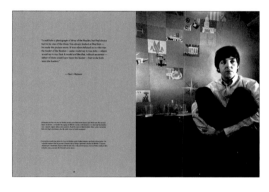

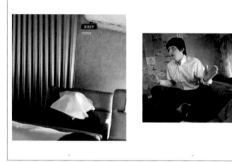

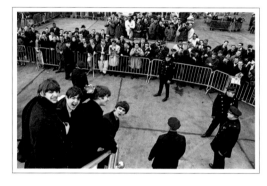

27

Onboard an American Airlines flight—on the way to Chicago for a Beatles concert. February 1964.

An Bord einer American-Airlines-Maschine auf dem Weg zu einem Beatles-Konzert in Chicago. Februar 1964.

En route pour un concert des Beatles à Chicago à bord d'un vol American Airlines. Février 1964.

28–29

Asleep on a Pan Am flight from London to New York for the Beatles' first visit to America. February 7, 1964.

On a flight to Chicago. February 1964.

Schlafend während des Pan-Am-Flugs von London nach New York zum ersten Auftritt der Beatles in den USA. 7. Februar 1964.

Auf einem Flug nach Chicago. Februar 1964.

Paul endormi à bord d'un vol Pan Am entre Londres et New York ou se déroulera le premier concert des Beatles aux États-Unis. 7 février 1964.

En route vers Chicago. Février 1964.

30–31

"I was the fifth person stepping off the plane and yelled at the group to turn around for a photograph. They complied as I took the photograph," recalls Benson. New York, JFK airport, February 7, 1964.

„Ich kam als Fünfter aus der Maschine und rief den vieren hinterher, sie sollten sich für ein Foto umdrehen. Das taten sie, und ich machte die Aufnahme", erinnert sich Benson. JFK-Flughafen, New York, 7. Februar 1964.

«J'étais le cinquième à descendre de l'avion et j'ai crié au groupe de se retourner pour une photo. Ce qu'ils firent, et cela donna cette image», se rappelle Benson. Aéroport JFK, New York, 7 février 1964.

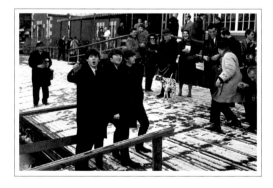

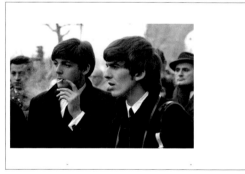

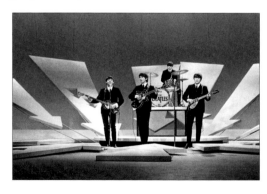

32–33

Paul, John Lennon, and Ringo Starr visit Central Park in the snow on a Saturday morning, February 8, 1964. George was back at the Plaza Hotel in bed with a sore throat.

Paul, John Lennon und Ringo Starr besuchen an einem Samstagmorgen den verschneiten Central Park. George hatte Halsweh und hütete im Plaza Hotel das Bett. 8. Februar 1964.

Paul, John Lennon et Ringo Starr visitent Central Park sous la neige le samedi matin du 8 février 1964. George, qui avait mal à la gorge, était retourné se coucher au Plaza Hotel.

34–35

Paul and George Harrison sightseeing before the Beatles performance that evening at the Olympia concert venue in the 9th arrondissement. Paris, January 1964.

Paul und George Harrison beim Sightseeing am Tag des Beatles-Konzerts im Olympia, der Konzerthalle im 9. Arrondissement von Paris. Januar 1964.

Paul et George en touristes avant un concert des Beatles le même soir à l'Olympia dans le IXᵉ arrondissement de Paris. Janvier 1964.

36–37

About 73 million fans saw the Beatles on television during their first appearance on *The Ed Sullivan Show*. The crowd in the studio had gone wild by the time they sang their last song, "I Want to Hold Your Hand." February 9, 1964.

An die 73 Millionen Fans sahen die Beatles im Fernsehen bei ihrem ersten Auftritt in der *Ed Sullivan Show*. Als sie zum Abschluss „I Want to Hold Your Hand" sangen, war das Studiopublikum längst in Ekstase. 9. Februar 1964.

Près de 73 millions de fans virent les Beatles lors de leur première apparition dans l'*Ed Sullivan Show*. Le public du studio tomba en extase quand ils interprétèrent en dernier «I Want to Hold your Hand». 9 février 1964.

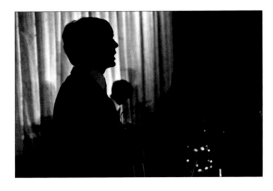
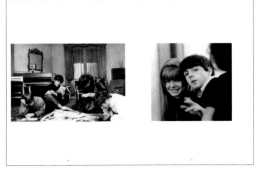
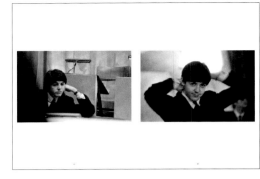

38–39

Jamming with Ringo on drums in the background.
Paris, 1964.

Jamsession. Im Hintergrund Ringo am Schlagzeug.
Paris, 1964.

Bœuf avec Ringo à la batterie en arrière-plan.
Paris, 1964.

40–41

Beatlemania had begun; reading their fan mail at the
George V Hotel. Paris, January 1964. – A private
moment with then girlfriend Jane Asher. London, 1964.

Beginn der Beatlemania: beim Fanpostlesen. Hotel
George V, Paris, Januar 1964. – Intimer Moment mit
damaliger Freundin Jane Asher. London, 1964.

La Beatlemania est lancée : lecture des lettres de leurs fans
à l'hôtel George V. Paris, janvier 1964. – Moment intime
avec son amie du moment, Jane Asher. Londres, 1964.

42–43

Paul resting on his elbow. Paris, 1964.
Paris, 1964.

Paul mit aufgestütztem Ellbogen. Paris, 1964.
Paris, 1964.

Paul au repos. Paris, 1964.
Paris, 1964.

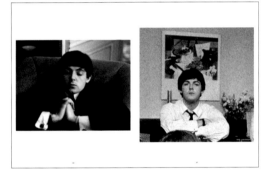
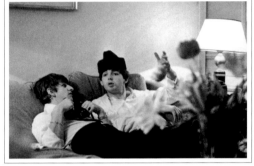
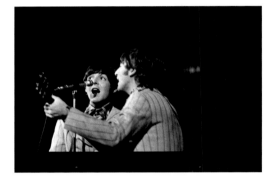

44–45

Sleeping while waiting for the other Beatles to join him.
Paris, 1964.

Hotel room in Copenhagen during a Beatles appearance
in the city. 1964.

Ein Nickerchen, bis die anderen Beatles dazukommen.
Paris, 1964.

In einem Hotelzimmer in Kopenhagen, einer Konzert-
station der Beatles. 1964.

Quelques minutes de sommeil en attendant les autres
Beatles. Paris, 1964.

Chambre d'hôtel à Copenhague, avant un concert. 1964.

46–47

Ringo with his camera and Paul wearing a cap relax
in their hotel suite after a Beatles performance at the
Olympia concert venue. Paris, January 1964.

Ringo mit seiner Kamera und Paul mit Kappe relaxen
nach einem Beatles-Konzert im Pariser Olympia in ihrer
Hotelsuite. Januar 1964.

Ringo et son appareil photo, Paul en bonnet, se
détendent dans leur hôtel après un concert des Beatles à
l'Olympia. Paris, janvier 1964.

48–49

Paul and John harmonize on stage during a concert
in Chicago during the Beatles first tour of America.
February 1964.

Paul und John singen gemeinsam bei einem Konzert
in Chicago, einer Station der ersten Amerikatour der
Beatles. Februar 1964.

Paul et John à l'unisson sur scène pendant un concert
à Chicago lors de la première tournée des Beatles en
Amérique. Février 1964.

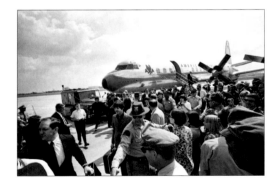
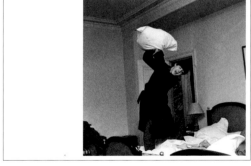
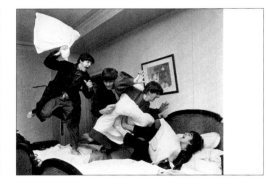

50–51

Paul, John, George, and Ringo leave an American
Airlines plane on their first American tour. 1964.

Ein American-Airlines-Flieger bringt Paul, John, George
und Ringo zu einer weiteren Station ihrer ersten US-
Tournee. 1964.

Paul, George, John et Ringo quittant un avion
d'American Airlines lors de leur première tournée
américaine. 1964.

52–53

Paul during a pillow fight at the George V Hotel in Paris
after a concert at the Olympia. "I Want to Hold Your
Hand" had just hit the American charts. January 18, 1964.

Kissenschlacht im Hotelzimmer nach einem Konzert
im Pariser Olympia. „I Want to Hold Your Hand" war
soeben in den US-Charts gelandet. 18. Januar 1964.

Paul lors d'une bataille de polochons à l'hôtel George V
à Paris après un concert à l'Olympia. « I Want to Hold
your Hand » venait de faire irruption dans les charts
américains. 18 janvier 1964.

54–55

Paul, John, and Ringo gang up on George in their suite at
the George V Hotel during their celebratory pillow fight.
January 18, 1964.

Paul, John und Ringo feiern den Abend mit einer
Kissenschlacht und gehen gemeinsam auf George los.
Hotel George V, Paris, 18. Januar 1964.

Paul, John et Ringo attaquent George lors de leur bataille
de polochons festive dans leur suite du George V.
18 janvier 1964.

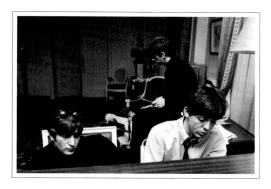

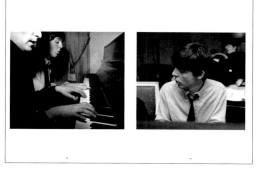

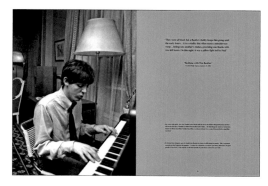

56–57

John and Paul deep in thought as they compose at the piano in their suite at the George V Hotel with George and Ringo in the background. Paris, January 1964.

John und Paul konzentriert am Klavier ihrer Hotelsuite, im Hintergrund George und Ringo. Hotel George V, Paris, Januar 1964.

John et Paul plongés dans leurs pensées composent sur le piano de leur suite du George V. George et Ringo sont en arrière-plan. Paris, janvier 1964.

58–59

John and Paul were oblivious to their surroundings as they compose a song. In a serious mood, Paul sits quietly at the piano in his suite. George V Hotel, Paris, January 1964.

John und Paul vergaßen alles um sich herum, als sie ein Lied komponierten. Paul in stillem Ernst am Klavier der Hotelsuite. Hotel George V, Paris, Januar 1964.

John et Paul, oubliant ce qui les entoure, composent une chanson. Un Paul sérieux, assis au piano de sa suite de l'hôtel George V. Paris, janvier 1964.

60

At the piano. George V Hotel, Paris, January 1964.

Am Klavier. Hotel George V, Paris, Januar 1964.

Paul au Piano. Hôtel George V, Paris, janvier 1964.

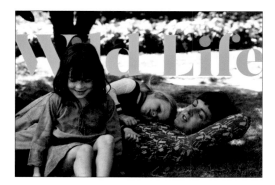

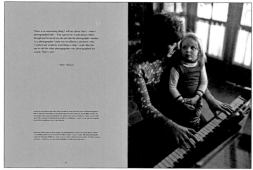

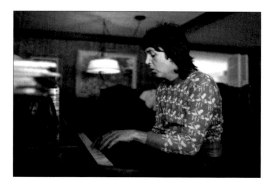

62–63

Playing on the lawn with his children Stella, 3, and Mary, 5, during a stay in Los Angeles. March 1975.

Beim Spielen im Garten mit Töchtern Stella (3) und Mary (5). Los Angeles, März 1975.

Paul au jardin avec ses filles Stella, 3 ans et Mary, 5 ans, à Los Angeles. Mars 1975.

65

Stella, 3, looks up lovingly at her father as Paul plays and sings for her during their stay in Los Angeles. March 1975.

Liebevoll blickt Stella (3) zu Papa Paul auf, der am Klavier für sie spielt und singt. Los Angeles, März 1975.

Stella, 3 ans, regarde avec amour son père jouant du piano et chantant pour elle. Los Angeles, mars 1975.

66–67

At the piano before Stella joins him during their stay in Los Angeles. March 1975.

Am Klavier, bevor Stella sich dazugesellt. Los Angeles, März 1975.

Paul au piano, avant que Stella ne le rejoigne. Los Angeles, mars 1975.

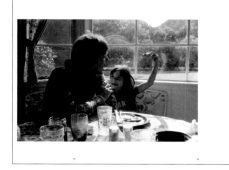

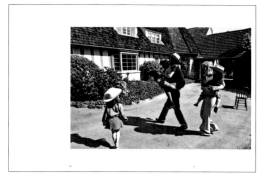

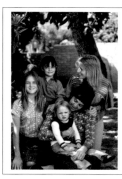

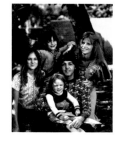

68–69

The impish Mary laughs as she tries to feed her father some toast at breakfast during their stay in Los Angeles. March 1975.

Schelmisch lachend versucht Mary beim Frühstück, ihren Vater mit Toast zu füttern. Los Angeles, März 1975.

L'espiègle Mary essaye de faire manger un toast à son père au petit-déjeuner. Los Angeles, mars 1975.

70–71

Mary, 5, watches while her mother Linda carries sister Stella, 3, and her father Paul carries half sister Heather, 12, and a young friend, all having fun during their stay in Los Angeles. March 1975.

Die fünfjährige Mary verfolgt, wie Mutter Linda ihre Schwester Stella (3) und Vater Paul ihre Halbschwester Heather (12) samt Freundin zum Haus tragen. Alle haben viel Spaß in Los Angeles. März 1975.

Mary, 5 ans, regarde sa mère Linda porter sa sœur Stella, 3 ans, tandis que son père s'est chargé de sa demi-sœur, Heather, 12 ans, et d'un autre enfant. Los Angeles, mars 1975.

72–73

Clockwise from left: Heather, 12, Mary, 5, Linda, Paul, and Stella, 3, at their home in Los Angeles. March 1975.

Von links, im Uhrzeigersinn: Heather (12), Mary (5), Linda, Paul und Stella (3), vor dem Haus in Los Angeles. März 1975.

Dans le sens des aiguilles d'une montre : Heather, 12 ans, Mary, 5 ans, Linda, Paul et Stella, 3 ans, dans leur maison à Los Angeles. Mars 1975.

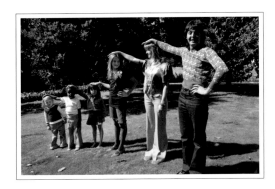
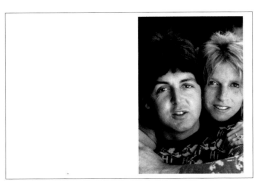
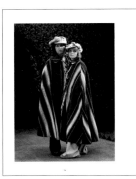

74–75

The family playfully posed during their stay in Los Angeles according to their height—Stella, 3, her friend, Mary, 5, Heather, 12, Linda, and Paul.

Zum Spaß der Größe nach aufgereiht posiert die Familie im Garten des Domizils in Los Angeles. Von links: Stella (3) und ihre Freundin Mary (5), Heather (12), Linda und Paul.

La famille posant selon la taille de ses membres : Stella, une amie, Mary, Heather, Linda et Paul.

77

Los Angeles, California, 1975.

Los Angeles, Kalifornien, 1975.

Los Angeles, Californie, 1975.

78–79

Paul and Linda in matching multicolored ponchos and caps. Los Angeles, March 1975.

Paul und Linda im farbenfrohen Poncho-und-Mützen-Partnerlook. Los Angeles, März 1975.

Paul et Linda en ponchos et casquettes multicolores assortis. Los Angeles, mars 1975.

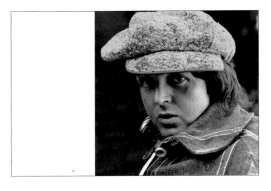
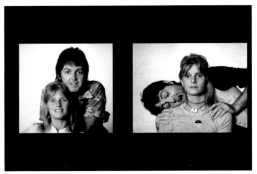
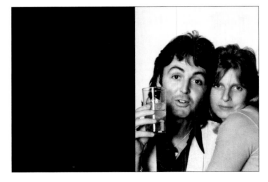

80–81

Wearing a trendy version of a golfer's cap. Los Angeles, March 1975.

Eine modische Version der Golfmütze. Los Angeles, März 1975.

Paul portant une casquette à la mode de type golfeur. Los Angeles, mars 1975.

82–83

Two playful portraits of Linda and Paul taken in their suite at the Stanhope Hotel during a stay in New York City. May 1976.

Zwei ungezwungene Porträts von Linda und Paul, aufgenommen in ihrer Suite im Stanhope Hotel während eines New-York-Aufenthalts im Mai 1976.

Deux portraits pour rire de Linda et Paul dans leur suite du Stanhope Hotel à New York. Mai 1976.

85

Stanhope Hotel, New York. May 1976.

Stanhope Hotel, New York im Mai 1976.

Stanhope Hotel à New York. Mai 1976.

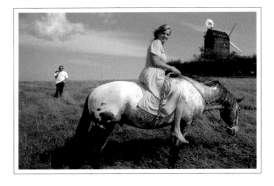
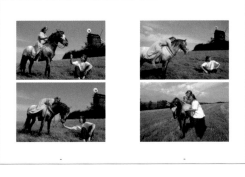
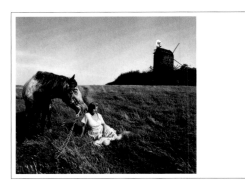

86–87

Paul approaches Linda who is sitting atop her favorite Appaloosa stallion, Blankit, at their farm in Peasmarsh, East Sussex. England, 1992.

Auf der Farm in Peasmarsh nähert sich Paul aus dem Hintergrund Linda, die auf ihrem Lieblingspferd Blankit posiert. East Sussex, 1992.

Paul s'approche de Linda chevauchant son cheval Appaloosa favori, Blankit. Ferme de Peasmarsh, East Sussex, Angleterre. 1992.

88–89

Peasmarsh, East Sussex, England. 1992.

Peasmarsh, East Sussex, England. 1992.

Peasmarsh, East Sussex, Angleterre. 1992.

90–91

Linda in repose sitting on the grass with her Appaloosa, Blankit. East Sussex, England, 1992.

Linda rastet im Gras, an ihrer Seite der Appaloosa-Hengst Blankit. East Sussex, England, 1992.

Linda, assise dans l'herbe, se repose auprès de son cheval Blankit. East Sussex, Angleterre, 1992.

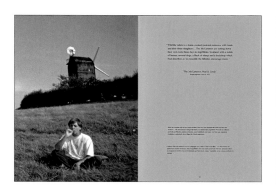

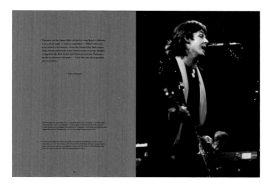

92

Relaxing at their lovely farm. East Sussex, England, 1992.

Erholung auf der idyllischen Farm. East Sussex, England, 1992.

Moment de détente à leur ferme bucolique. East Sussex, Angleterre, 1992.

94–95

On stage with guitarist Denny Laine in the background during a *Wings Over America* concert, USA, 1976.

Auf der Bühne mit Gitarrist Denny Laine bei einem Konzert der Tour *Wings Over America*. USA, 1976.

Sur scène avec le guitariste Denny Laine en arrière-plan. Concert *Wings Over America*, États-Unis, 1976.

97

On stage with Linda singing back up, USA, 1976.

Bei einem Konzert mit Linda als Backgroundbegleitung. USA, 1976.

En scène avec Linda en choriste, États-Unis, 1976.

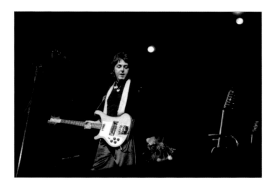

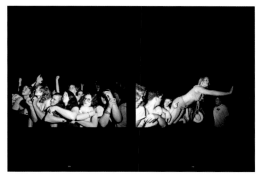

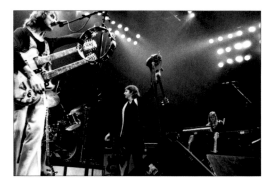

98–99

Paul with a bouquet of flowers from a fan in the front row. The American tour coincided with the release of the successful record *Wings at the Speed of Sound*. USA, 1976.

Paul mit dem Blumenstrauß einer Verehrerin aus der vordersten Reihe. Die Amerikatour fiel zeitlich mit der Veröffentlichung des erfolgreichen Albums *Wings at the Speed of Sound* zusammen. USA, 1976.

Paul avec un bouquet jeté par un fan du premier rang. La tournée américaine coïncidait avec la sortie du disque *Wings at the Speed of Sound*. États-Unis, 1976.

100–101

Exuberant fans. Paul hadn't played live in America since the Beatles' final concert in 1966. USA, 1976.

Begeisterte Fans. Seit dem letzten Konzert der Beatles im Jahr 1966 war Paul nicht mehr live in Amerika aufgetreten. USA, 1976.

Fans en folie. Paul n'avait pas joué aux États-Unis depuis le dernier concert des Beatles en 1966. États-Unis, 1976.

102–103

Saluting with his guitar in the air, Linda on keyboards and Denny Laine on guitar. USA, 1976.

Salut mit hochgereckter Gitarre, flankiert von Linda am Keyboard und Denny Laine an der Gitarre. USA, 1976.

Paul salue en brandissant sa guitare, Linda est au clavier, Denny Laine à la guitare. États-Unis, 1976.

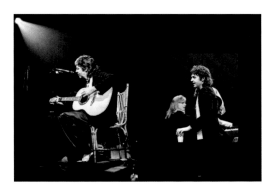

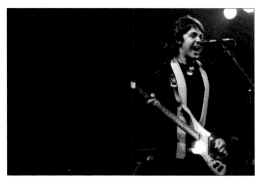

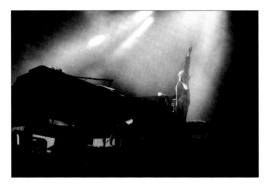

104–105

Sitting quietly playing the guitar and singing on stage. USA, 1976.

Paul and Linda. USA, 1976.

Paul sitzt allein auf der Bühne, spielt Gitarre und singt. USA, 1976.

Paul und Linda. USA 1976.

Paul, assis, joue tranquillement de sa guitare en chantant. États-Unis, 1976.

Paul et Linda. États-Unis, 1976.

107

A gleeful Paul on stage. USA, 1976.

Paul in Hochform. USA, 1976.

Paul, heureux sur scène. États-Unis, 1976.

108–109

Standing at the piano, arm raised. USA, 1976.

Paul stehend am Flügel, den Arm in die Höhe gereckt. USA, 1976.

Debout devant le piano, bras levé. États-Unis, 1976.

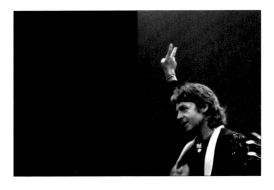

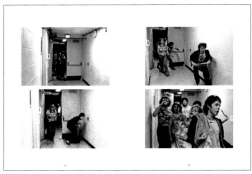

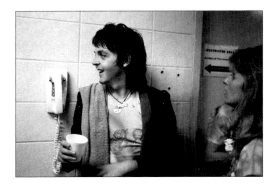

111

Paul signals V for Venus in reference to their record *Venus and Mars* and "victory" at the end of a concert during their American tour. 1976.

Am Ende eines Konzerts der Amerika-Tour zeigt Paul ein V, das sowohl für Victory als auch für Venus stehen soll, in Anspielung auf das Wings-Album *Venus and Mars*. 1976.

Paul fait le V de Venus en référence à l'album *Venus and Mars* et à la victoire en fin du concert de sa tournée américaine. 1976.

112 – 113

Paul and Linda and members of the band run off stage in Philadelphia after a performance. May 12, 1976.

Paul, Linda und Mitglieder der Band stürmen nach einem Konzert in Philadelphia von der Bühne. 12. Mai 1976.

Paul, Linda et des membres du groupe déboulent de la scène après un concert à Philadelphie. 12 mai 1976.

114 – 115

Backstage after a concert. Wings played 31 concerts in the USA and Canada between May 3 and June 23, 1976. USA, 1976.

Backstage nach einem Auftritt. Vom 3. Mai bis zum 23. Juni 1976 gaben die Wings in den USA und Kanada 31 Konzerte. USA, 1976.

En coulisse après un concert. Wings donna 31 concerts aux États-Unis et au Canada entre le 3 mai et le 23 juin 1976. États-Unis, 1976.

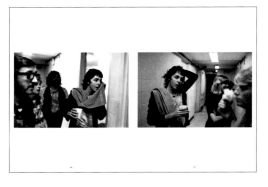

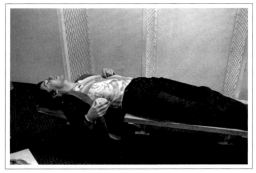

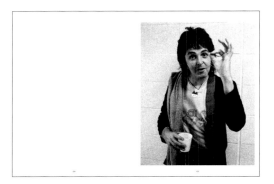

116 – 117

Backstage wiping the perspiration from his brow after a hard workout and terrific performance during their American tour, 1976.

Ein ausgepowerter Paul trocknet sich nach einem mitreißenden Konzert backstage den Schweiß ab. USA, 1976.

Paul s'essuie le visage après une dure répétition et une superbe performance pendant la tournée américaine. 1976.

118 – 119

A candid moment lying down backstage for just an instant after a strenuous performance. Tucson, Arizona, June 18, 1976.

Ungestellt: Kurzes Ausruhen hinter der Bühne nach einem kraftraubenden Auftritt. Tucson, Arizona, 18. Juni 1976.

Moment d'abandon en coulisse après un concert épuisant. Tucson, Arizona, 18 juin 1976.

121

Tucson, Arizona, June 18, 1976.

Tucson, Arizona, 18. Juni 1976.

Tucson, Arizona, 18 juin 1976.

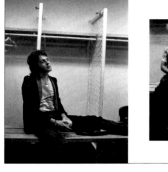

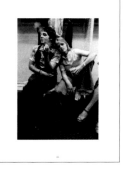

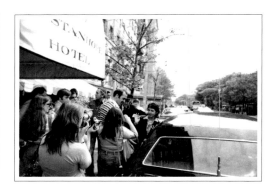

122 – 123

Quiet moments backstage. 1976.

Ruhige Momente hinter der Bühne. 1976.

Moments d'accalmie en coulisse. 1976.

124 – 125

Backstage after a performance at the Tucson Community Center Arena with superstar visitors. Left to right: Don Henley and Don Felder of the Eagles; Jane Asher's brother, Peter; and singer Linda Ronstadt. June 18, 1976.

Hochkarätiger Besuch backstage nach einem Auftritt in der Arena des Tucson Community Centers (von links): Don Henley und Don Felder von den Eagles, Jane Ashers Bruder Peter und die Sängerin Linda Ronstadt. 18. Juni 1976.

En coulisse après le concert à la Tucson Community Centre Arena. Visiteurs célèbres de gauche à droite : Don Henley et Don Felder des Eagles ; le frère de Jane Asher, Peter, et la chanteuse Linda Ronstadt. 18 juin 1976.

126 – 127

Greeting fans outside the Stanhope Hotel in New York City where they stayed during their New York performances. May 1976.

Kontakt zu Fans vor dem Stanhope Hotel, wo Paul und Linda während ihres New-York-Gastspiels wohnten. Mai 1976.

Accueil de fans devant le Stanhope Hotel à New York où ils séjournèrent pendant leur séjour new-yorkais. Mai 1976.

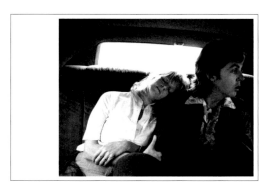

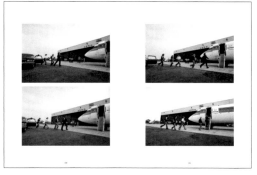

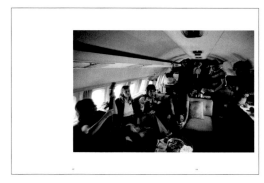

128–129

Linda rests her head on Paul's shoulder on the way to New York's LaGuardia Airport. May 26, 1976.

Auf dem Weg zum Flughafen LaGuardia ruht sich Linda an Pauls Schulter aus. New York, 26. Mai 1976.

En route pour l'aéroport LaGuardia à New York, Linda repose sa tête sur l'épaule de Paul. 26 mai 1976.

130–131

Leaving New York's LaGuardia Airport on their way to the next gig in Cincinnati, Ohio. May 26, 1976.

Abflug vom New Yorker Flughafen LaGuardia zum nächsten Auftritt in Cincinnati, Ohio. 26. Mai 1976.

Quittant New York à l'aéroport LaGuardia à New York, en route pour un concert à Cincinnati, Ohio. 26 mai 1976.

132–133

Jamming on the Wings plane. Seated, left to right: Jimmy McCulloch playing a guitar, Linda, Paul, and Joe English. May 26, 1976.

Session im Wings-Flieger. Sitzend, von links: Jimmy McCulloch an der Gitarre, Linda, Paul und Joe English. 26. Mai 1976.

Bœuf dans l'avion. Assis de gauche à droite : Jimmy McCulloch à la guitare, Linda, Paul et Joe English. 26 mai 1976.

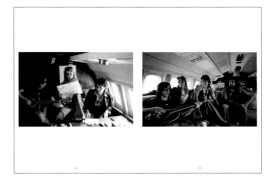

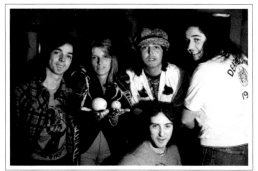

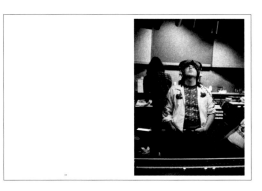

134–135

Downtime moments aboard the *Wings Over America* plane, May 26, 1976.

Auszeit an Bord der *Wings Over America*. 26. Mai 1976.

Des moments de temps mort dans l'avion de *Wings Over America*. 26 mai 1976.

136–137

On the Wings plane during the American leg of the *Wings Over the World* tour. May 26, 1976.

Im Wings-Flieger auf der Tour *Wings Over the World* in den USA. 26. Mai 1976.

Dans l'avion des Wings pendant leur tournée *Wings Over the World*. 26 mai 1976.

139

At a recording studio, Los Angeles, March 1975.

Im Aufnahmestudio. Los Angeles, März 1975.

Dans un studio d'enregistrement à Los Angeles. Mars 1975.

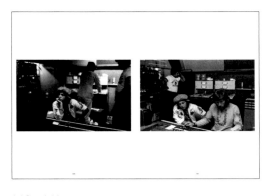

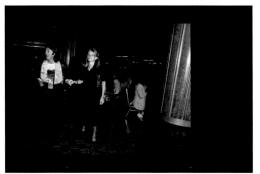

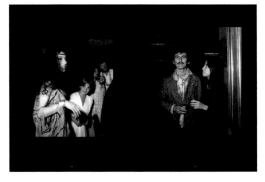

140–141

Los Angeles, March 1975.
Los Angeles, März 1975.
Los Angeles, Mars 1975.

142–143

At the glittering, star-studded Wings wrap party for their latest album, *Venus and Mars*, Linda and Paul step onto the dance floor aboard the luxury liner, the *Queen Mary*, dry-docked in Long Beach, California. March 24, 1975.

Auf der rauschenden, prominent besetzten Party für das neue Wings-Album *Venus and Mars* betreten Linda und Paul die Tanzfläche an Bord des Luxusliners *Queen Mary* im Trockendock in Long Beach. 24. März 1975.

À la brillante soirée donnée pour le lancement de leur dernier album *Venus and Mars* à bord du *Queen Mary*, amarré à Long Beach en Californie, Linda et Paul arrivent sur la piste de danse. 24 mars 1975.

144–145

Superstar Cher enters the party. George and Olivia Harrison; the first time Paul and George had been seen in public together since the Beatles break-up.

Superstar Cher erscheint auf der Party. Auch George und Olivia Harrison und, das erste Mal seit Auflösung der Beatles, auch Paul und George zeigen sich wieder gemeinsam in der Öffentlichkeit.

Arrivée à la réception de la superstar Cher. George et Olivia Harrison posent pour une photo. C'était la première fois que Paul et George étaient vus ensemble en public depuis la rupture des Beatles.

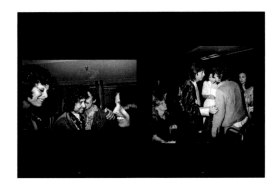

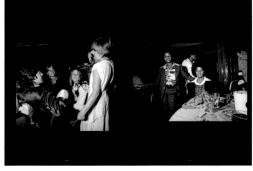

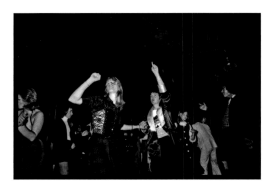

146–147

Sara and Bob Dylan greet George and Olivia Harrison.

Sara und Bob Dylan begrüßen George und Olivia Harrison.

Sara et Bob Dylan saluent George et Olivia Harrison.

148–149

Actress Tatum O'Neal attended with her father, actor Ryan O'Neal. Michael Jackson joined the party with two of his brothers from the Jackson 5.

Die zwölfjährige Tatum O'Neal kam mit ihrem Vater, dem Schauspieler Ryan O'Neal, zur Party. Michael Jackson kam mit zwei seiner Brüder von den Jackson 5.

Tatum O'Neal arrive avec son père, l'acteur Ryan O'Neal. Michael Jackson vint avec deux de ses frères des Jackson 5.

150–151

Rocking the dance floor while daughter Heather dances with Michael Jackson in the background.

Linda und Paul tanzen; im Hintergrund Tochter Heather mit Michael Jackson.

En piste avec leur fille Heather. Michael Jackson en arrière-plan.

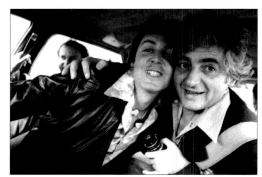

152

Sneaking out of their party and past the security guards aboard the *Queen Mary*. March 24, 1975.

Paul und Linda schleichen sich an den Sicherheitsleuten vorbei von der eigenen Party an Bord der *Queen Mary*. 24. März 1975.

Paul et Linda fuient du *Queen Mary* à l'anglaise. 24 mars 1975.

163

Los Angeles, March 1975.

Los Angeles, März 1975.

Los Angeles, Mars 1975.

164–165

Linda took Harry's camera to photograph him and Paul in their limo on the way to the *Wings Over America* plane. Los Angeles, 1976.

Auf der Fahrt zu ihrer Privatmaschine *Wings Over America* schnappte Linda sich Harrys Kamera, um ihn und Paul in der Limousine zu fotografieren. Los Angeles, 1976.

Sur la route les menant vers leur avion *Wings Over America*, Linda avait pris l'appareil d'Harry pour le photographier avec Paul dans leur limousine. Los Angeles, 1976.

166

Harry sitting between Paul and Ringo. The photo was taken by John Lennon with Benson's camera. Paris, January 1964.

Harry sitzt zwischen Paul und Ringo. Aufgenommen hat das Foto John Lennon mit Bensons Kamera. Paris, Januar 1964.

Harry assis entre Paul et Ringo. La photo a été prise par John Lennon avec l'appareil d'Harry Benson. Paris, janvier 1964.

168

Paul and Harry in Los Angeles. March 1975.

Paul und Harry in Los Angeles. März 1975.

Paul et Harry à Los Angeles. Mars 1975.

170

At Paul's Peasmarsh farm. East Sussex, England, 1992.

Auf Pauls Farm in Peasmarsh, East Sussex, England, 1992.

À la ferme de Peasmarsh, East Sussex, Angleterre, 1992.

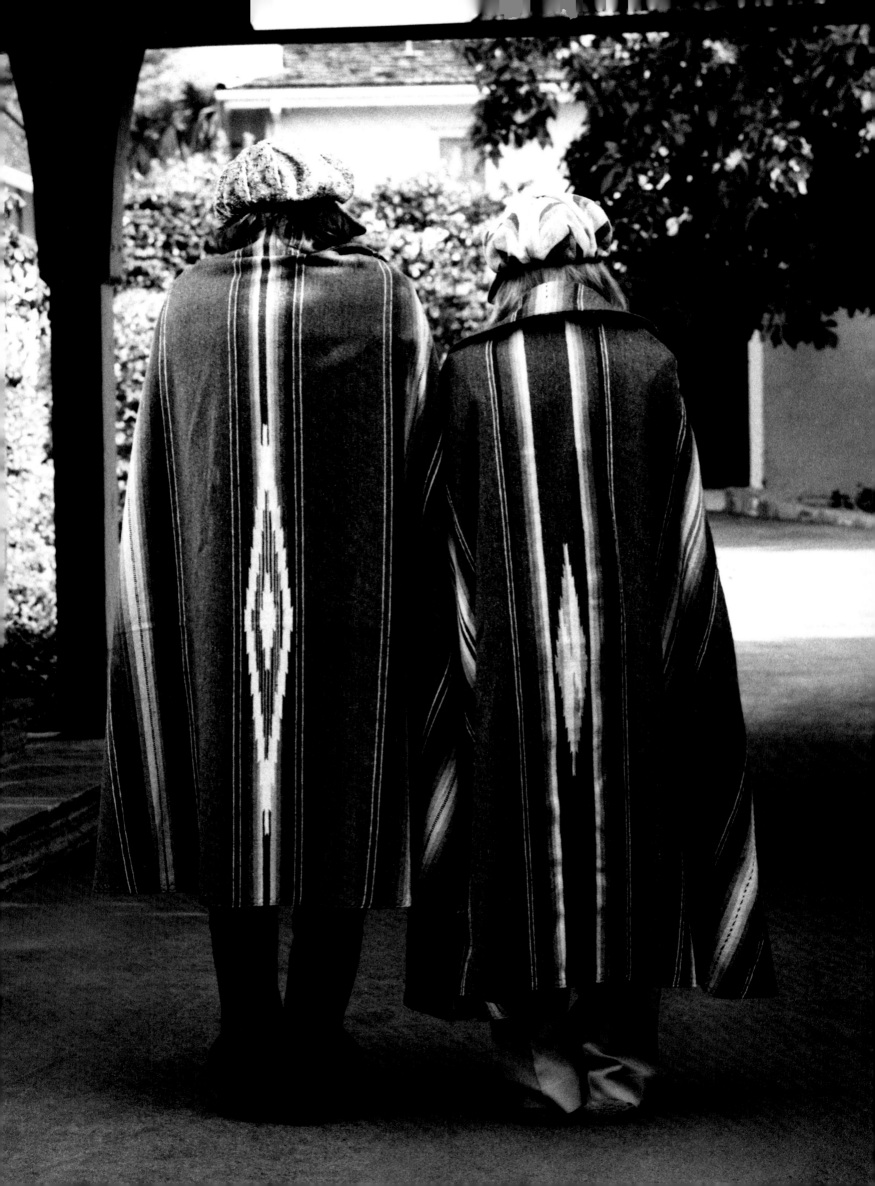

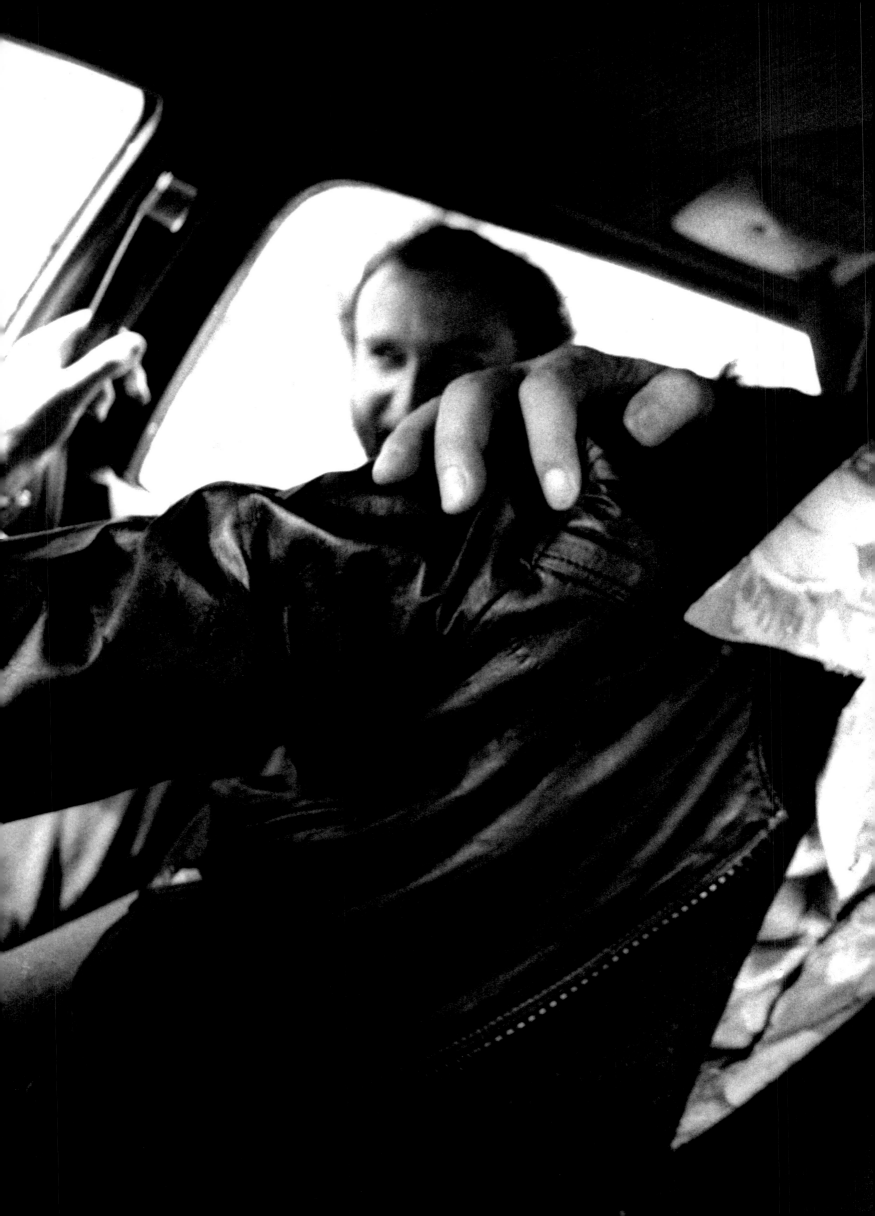

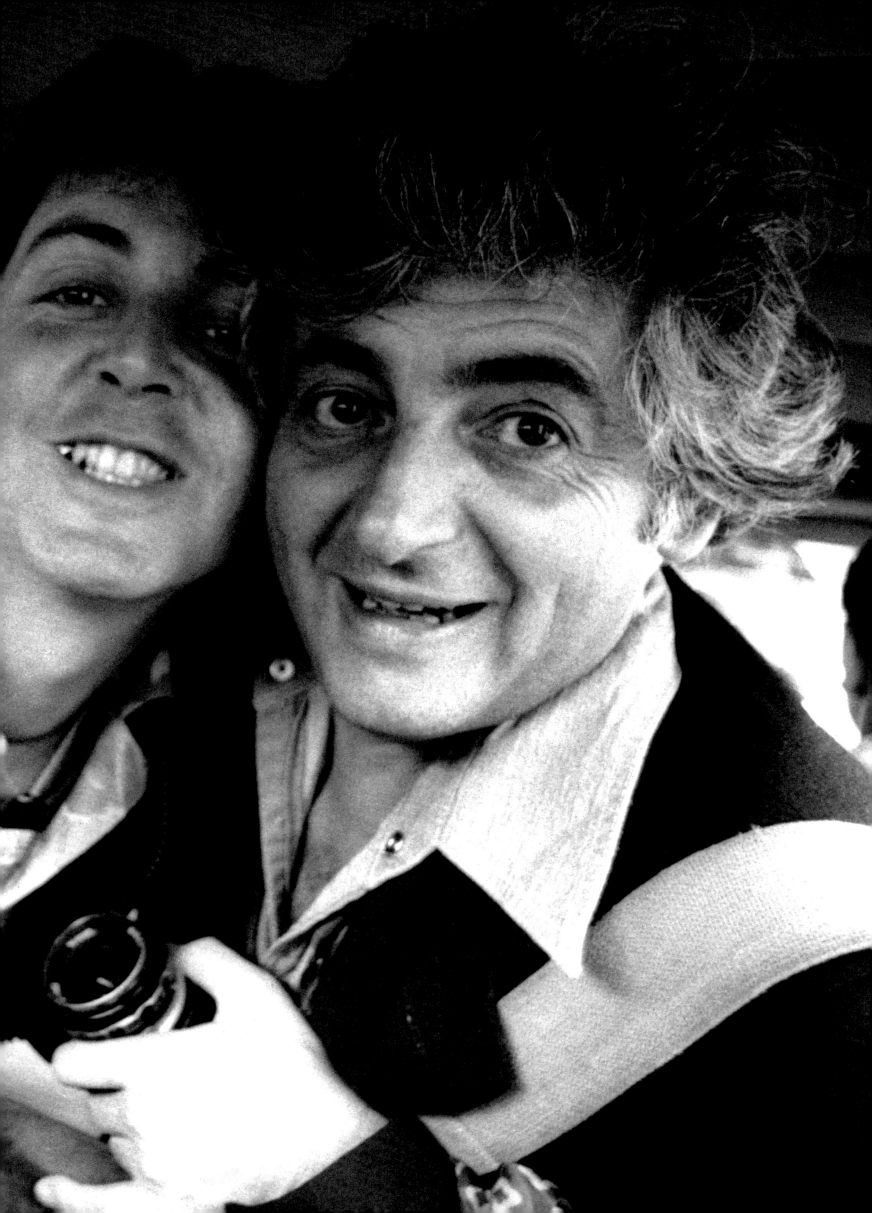

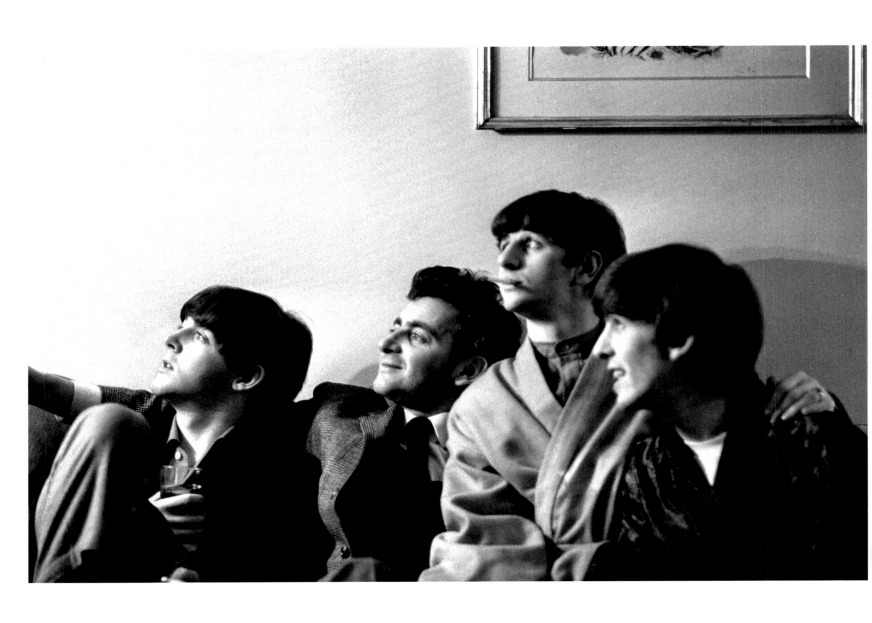

A Portrait of Harry Benson

Glasgow-born Harry Benson CBE had his first photograph published when he was 16 years old in the city's *Evening Times*. His professional career began at Butlin's holiday camp taking holiday snaps, and by 1952 he was at the *Hamilton Advertiser*, the largest weekly newspaper in Scotland. He then freelanced for the London-based paper *The Daily Sketch* covering Scottish stories, and after coming in second as British Press Photographer of the Year, he moved down to London's famed Fleet Street in 1957 for the *Sketch* and in 1958 became a staff photographer for Lord Beaverbrook's *Daily Express*.

While working for the paper, he came to America in 1964 with the Beatles to cover their first US tour, settling permanently in New York in the same year. He continued to work for the *Express* until 1967 when he joined *Life* magazine until it closed in 2000. For several years he was contracted to *Vanity Fair*, and during the early years of *People* magazine, Benson photographed over 100 covers. He has photographed every US president since Dwight D. Eisenhower and was next to Robert F. Kennedy when he was assassinated. He has covered the upheavals in Iraq, Bosnia, Afghanistan, the Civil Rights movement, and photographed countless world leaders and luminaries as diverse as Winston Churchill, Amy Winehouse, Andy Warhol, and Brad Pitt.

In 2017 Harry received the Lifetime Achievement Award from the International Center of Photography (ICP) in New York and was inducted into the International Photography Hall of Fame in St. Louis. In 2013, he received an Honorary Doctor of Letters from St. Andrews University, Scotland. When Queen Elizabeth's 2009 New Year's Honours List was announced, Benson was named a Commander of the British Empire (CBE) for service to photography and received his honor at Buckingham Palace. He was made a Fellow of the Royal Photographic Society (FRPS) in 2009, while the Glasgow School of Art and Glasgow University awarded him a Doctor of Letters in 2008. Benson has won 12 awards from the National Press Photographer Association and was twice named its Magazine Photographer of the Year (1981 and 1985), was awarded the 2005 LUCIE Award for Lifetime Achievement in Portrait Photography, the 2005 American Photo Award for Photography, and the 2006 Scottish National Press Photographers' Lifetime Achievement Award.

Benson has had over 40 solo exhibitions of his work in the US and Europe, including exhibitions at the National Portrait Gallery, Edinburgh (2006); the Smithsonian National Portrait Gallery, Washington, DC (2007); the Scottish Parliament, Edinburgh (2017); and Kelvingrove Museum of Art, Glasgow (2008). His work is in the permanent collection of each. Other exhibitions include the Tucson Museum of Art, Arizona; Christie's, New York (2003); Norton Museum of Art, West Palm Beach (2004); and Pollok House, Glasgow (2019).

Benson has had 16 books of his photographs published, including *The Beatles on the Road 1964–1966* for TASCHEN. He also frequently lectures on photography both in the United States and abroad. The documentary *Harry Benson: Shoot First*, released by Magnolia Pictures in 2016, is available on Hulu. He is also featured in the HBO documentary *Bobby Fischer Against the World*— Benson extensively photographed the controversial chess grandmaster in 1972.

Benson lives in New York and Florida with his wife, Gigi, who works with him on his exhibitions and books; while their two daughters, Wendy Benson Landes and Tessa Benson Tooley both live and work in Los Angeles.

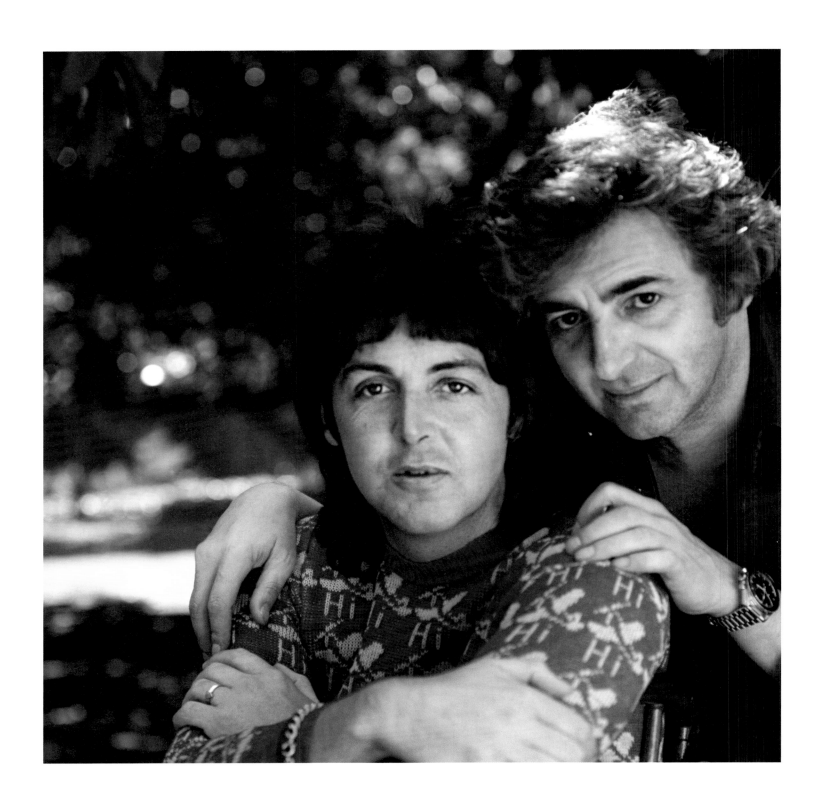

Ein Porträt von Harry Benson

Der in Glasgow geborene Harry Benson veröffentlichte sein erstes Foto in der Glasgower *Evening Times*, als er 16 Jahre alt war. Seine berufliche Karriere fing im Butlin's Holiday Camp mit Fotos von Urlaubern an, 1952 war er bereits beim *Hamilton Advertiser*, der größten Wochenzeitung in Schottland. Danach war er als freier Mitarbeiter der Londoner Zeitung *The Daily Sketch* für die Berichterstattung aus Schottland zuständig. Nachdem er den zweiten Preis bei dem Wettbewerb „Bester britischer Pressefotograf des Jahres" gewonnen hatte, ging er 1957 für den *Daily Sketch* in die berühmte Londoner Fleet Street; 1958 wurde er dann Fotoreporter bei Lord Beaverbrooks *Daily Express*.

Als Mitarbeiter dieser Zeitung kam er 1964 mit den Beatles nach Amerika, um deren erste Amerikatournee zu fotografieren, und ließ sich im gleichen Jahr in New York nieder. Er arbeitete bis 1967 weiter für den *Daily Express* und wechselte dann zur berühmten Zeitschrift *Life*, für die er bis zu deren Einstellung im Jahr 2000 tätig war. Mehrere Jahre lang arbeitete er außerdem für *Vanity Fair* und in den Anfangsjahren für die Zeitschrift *People* und fotografierte über 100 Titelbilder. Er hat seit Dwight D. Eisenhower jeden amerikanischen Präsidenten fotografiert und stand neben Robert Kennedy, als dieser ermordet wurde. Er hat über die Konflikte im Irak, in Bosnien und Afghanistan berichtet und zahllose führende Persönlichkeiten aus aller Welt fotografiert, von Winston Churchill über Amy Winehouse und Andy Warhol bis zu Brad Pitt.

2017 wurde Bensons Lebenswerk mit dem Lifetime Achievement Award des International Center of Photography (ICP) in New ork ausgezeichnet, und er wurde in die International Photography Hall of Fame in St. Louis aufgenommen. Im Jahr 2013 wurde er Ehrendoktor an der St Andrews University in Schottland. Als Königin Elisabeth 2009 die „New Year's Honours List" bekannt gab, war Harry Benson mit dabei und nahm im Buckingham Palace seinen Orden als Commander of the British Empire (CBE) für seine Verdienste um die Fotografie entgegen. Ebenfalls 2009 wurde er Fellow of the Royal Photographic Society (FRPS). Die Glasgow School of Art sowie die Glasgow University hatten ihm bereits 2008 die Ehrendoktorwürde verliehen. Benson wurde mit zwölf Preisen der National Press Photographer Association und zweimal als deren „Zeitschriftenfotograf des Jahres" geehrt (1981 und 1985). 2005 erhielt er den LUCIE-Preis für sein Lebenswerk in der Porträtfotografie und den American Photo Award sowie 2006 den Preis für sein Lebenswerk in der Pressefotografie der Scottish National Press.

Benson hatte mehr als 40 Einzelausstellungen in den USA und Europa, unter anderem in der National Portrait Gallery, Edinburgh (2006), der Smithsonian National Portrait Gallery, Washington, D. C. (2007), und im Kelvingrove Museum of Art, Glasgow (2008). Seine Werke gehören in allen drei Museen zur ständigen Sammlung. Weitere Ausstellungen fanden im Tucson Museum of Art, Arizona, bei Christie's in New York (2003), im Norton Museum of Art, West Palm Beach (2004), und im Pollok House in Glasgow (2019) statt.

Zu den 16 Büchern, in denen Bensons Fotos veröffentlicht wurden, gehört auch The Beatles on the Road 1964–1966, das bei TASCHEN erschien. Er hält in den USA und darüber hinaus häufig Vorträge über Fotografie. Die Dokumentation Harry Benson: Shoot First, die Magnolia Pictures 2016 veröffentlichte, ist auf Hulu zu sehen. Er ist auch in der HBO-Dokumentation Bobby Fischer Against the World dabei, denn Benson fotografierte den umstrittenen Schachweltmeister 1972.

Benson lebt mit seiner Frau Gigi, mit der er bei seinen Ausstellungen und Büchern zusammenarbeitet, in New York und Florida; seine beiden Töchter Wendy Benson Landes und Tessa Benson Tooley leben und arbeiten in Los Angeles.

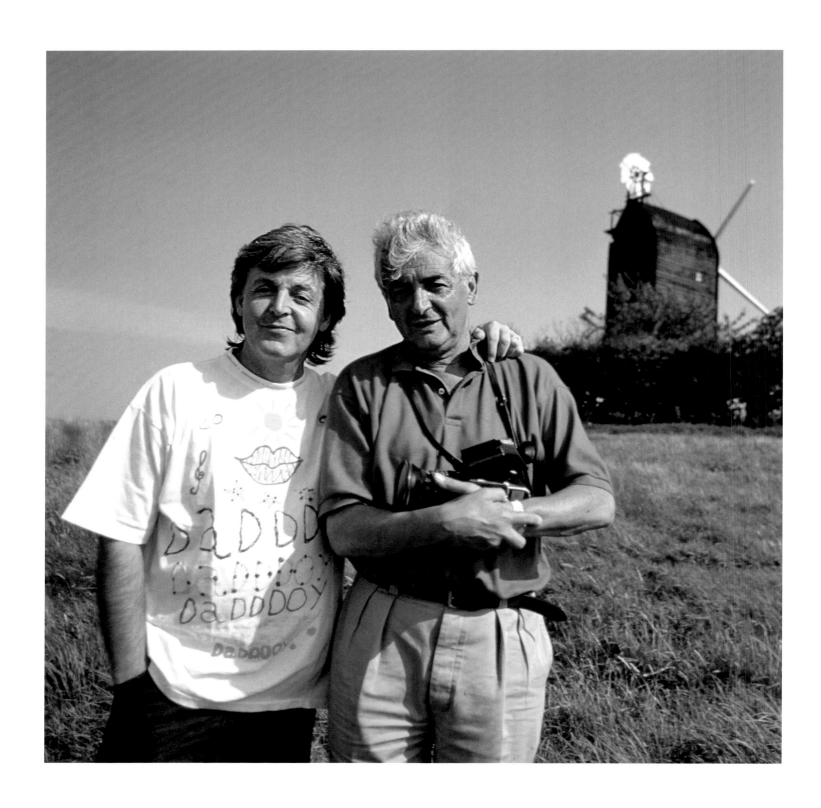

Un portrait de Harry Benson

Originaire de Glasgow, Harry Benson n'avait que seize ans lorsqu'une de ses photos fut publiée pour la première fois dans un journal de sa ville natale, le *Evening Times*. Il commença sa carrière professionnelle en photographiant les estivants dans un camp de vacances Butlin's puis, à partir de 1952, entra au service du *Hamilton Advertiser*, le plus grand hebdomadaire d'Écosse. Parallèlement, il travaillait en freelance pour *The Daily Sketch*, basé à Londres, couvrant les actualités écossaises. En 1957, après avoir manqué de peu le prix du meilleur photographe de presse britannique de l'année, il partit pour la fameuse Fleet Street à Londres afin de poursuivre ses reportages pour *The Daily Sketch* et, en 1958, il fut recruté à plein temps par le *Daily Express*, propriété de lord Beaverbrook.

En 1964, le journal l'envoya couvrir la tournée américaine des Beatles et, la même année, il s'installa définitivement à New York. Il continua de travailler pour le *Daily Express* jusqu'en 1967 puis rejoignit le staff du magazine *Life* jusqu'à la fermeture de ce dernier en 2000. Il travailla pendant plusieurs années pour *Vanity Fair* et participa aux débuts du magazine *People* en réalisant plus de cent couvertures pour ce dernier. Il a par ailleurs photographié tous les présidents des États-Unis depuis Dwight D. Eisenhower, et se trouvait aux côtés de Robert Kennedy quand celui-ci fut assassiné. Il a couvert les événements en Irak, en Bosnie et en Afghanistan, et a réalisé d'innombrables portraits de chefs d'État et de célébrités aussi divers que Winston Churchill, Amy Winehouse, Andy Warhol ou Brad Pitt.

En 2017, Harry a reçu le prix pour l'ensemble de sa carrière du Centre international de la photographie (ICP) à New York et a été intronisé au International Photography Hall of Fame à St. Louis. En 2013, il a reçu un doctorat honorifique en lettres de l'université de St. Andrews, en Écosse. En 2009, à l'occasion de la publication de la liste des ordres honorifiques de la reine Elizabeth II, Benson a été nommé commandeur de l'ordre de l'Empire britannique (CBE) pour ses services au monde de la photographie. La médaille lui a été remise à Buckingham Palace. Il a été fait membre de la Royal Photographic Society (FRPS) la même année et docteur honoris causa de la School of Art de Glasgow et de l'université de Glasgow en 2008. Benson a été primé douze fois par la National Press Photographer Association, qui l'a élu à deux reprises photographe de magazine de l'année (en 1981 et 1985). En 2005, il a reçu le LUCIE Award pour l'ensemble de sa carrière en tant que photographe de portraits, ainsi que l'American Photo Award. En 2006, il a également été récompensé pour l'ensemble de sa carrière par l'association écossaise des photographes de presse.

Quarante expositions personnelles aux États-Unis et en Europe ont consacré le travail de Benson, notamment à la National Portrait Gallery d'Édimbourg (2006), à la Smithsonian National Portrait Gallery de Washington (2007), au Kelvingrove Museum of Art à Glasgow (2008) et au Parlement écossais à Édimbourg (2017). Tous ces musées ont intégré ses œuvres dans leurs collections permanentes. Parmi d'autres institutions ayant accueilli ses expositions, on compte le Tucson Museum of Art en Arizona, Christie's à New York (2003), le Norton Museum of Art à West Palm Beach (2004) et Pollok House à Glasgow (2019).

Benson a publié seize livres à partir de ses photographies, dont *The Beatles on the Road 1964–1966* pour TASCHEN. Il donne régulièrement des conférences sur la photographie aux États-Unis et dans le monde. Le documentaire *Harry Benson: Shoot First*, édité par Magnolia Pictures en 2016, est disponible sur Hulu. Il a également participé au documentaire de la chaîne américaine HBO *64 cases pour un génie : Bobby Fischer*. Il a photographié le sulfureux grand maître des échecs à de nombreuses reprises en 1972.

Benson vit à New York et en Floride avec son épouse Gigi, qui collabore à ses expositions et ses livres. Leurs deux filles, Wendy Benson Landes et Tessa Benson Tooley, vivent et travaillent à Los Angeles.

I would like to dedicate this book to my wife, Gigi, our daughters, Wendy and Tessa, and our grandchildren, Mimi, Dominic, and Tucker.

I would like to thank:
Paul McCartney and equally Linda McCartney who would arrange Paul's schedule to help me… a great person…like everyone, I miss her…
The Beatles…for instead of going to Africa on assignment I went to Paris and then on to America with the Beatles and that changed my life…
Benedikt Taschen for his vision in publishing the book of which I am very proud.
Reuel Golden, my editor on the book, for his intelligence, patience, and humor throughout.
Josh Baker for his creative art direction.
The TASCHEN team who worked on the book—Frank Goerhardt, Stefan Klatte, Kathrin Murr, and Sarah Wrigley.
Photographer Jonathan Delano who has worked with me over the years…
I would also like to thank Rolleiflex, Minolta, Canon, Epson, and of course Kodak because without Tri-X, to me the greatest film ever made, I would never have had a career…
And to my wife, Gigi, whose dedication and hard work have made this book a reality.

— HARRY BENSON
New York City, 2022

All photos © Harry Benson

To stay informed about TASCHEN and our upcoming titles, please subscribe to our free magazine at www.taschen.com/magazine, follow us on Instagram and Facebook, or e-mail your questions to contact@taschen.com.

EACH AND EVERY TASCHEN BOOK PLANTS A SEED!

TASCHEN is a carbon neutral publisher. Each year, we offset our annual carbon emissions with carbon credits at the Instituto Terra, a reforestation program in Minas Gerais, Brazil, founded by Lélia and Sebastião Salgado. To find out more about this ecological partnership, please check: www.taschen.com/zerocarbon

Inspiration: unlimited. Carbon footprint: zero.

Edited by Reuel Golden, New York
Design by Josh Baker, Oakland
German translation by Julia Heller, Munich
French translation by Jacques Bosser, Montesquiou

© 2022 TASCHEN GmbH
Hohenzollernring 53, D-50672 Köln, Germany
www.taschen.com

ISBN 978-3-8365-9204-8
Printed in Italy